MW01485251

Graphis Inc. is committed to celebrating exceptional work in Design, Advertising, Photography & Art/Illustration internationally.

Published by **Graphis** | Publisher & Creative Director: **B. Martin Pedersen**

Design Director: **Hee Ra Kim** | Designer: **Hie Won Sohn** | Assistant Editor: **Stephanie Ginzburg** | Account/Production: **Leslie Taylor**

Design Intern: **Hanna Meyers** | Editorial Interns: **Nicole Bressi, Sara Gonzalez**

Graphis Advertising Annual 2020

Published by:
Graphis Inc.
389 Fifth Avenue, Suite 1105
New York, NY 10016
Phone: 212-532-9387
www.graphis.com
help@graphis.com

Distributed by:
National Book Networks, Inc.
15200 NBN Way
Blue Ridge Summit, PA 17214
Toll Free (U.S.): 800-462-6420
Toll Free Fax (U.S.): 800-338-4550
Email orders or Inquiries:
customercare@nbnbooks.com

Legal Counsel: John M. Roth
4349 Aldrich Avenue, South
Minneapolis, MN 55409
Phone: 612-360-4054
johnrothattorney@gmail.com

ISBN 13: 978-1-931241-83-0
ISBN 10: 1-931241-83-0

We extend our heartfelt thanks to
the international contributors
who have made it possible to publish
a wide spectrum of the best work
in Design, Advertising, Photography,
and Art / Illustration.
Anyone is welcome to submit
work at www.graphis.com.

Contents

In Memoriam

THE AMERICAS

Rolland "Ron" Anderson
Global Creative Director,
Bozell Worldwide
1936-2018

Roy Blackfield Jr.
Chief Executive Officer,
Sawyer Ferguson Walker Corp.
1929-2019

Terry Clarke
CEO,
Clarke Goward Advertising
1938-2018

Sharon Lee Cunliffe
Director of Advertising Dev.,
Procter & Gamble
1957-2019

Rod Lee Downing
Advertising executive,
Viamedia
1955-2019

Denise Fedewa
Executive Vice President,
Leo Burnett Worldwide
1962-2019

Bernard "Bud" Frankel
Founder,
Frankel & Co.
1930- 2019

William "Bill" Fultz
President,
CMF&Z Des Moines Office
1931-2019

Barbara Gardner Proctor
Founder,
Proctor & Gardner Advertising
1932- 2018

Philip Geier
Former Chairman & CEO,
The Interpublic Group of
Companies, Inc.
1935-2019

Jerry Gibbons
Western Regional Executive
Vice President,
American Association of
Advertising Agencies
1937- 2019

Doug Laughlin
Chairman,
LM&O Advertising
1942-2018

Jane Maas
Advertising Legend,
Agency Officer
Ogilvy & Mather
1932-2018

Nadeen Peterson
Advertising Woman of
the Year (1992)
1934-2019

Greg Smith
Chief Creative Officer,
The Via Agency
1967-2019

EUROPE

Timothy John Leigh Bell,
Baron Bell
Co-founder & former head,
Bell Pottinger
1940-2019

Nancy Fouts
Designer & Founder,
Shirt Sleeve Advertising Studio
1945-2019

Peter Mayle
Former Creative Director,
BBDO London
1940-2018

Douglas McArthur
Founder,
Radio Advertising Bureau &
Chairman of UKOM
1950-2019

ASIA

Seung Choon Yang
Graphic Designer
1940-2017

A Decade in Advertising: 2010 to 2020

As we reflect on a 10-year journey into the modern age of advertising, these award-winning agencies continue to inspire newcomers and longtime creators alike.

Presented are 11 Platinum Winners from 2010:
MacLaren McCann of Canada, Polo Ralph Lauren, New York, BBDO Minneapolis, PPK, Heye GmbH of Germany, Dunn&Co., FABRICA of Italy, Goodby, Silverstein & Partners, Publicis Dallas, Hill Holliday, and 22squared, Tampa.

Refresh on the COKE side of life | Coca-Cola Canada | **MacLaren McCann**

McDonald's 24/7 | McDonald's Germany | **Heye, Group GmbH**

Visit the Pin Campaign | City of Boston | **Hill Holliday, Marblehead**

300 DIFFERENT BEERS TO CRY IN.

St. Paul Guy | Williams Pub | BBDO Minneapolis

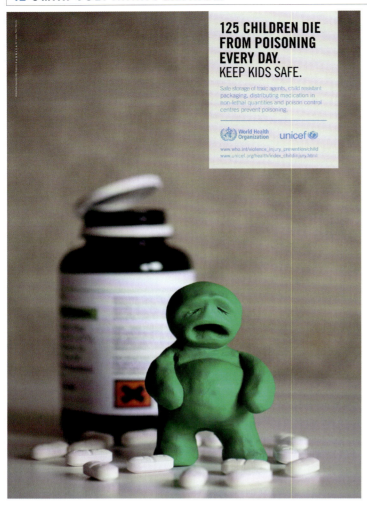

125 CHILDREN DIE FROM POISONING EVERY DAY.
KEEP KIDS SAFE.

Safe storage of toxic agents, child resistant packaging, distributing medication in non-lethal quantities and poison control centres prevent poisoning.

World Health Organization unicef

www.who.int/violence_injury_prevention/child
www.unicef.org/health/index_childinjury.html

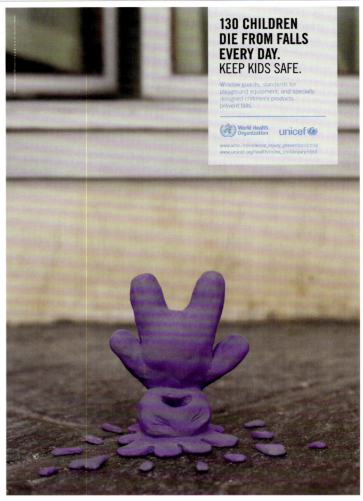

130 CHILDREN DIE FROM FALLS EVERY DAY.
KEEP KIDS SAFE.

Window guards, standards for playground equipment, and specially designed children's products prevent falls.

World Health Organization unicef

www.who.int/violence_injury_prevention/child
www.unicef.org/health/index_childinjury.html

480 CHILDREN DIE FROM DROWNING EVERY DAY.
KEEP KIDS SAFE.

Life jackets, fencing around swimming pools, covering water hazards and prompt first aid prevent drowning.

World Health Organization unicef

www.who.int/violence_injury_prevention/child
www.unicef.org/health/index_childinjury.html

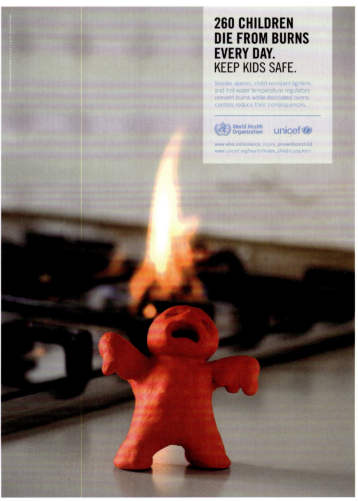

260 CHILDREN DIE FROM BURNS EVERY DAY.
KEEP KIDS SAFE.

Smoke alarms, child-resistant lighters and hot-water temperature regulators prevent burns while dedicated burns centres reduce their consequences.

World Health Organization unicef

www.who.int/violence_injury_prevention/child
www.unicef.org/health/index_childinjury.html

White Water | Dagger Kayaks | **22squared, Tampa**

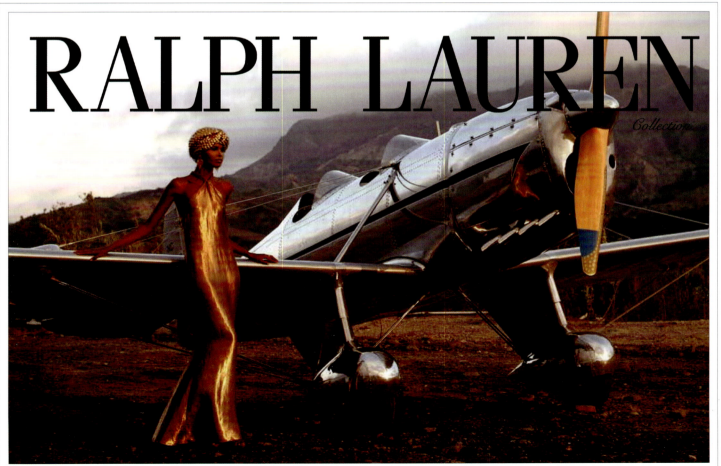

Ralph Lauren Collection Spring 2009 | Ralph Lauren | **Polo Ralph Lauren**

Piece by Piece Poster | The ALS Association Florida Chapter | **Dunn&Co.**

DRINK RESPONSIBLY.

The handmade tequila.

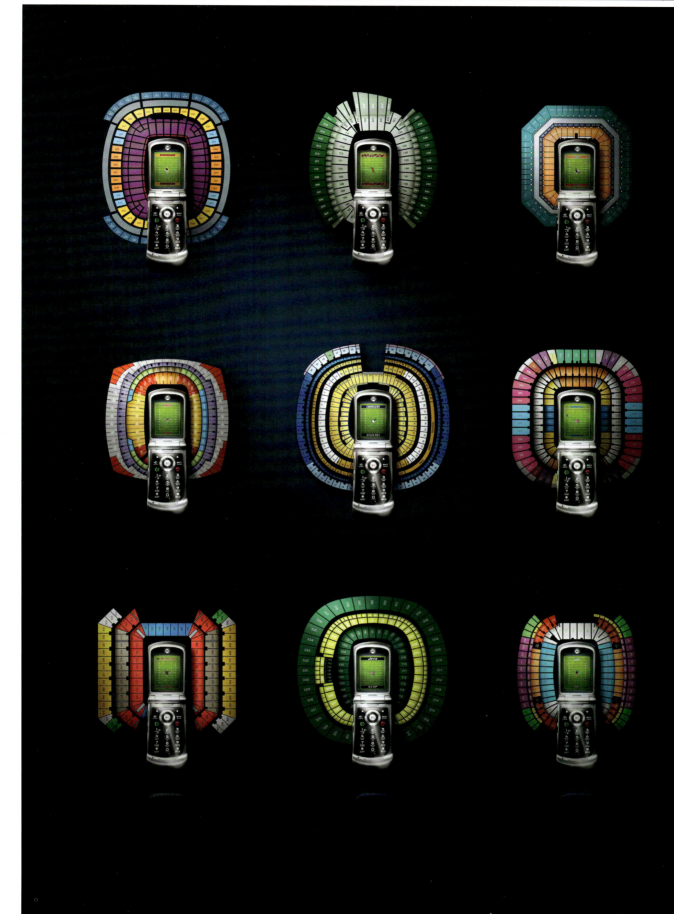

Live from your pocket, it's the NFL.

Benjamin Bailey | Creative Director, Head of Design | Doner
Biography: Benjamin Bailey has experience that spans the globe and the industry, from traditional to experiential, and start-ups to giants. He has helmed major content productions in Mexico's agave fields and Indonesian rice terraces; translated Chris Blackwell's island lifestyle for savvy travelers; dusted off Martini's iconic ball-and-bar for a new generation in Rome and all roads leading out; helped Chobani's founder Hamdi rethink and redesign his ecosystem from products to incubators to resources for refugees; added digital amplification to American Express' live experiences; designed the most enduring transportation symbol in NYC and much more. Now, as Head of Design, he has turned to the heartland helping transform Doner into a next-level creative agency where Modern meets Main Street.
Commentary: The work was polite and, at times, showed craft. The ads for the Atlanta Fireman's Association rose to the top for me. They are emotive and raised the bar on what might be expected from an otherwise muscular profession.

Jimmy Bonner | Creative Director, Art Director | The Richards Group
Biography: Jimmy is a Group Creative Director/Art Director at The Richards Group in Dallas, Texas. He has worked on dozens of brands over the course of his career. His most notable piece was for a Ram Truck super bowl commercial, "So God made a Farmer" narrated by the late Paul Harvey. Along with Ram Trucks, he has produced award-winning work for Biltmore, Sea Island, The Ritz-Carlton, Winston Fly Rods, GoRVing, Bridgestone, Firestone, The PGA Tour Superstore, The Home Depot, Spalding, Legg Mason, and Wyoming Tourism. The latter being where he survived three -30 degree winters in Jackson Hole with his wife Molly.
Originally from New Orleans, his creative path was inspired by his father, a graphic designer. After earning his degree in Graphic Design at Alabama, he then graduated from The Portfolio Center in Atlanta. His two children have also picked up the creative torch, attending SCAD in Savannah.
He began his career at the Richards Group and toured the country for 8 years with agency stops in Jackson Hole, Atlanta and Chapel Hill. He returned to The Richards Group in 2001 and was forbidden by his family to ever move again.
His work has been featured in TED Talks, Google Sandbox, Cannes Lion Festival, CA, One Show, Graphis and Archive magazine where he's ranked among the top 20 art directors in the U.S.
Commentary: It's a real honor to have your work featured in Graphis. Being asked to judge a Graphis Annual, well, that feels like you've been invited to sit at the big kids table. Kidding aside, Graphis turned 75 years old in 2019. They deserve our gratitude for being curators, protectors, and keepers of our stories. Graphis is a special place for anyone who goes by the title "creative."
A few highlights from the show came from the Entertainment category, which had a significant amount of entries this year.
I really enjoyed HBO's #ForTheThrone piece, created by 360i, where they enlisted 18 international artists to reimagine and execute GOT props in their own unique style. The art collection was then used to inspire millions of GOT fans around the world, inviting them to create their own unique fan art. That is the stuff of legends, in any kingdom.
For the best, short, not-so-sweet, and to the point category, Cold Open's poster execution for HBO's 'Deadwood the Movie' was good. Real "F-ing" good.

Matt Herrmann | Group Creative Director | BVK
Biography: The best thinkers are original, strategic, and prolific. Matt Herrmann notches the trifecta with solutions that blend smart concepts and tasteful, often beautiful design. At BVK, Matt applies this all-around craftsmanship to everything from tourism and higher education, to healthcare and packaged goods. He also brings a unique literary aptitude to his work, penning original movie ideas in his free time. His work has been shortlisted at Cannes and recognized by numerous award shows, including those with an emphasis on advertising effectiveness. A high jumper in college, Matt continues to set the bar high for himself and his clients.
Commentary: This year's entries showcased a diverse range of creative executions. The work that stood out the most to me featured bold, graphic solutions with a keen eye for production details.

Jin-soo Jeon | Representative Director, Chief Creative Director | Brand Directors
Biography: Jin-soo Jeon is the Representative Director and Chief Creative Director of BRAND DIRECTORS, a Korean design company. Selected as one of the next-generation design leaders in Korea in 2007, he has won the IF Design Award, RED-DOT Award, Graphis Award, and 60 other awards, having his work continuously shown around the world.
After obtaining a BA in Visual Design and an MA in Business Administration in Korea, he conducted numerous convergence studies and projects, playing a role as a bridge between design and business administration.
Commentary: The artwork was excellent and very inspirational. I appreciate having the opportunity to be a judge for this competition. I wish all of the creators success.

John Peed | Founder, CEO | Cold Open
Biography: John Peed was an active artist from an early age, exploring a variety of media and styles. His earliest inspirations came from album art, old signage, modern painters, and punk rock flyers. John grew up in North Carolina and attended the University of Georgia, graduating with a degree in fine art and a concentration in graphic design. After college, he moved to Los Angeles and spent seven years as a freelance art director, working with many agencies and studios. In 1999, John founded Cold Open. Since then, he and his team have created numerous award-winning campaigns.
Commentary: I was honored to judge this year's competition. As a designer, I've always found inspiration everywhere, so I really appreciated viewing and considering the wide range of work from so many industries.

Xosé Teiga | Creative Director, Art Director | Xosé Teiga, Studio
Biography: Xosé Teiga studied Fine Arts at the University of Vigo, specializing in Audiovisual, having previously obtained a degree in Design from ESAD at Santiago de Compostela, with a specialization in Graphic Advertising and Ephemeral Architecture. His works have been recognized with over 200 international awards, including Laus, Wolda, Design & Design, Anuaria, Cannes Lions Design, Graphis, Communication Arts, and the Art Directors Club Europe.
Currently, he is the Creative Director of Xosé Teiga Studio, a business specializing in branding and advertising. He had previously worked at different agencies such as Unlimit-ed, McCann World Group, DDB Health, and Luis Carballo. He complements his professional activities with education, teaching at different Spanish universities.
Commentary: In general, both the concept as well as the execution of the awarded works have had a good level of focus at the moment of briefing, resulting in a high level. I have seen work with good results, and some works being standouts from the rest. I was very surprised by the work from INNOCEAN, The Designory, ARSONAL, Doe Anderson, and PPK.

As judge Cold Open was an entrant and winner, special care was taken to insure that they did not judge their own work.

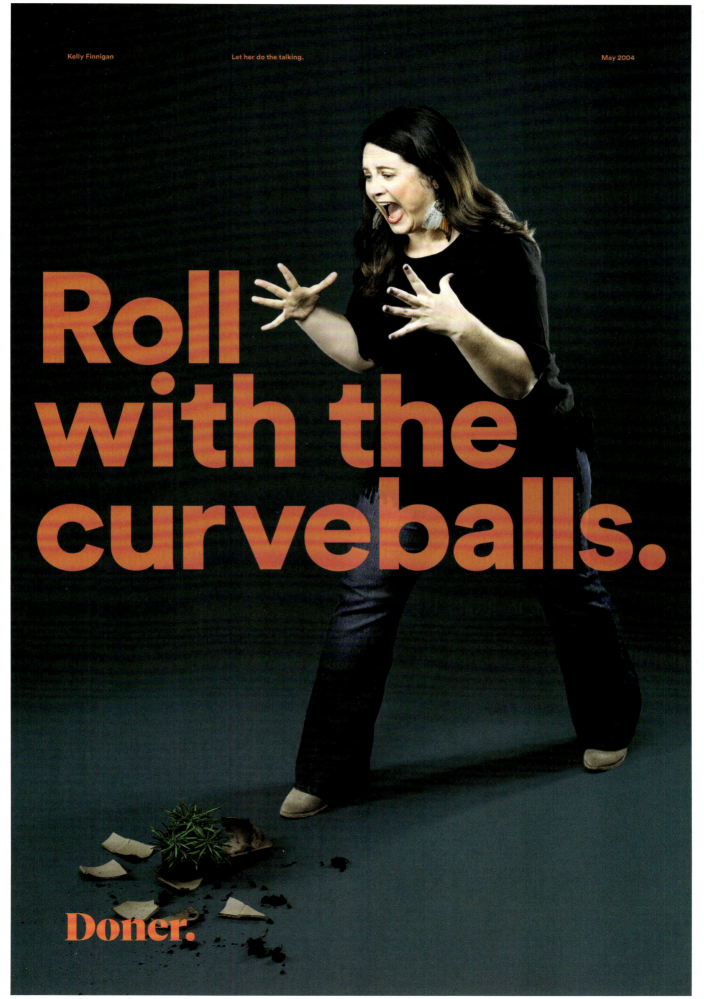

Kelly Finnigan Let her do the talking. May 2004

Roll
with the
curveballs.

Doner.

Doner | Self-initiated | Doner

One will dominate.
The rest will submit.

Footin.com National Endurance Barefoot Water Ski Championships • August 25-26, 2018 • Crandon, WI

footstock
FOOTSTOCK2018.COM

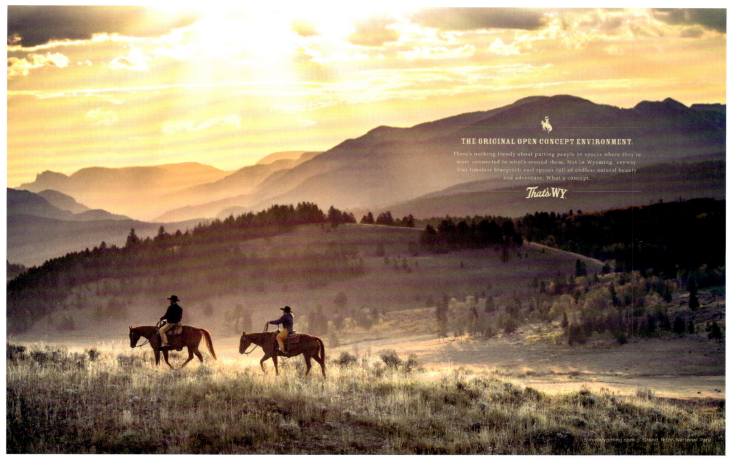

THE ORIGINAL OPEN CONCEPT ENVIRONMENT.

There's nothing trendy about putting people in spaces where they're more connected to what's around them. Not in Wyoming, anyway. Our timeless blueprint: vast spaces full of endless natural beauty and adventure. What a concept.

That's **WY**

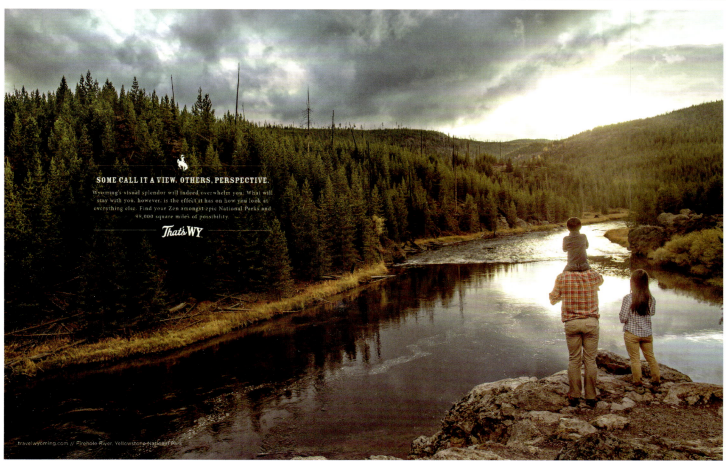

SOME CALL IT A VIEW. OTHERS, PERSPECTIVE.

Wyoming's visual splendor will indeed overwhelm you. What will stay with you, however, is the effect it has on how you look at everything else. Find your Zen amongst epic National Parks and 98,000 square miles of possibility.

That's **WY**

That's WY Print Campaign | Wyoming Office of Tourism | **BVK**

Activate Electronic Child Safety Lock

Try to inactivate
Electronic Child Safety Lock

Make Quality Time

Rear Occupant Alert (Hide-and-Seek) | HYUNDAI MOTOR GROUP | BRAND DIRECTORS

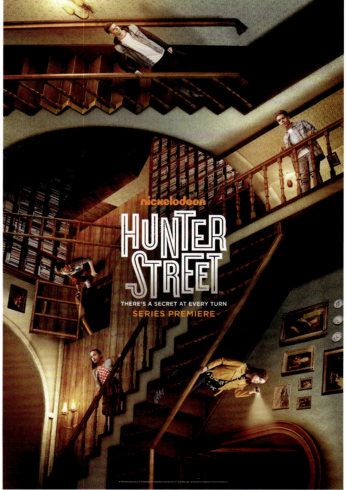

Runaways - Series, Life of the Party, Banshee S4, Hunter Street S1 | Hulu, Warner Bros. Pictures, Cinemax, Nickelodeon | **Cold Open**

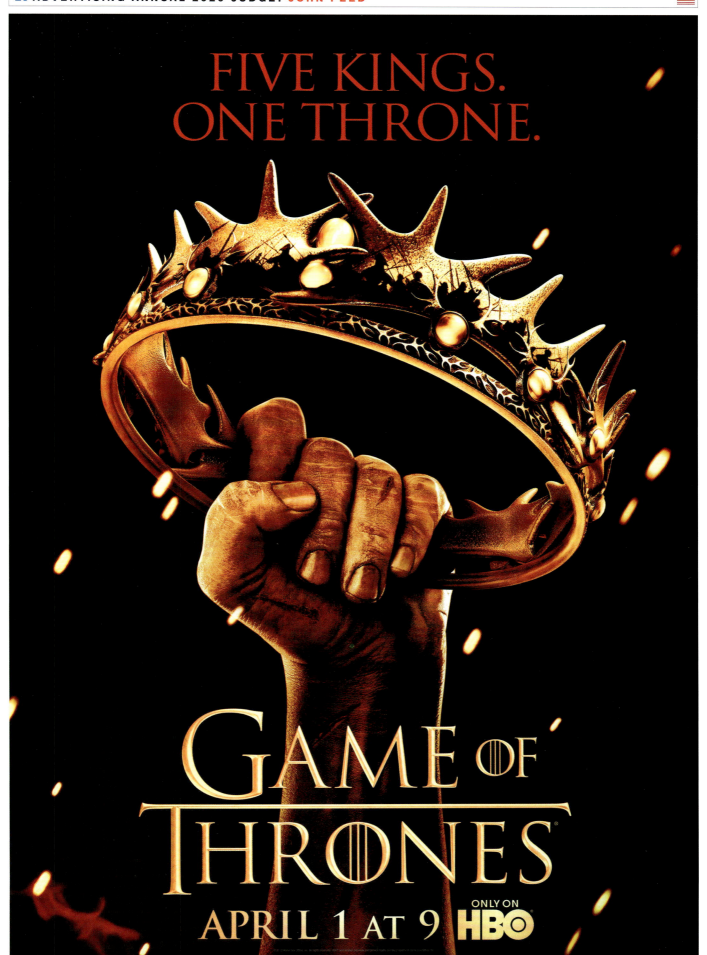

Game Of Thrones | HBO | Cold Open

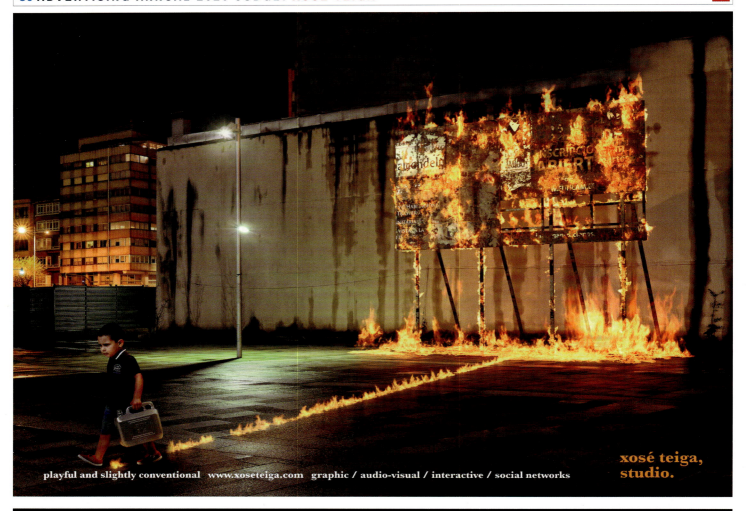

playful and slightly conventional www.xoseteiga.com graphic / audio-visual / interactive / social networks

xosé teiga, studio.

playful and slightly conventional www.xoseteiga.com graphic / audio-visual / interactive / social networks

xosé teiga, studio.

Unconventional | Self-initiated | xosé teiga, studio.

We'll always have different ways of seeing things. Merry Christmas

www.xoseteiga.com

xosé teiga,
studio.

ARSONAL | www.arsonal.com | Page: 36
Biography: ARSONAL has been behind some of the most eye-catching campaigns in their field, and they have been recognized as a leader in entertainment advertising with clients that include, 20th Century Fox, A&E, ABC, Amazon Prime Video, Audience Network, Bravo, Cinemax, Disney, Focus Features, FOX, FX Networks, HBO, Hulu, IFC, National Geographic, Netflix, Nickelodeon, Showtime, Starz, TBS, The CW, TNT, TruTV, USA and Warner Bros.

FBC Design | Page: 37
Biography: A division of FOX Entertainment Creative Advertising, FBC Design is one of the teams behind the award-winning creative marketing for hit shows like 9-1-1, THE MASKED SINGER, EMPIRE, HOUSE, 24, The X-Files and American Idol, delivering high-quality key art, show graphics, social marketing and out of home advertising.
FOX Entertainment's 30-year legacy of innovative, hit programming includes scripted, non-scripted and live content. FOX Entertainment's broadcast network airs 15 hours of primetime programming a week, as well as major sports. It is the only major network to post year-over-year growth among viewers during the 2018-2019 broadcast season.

Silver Cuellar III | Creative Director | **Brunner** | www.brunnerworks.com | Pages: **38, 39**
Biography: Silver Cuellar III is a Creative Director at Brunner in Atlanta, Georgia. He specializes in strategic brand building, Pokémon Go, and facial hair. Silver has spent the past 18 or so years working at McGarrah Jessee, Mullen, The Richards Group, and BBDO, on everything from fried chicken to ladies underpants. Along the way, he's been fortunate enough to gather recognition from CA, The One Show, Archive, Obies, Clios, and his parents' refrigerator door.
Outside of work you can find Silver roving the Georgia countryside, poking around various local barbecue establishments as he is also a self-taught Meat Whisperer.
Currently, he resides in Roswell, Georgia, with his high school sweetheart Susan, their 9-year-old daughter and future stunt woman Sophia, Silver the 4th though he's only 5, wildling toddler Simon Bear, as well as all the forest critter folk lurking in the forests of Northern Atlanta.

Michael Schillig | Creative Director | **PPK, USA** | www.uniteppk.com | Pages: **40, 41, 154, 155**
Biography: Michael has been with PPK for over 14 years and has created many award-winning campaigns for diverse local, regional and national clients. He's worked with Circle K, Tires Plus, Pirelli Tires, Sweetbay Supermarket, Tampa Bay Rays, GTE Financial, Big Boy Restaurants, Wichita Brewing Company, and Touch Vodka, just to name a few. However, he has received the most gratification from helping several nonprofits gain national creative acclaim, such as Big Cat Rescue, the National Pediatric Cancer Foundation, Metropolitan Ministries, ASPCA, Jailhouse Fire Hot Sauce, and the Florida Aquarium.
In the process, his work has been showcased in the Graphis Advertising Annual for 13 years in a row, including being a nine-time winner of the coveted Graphis Platinum Award. He's also been honored multiple times in the International Radio Mercury Awards; OBIE Awards; National ADDY Awards; Communications Arts; Lürzer's International Archive; How International Design; Print Regional Design; and ADWEEK, among others. When he's not writing, Michael is probably spending time with his wonderful wife, Gisela, or enjoying his other strong love– tennis.

Trushar Patel | Associate Creative Director, Art Director | **PPK, USA** | www.uniteppk.com | Pages: **40, 41, 154, 155**
Biography: Born deep in the mountains of the northeast—battling and taming its harsh culture but inspiring landscape this first generation East Indian had a great vision as many kids did in the 80s. It was to travel through outer space and explore the universe as an astronaut. How could you blame him? It was the hey day of NASA, ET, Dune, Star wars, Aliens, Predator, and the list goes on. All of these works of moving art, photos, drawings, VFX of spaceships, creatures, costumes, and distant fantastical landscapes sent his tiny little brain into an explosion of wonderment and ideas. In this moment, a chubby little Indian kid decided to go against the grain of his roots and choose not be a doctor or an engineer, but rather pursue a field in art.
On his journey into the Arts, he lived excessively and did his best to leave no stone unturned. He fell in love with history, printmaking, Toulouse Lautrec, Japanese wood blocks, surrealist like David Lachapelle, and the local collective of creators out of Philly. Fueled by this, like a raging inferno, he pursued a career as an art director. A fast life of temporary fleeting moments—racing to get his next fix, the next big idea, the next mind blowing production, pushing whatever boundaries he could. As his endeavor continues he realizes that living in this brilliant light of enchantment is very short-lived. To be content with that realization is where he finds his happiness and glory. And by the good graces of advertising, a legacy of sorts. All bound by the mantra "give more than you take and absolutely never bow down."

Fabian Oefner | www.fabianoefner.com | Pages: **148, 149**
Biography: Fabian Oefner is a multidisciplinary artist, whose work explores the boundaries between time, space, and reality. He creates fictional moments and spaces, that look and feel absolutely real, yet aren't. Through this, Oefner dissects the different components of reality and gives us a clearer understanding of how we perceive and define it. Oefner's photographs, sculptures, and videos are part of numerous private and public collections. His work is regularly featured in publications like The Washington Post, Wired, National Geographic and many more. He works and lives in New York.

The Designory | www.designory.com | Pages: **150, 151**
Biography: Designory is a global, award-winning, creative content marketing agency that employs data-informed storytelling to inspire next step action and engagement across media channels. With expertise across the content creation spectrum, including digital, print and video, delivering the most relevant ideas is our mission: helping customers discover and appreciate a brand through the lens of its products, inspiring action, affinity and results. With 7 offices around the world and a 47-year heritage, Designory is a proven team of hungry and grounded, yet personally confident product marketers, content creators, and digital experts with a genuine and unwavering passion for our craft.

INNOCEAN USA | www.innoceanusa.com | Pages: **152, 153**
Biography: Founded in 2009, INNOCEAN USA is headquartered in Huntington Beach, California, with offices in New York, Chicago, and Dallas. With 400 employees, INNOCEAN USA is part of the INNOCEAN Worldwide network and currently serves as lead agency for Hyundai Motor America and Genesis Motor America, as well as partners with KIA Motors America. Additional accounts include Hankook Tire, The Habit Burger Grill, Wienerschnitzel and UC Davis Health.

David Chandi | Creative Director | **daDá** | www.dada.com.ec | Pages: **156, 157**
Biography: Estudios realizados en la Universidad Tecnológica Equinoccial, de Diseño Gráfico y Lic. en Publicidad, aficionado a la fotografía con 20 años de experiencia en el medio publicitario y más de 60 reconocimientos a nivel nacional e internacional.
Me mueve la pasión por la publicidad, los mensajes, los códigos visuales, la creación de marcas, la irreverencia, lo que no se debe hacer, la constante búsqueda de nuevas formas de comunicar, actualmente socio fundador de la agencia daDá, agencia dedicada al sector privado, con el objetivo de crear mensajes memorables.
David Chandi carried out his studies at the Equinoctial Technological University, with a Graphic Design and Advertising Degree. He is a photography fan with 20 years of experience in advertising and more than 60 national and international awards.
He is moved by the passion for advertising, messages, visual codes, brand creation, irreverence, and the constant search for new ways of communicating. He is currently a founding partner of the daDá agency, an agency dedicated to private sectors, with the aim of creating memorable messages.

Duncan Channon | www.duncanchannon.com | Pages: **158, 159**
Biography: Duncan Channon is an award-winning independent, integrated advertising and design agency with offices in San Francisco, Los Angeles and New York. Founded in 1990, Duncan Channon is best known for turning StubHub into a household name, bottling the Hawaiian mindset for Kona Beer and educating the public on the dangers of e-cigarettes for the California Tobacco Control Program. This year, DC acquired A2G, a two-time Ad Age Small Agency of the Year and pioneer in experiential, influencer and social marketing, bringing a dynamic new roster of talent and capabilities to the agency. Duncan Channon runs on the philosophy of guanxi, the belief that clients and staff, brands and customers all win when they build real, trusting relationships.

Shine United | www.shineunited.com | Pages: **156, 157**
Biography: Shine United is a $51 million advertising, design and interactive agency located in Madison, Wisconsin. The privately held company's client roster includes national consumer brands such as Harley-Davidson, Wisconsin Cheese, GORE-TEX, Amazon.com, UW Health, Quartz Health Solutions, Veridian Homes, LaCrosse Footwear and Big Ass Fans.
Since first opening its doors in 2001 Shine has served its clients by being less concerned with the dog-and-pony show and more concerned with creatively-driven, results-based solutions. Shine fosters an environment where creativity, brilliance and teamwork flourish — an environment where the idea is always king. It's no wonder that the agency has been named as one of the best places to work in America by Outside Magazine for the past six years.

As a designer, I have always found inspiration everywhere, so I really appreciated viewing and considering the wide range of work here.

John Peed, *Founder & CEO, Cold Open*

The work that stood out the most to me featured bold, graphic solutions with a keen eye for production details.

Matt Herrmann, *Group Creative Director, BVK*

Visit our Credits & Commentary section in the back of the book to read the full assignments, approaches, and results from this year's Platinum Winners.

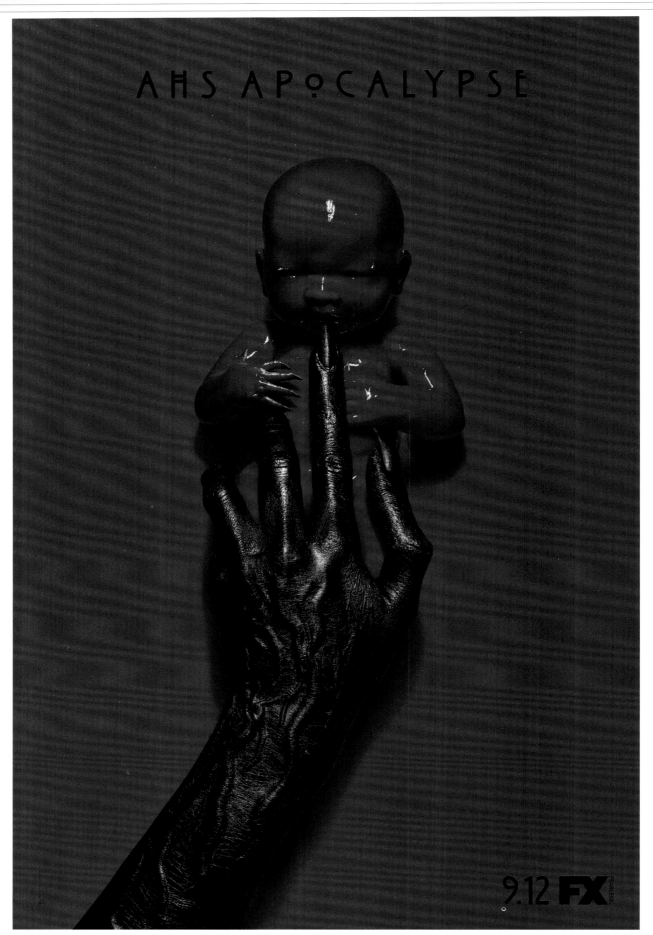

AHS APOCALYPSE

9.12 **FX**

American Horror Story: Apocalypse | **FX Networks** | **ARSONAL**

Assignment: To play with the theme of the antichrist and his potential connections to past seasons of American Horror Story.
Approach: We landed on art that represented the birth of this season's central figure, the antichrist, hinting at the evil to come.
Results: This campaign mirrored the same bold palette of the iconic Season 1 American Horror Story poster and was equally provocative.

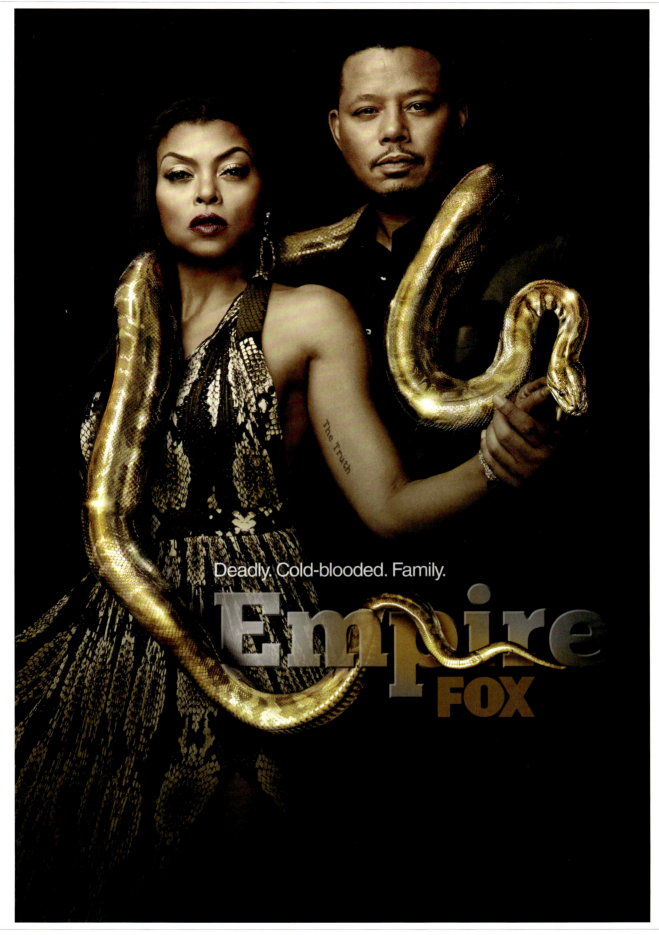

Deadly. Cold-blooded. Family.

EMPIRE – "Coiled in Deception" | **Fox Entertainment** | **FBC Design**

Assignment: Our goal was to create key art for Empire that addressed the complicated relationship of the two main characters, Cookie and Lucious.
Approach: The snake coiled around their bodies represents the drama and wealth that envelopes them.
Results: We created a piece that is visually striking, which speaks to the deep and complex connection between two iconic characters.

FIRES A

Join the tea

Pride Banner | Atlanta Fire Rescue Foundation | Brunner

Assignment: To create content to drive the Atlanta Fire Rescue Department's diversity initiative.
Approach: One particularly under-resourced recruitment group is the LGBTQ community. Pride 2018 presented a great opportunity to speak

CRIMINATE. SO ARE WE.

rescue.com or call **1-844-ATL-FIRE**.

to them with a message of acceptance and solidarity. We created an AFRD Pride banner for the fire engine used during the department's procession in the parade. We reminded the crowd that it doesn't matter how you identify; all that matters is you step forward and answer the call.

THINK OUTSIDE THE TOOL B

5³/₈" 135 mm

48-40-4070

FERR
Ferroso

3

The last thing dad needs for Father's Day is another tool. So give him an exciting, new gift that wil

Father's Day Tool Fish | The Florida Aquarium | **PPK, USA**

Assignment: Our assignment was to come up with a memorable concept for the Florida's Aquarium's special Father's Day promotion, which offered free admission to dads over that weekend.

ea of memories for the whole family. **All dads get in free, June 15 and 16**.

THE FLORIDA
AQUARIUM™

Approach: We wanted to play up just how terrific this Father's Day gift idea was, especially in comparison to your typical unimaginative gifts.
Results: These posters were definitely seen and talked about. The dramatic 'tool fish' really stood out from more traditional Father's Day gifts.

THE 2019 **ILX**

TOTAL(CONTROL)

ACURA
PRECISION CRAFTED PERFORMANCE

Performance comes in all sizes, and the new 2019 ILX packs plenty of punch in a sport compact frame. A quick-shifting 8-speed Dual-Clutch Transmission and Sequential SportShift paddle shifters make swift work of freeway passing and city commutes. And with an ultraresponsive 2.4-liter, 16-valve i-VTEC® engine under the hood, the 2019 ILX is engineered to thrill.

Acura ILX | Acura | MullenLowe LA

P120 Fighter

r, you can try riding a Picass

F131 Hellcat

$90,000

m a g n e t

mistress

B120 Wraith

landspeed record
bonneville utah, salt flats
166 m.p.h.

La nueva

PLANET EARTH'S FAVORITE VODKA

ABSOLUT.

Absolut Straws | Absolut Vodka | 360i

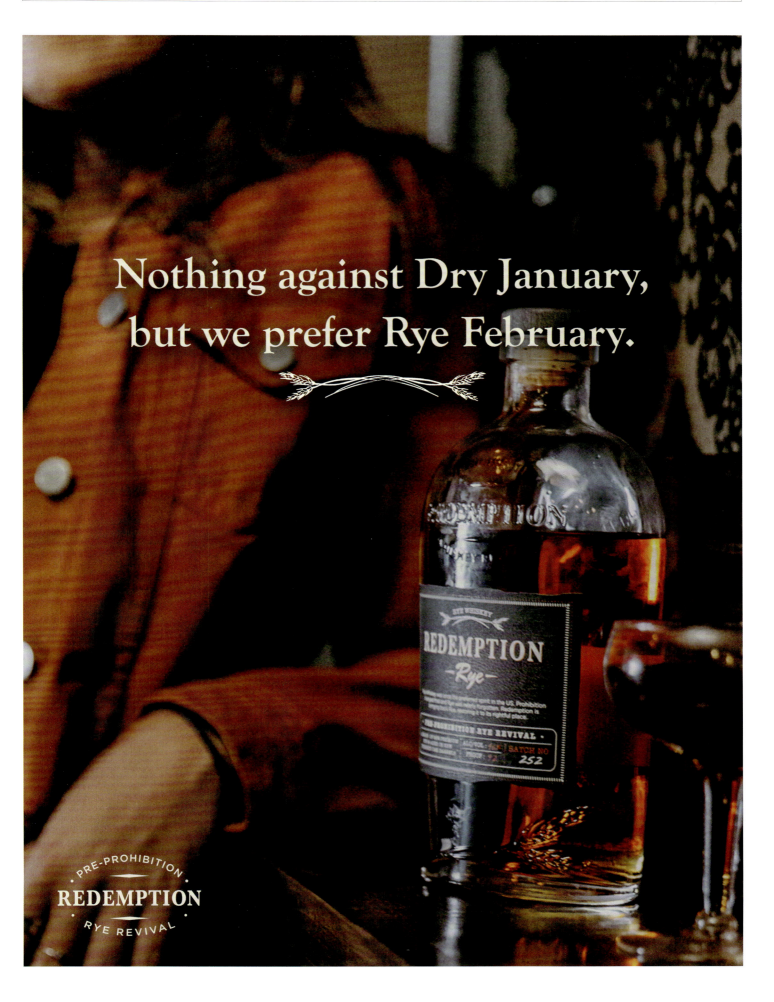

Nothing against Dry January, but we prefer Rye February.

Redemption Rye Wits | Redemption Rye Whiskey | The BAM Connection

Visit website to view full series

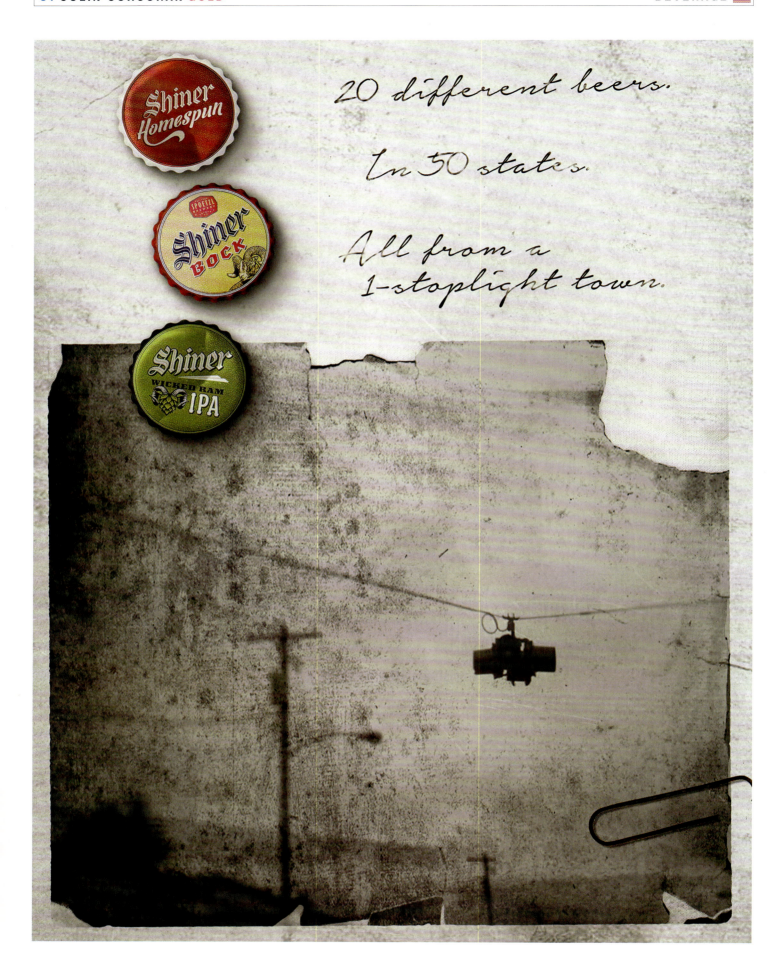

20 different beers.

In 50 states.

All from a
1-stoplight town.

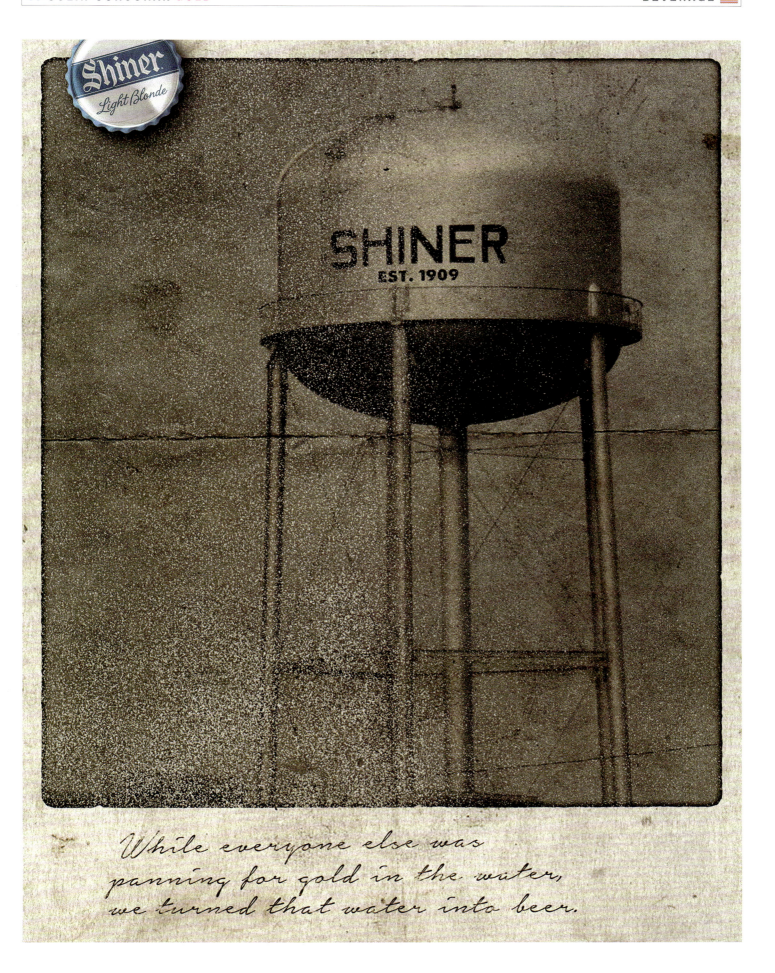

While everyone else was panning for gold in the water, we turned that water into beer.

Maker's Mark Hand Painted OOH Murals | Beam Suntory/Maker's Mark | **Doe Anderson**

Maker's Mark Hand Painted OOH Murals | Beam Suntory/Maker's Mark | Doe Anderson

広告って、
ドキドキする。

JAAA
Japan Advertising Agencies Association
一般社団法人 日本広告業協会

会員社一覧（社名50音順）

（株）I&S BBDO	（株）京橋エイジェンシー	（株）JTBコミュニケーションデザイン	（株）電通	（株）ハヤカワ・エージェンシー
（株）アイプラネット	協立広告（株）	（株）シネブリッジ	（株）電通アドギア	ビーコンコミュニケーションズ（株）
（株）アイレップ	（株）協和企画	（株）シマ・クリエイティブハウス	（株）電通九州	（株）BBDO JWEST
（株）アサツー ディ・ケイ	（株）近宣	（株）春光社	（株）電通デジタル	（株）BBDO JAPAN
（株）朝日エージェンシー	（株）クオラス	松竹ナビ（株）	（株）電通西日本	（株）ビデオプロモーション
（株）朝日オリコミ	（株）グリーンポート・エージェンシー	（株）昭通	（株）電通東日本	ビルコム（株）
（株）朝日広告社	（株）グレイワールドワイド	（株）新通	（株）電通北海道	（株）双葉通信社
（株）アド電通大阪	（株）ケー・アンド・エル	（株）新東通信	（株）電通名鉄コミュニケーションズ	（株）フロンテッジ
（株）アド・ベスト	（株）京王エージェンシー	（株）真和	電通ヤング・アンド・ルビカム（株）	（株）文協
（株）アドベル	（株）京急アドエンタープライズ	（株）伸和エージェンシー	（株）東映エージエンシー	（株）文宣
（株）ADKインターナショナル	（株）京成エージェンシー	（株）スコープ	（株）東急エージェンシー	（株）プライズコミュニケーション
（株）栄光社	廣告社（株）	（株）スタンダード通信社	（株）東京アドエージェンシー	（株）ホープ
（株）エイムクリエイツ	（株）広美	（株）セプテーニ	（株）とうこう・あい	（株）毎日広告社
（株）NKB	（株）広明通信社	（株）第一通信社	（株）東邦社	（株）マッキャンエリクソン
（株）HELIOS	（株）国連社	（株）大広	（株）東宣	（株）松本広告
（株）ENJIN	（株）コスモ・コミュニケーションズ	（株）大広九州	（株）TOMOE	（株）ムサシノ広告社
（株）オーエムシー	コモンズ（株）	（株）大広メディアックス	（株）内藤一水社	メディアエムジー（株）
オグルヴィ・アンド・メイザー・ジャパン（同）	（株）サイバーエージェント	大東廣告（株）	（株）西広	（株）メディックス
（株）オゾンネットワーク	（株）産案	（株）タグ・ホールディングス	（株）西鉄エージェンシー	（株）メトロアドエージェンシー
（株）小田急エージェンシー	（株）三栄広告社	（株）中央アド新社	（株）ニットー	（株）モメンタムジャパン
（株）オプト	（株）SANKO	（株）中外	（株）日本経済広告社	（株）山形アドビューロ
オリオンSP（株）	（株）三晃社	（株）中日アド企画	（株）日本経済社	（株）大和通信社
（株）オリコム	（株）三友エージェンシー	（株）千代田広告社	（株）日本廣業社	（株）横浜メディアアド
（株）ガイアコミュニケーションズ	（株）サンライズ社	（株）T&Tアド	（株）日本廣告社	（株）読売IS
（株）ギャンビット	（株）三和広告社	（株）TBWA\HAKUHODO	（株）日本広明社	（株）読売エージェンシー
（株）キョウエイアドインターナショナル	GMOアドパートナーズ（株）	（株）DAサーチ＆リンク	（株）日本スタデオ	（株）読売広告社
（株）協同エージェンシー	（株）ジェイアール東海エージェンシー	（株）DGコミュニケーションズ	（株）博報堂	（株）読売連合広告社
（株）共同広告社	（株）JR西日本コミュニケーションズ	（株）テー・オー・ダブリュー	（株）博報堂DYホールディングス	（株）ライダーズ・パブリシティ
（株）協同宣伝	（株）ジェイアール東日本企画	（株）デルフィス	（株）博報堂DYメディアパートナーズ	（株）ワントゥーテンデザイン
	ジェイ・ウォルター・トンプソン・ジャパン（同）	（株）電広エイジェンシー	（株）ハッピーアワーズ博報堂	会員社：149社（平成30年3月現在）

〒104-0061 東京都中央区銀座7-4-17 電通銀座ビル　http://www.jaaa.ne.jp　一般社団法人 **日本広告業協会**

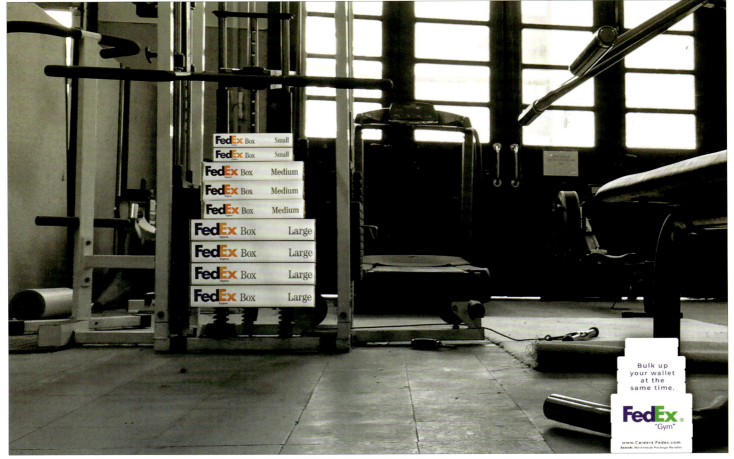

FedEx "Gym" Print & Poster Campaign | FedEx | Independent Copywriter

Visit website to view full series

Get paid for getting SWOL.

www.Careers.Fedex.com | **Search:** Warehouse Package Handler

FedEx ®
"Gym"

Unlike other vacuums,
the suction power of a Dyson doesn't fade.

glue-strip

REINTRODUCING THE WORLD'S THINNEST SMARTPHONE. AGAIN.

motorazr V4
A Lenovo Company

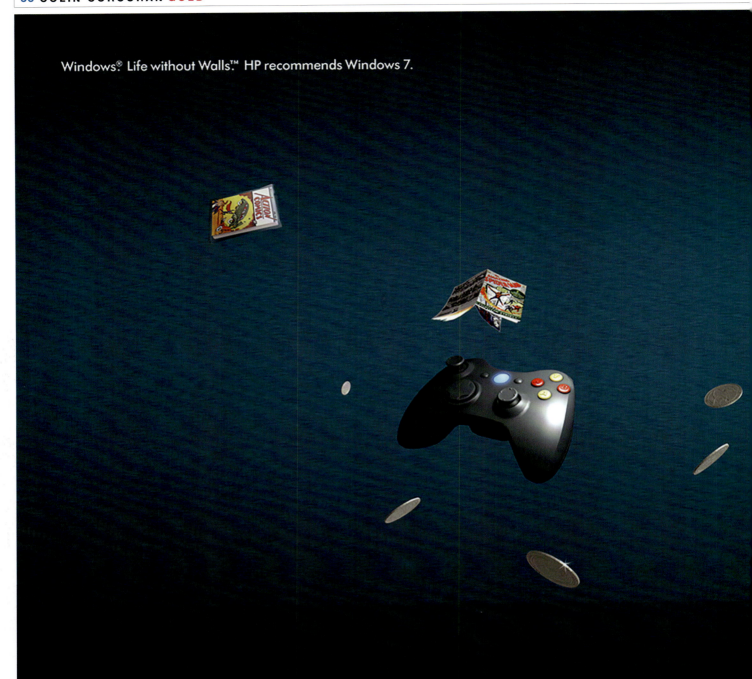

Windows.® Life without Walls.™ HP recommends Windows 7.

You touch it, you buy it.

Buy, sell or browse just about anything you can imagine through the power of human touch.
Only the new HP TouchSmart⁶⁰⁰ PC lets you experience your favorite websites and apps the
way you should: intuitively. Touch the future now at hp.com/touchsmart

The Man in the High Castle S3 | Amazon Prime Video | ARSONAL

ACADEMY AWARD WINNER **MAHERSHALA ALI**

TIME TAKES EVERYTHING
BUT THE TRUTH

TRUE DETECTIVE

JAN 13 AT 9PM **HBO**

True Detective S3 | HBO Program Marketing | **ARSONAL**

Evil has a
new home

THE EXORCIST
FOX FALL

THE EXORCIST Season 2 - "Demon Within" | Fox Entertainment | FBC Design

THE ONES WHO CHANGED
WILL CHANGE EVERYTHING

FROM PRODUCERS OF
STRANGER THINGS AND ARRIVAL

THE
DARKEST
MINDS

COMING SOON

The Darkest Minds - Int'l Key Art | 20th Century Fox | Cold Open

齋天大聖
The Monkey King

GREAT SAGE EQUALLY HEAVEN

Great Sage Equalling Heaven Handsome Monkey King

LUCIFER Season 3 ComicCon Art - "Devil Winged Chair from Hell" | Fox Entertainment | **FBC Design**

THIS IS NO LONGER OUR PLANET.

FROM THE DIRECTOR OF
RISE OF THE PLANET OF THE APES

CAPTIVE STATE

JOHN GOODMAN ASHTON SANDERS AND VERA FARMIGA

PARTICIPANT MEDIA PRESENTS A LIGHTFUSE & GETTAWAY PRODUCTION "CAPTIVE STATE" JOHN GOODMAN ASHTON SANDERS JONATHAN MAJORS COLSON BAKER AND VERA FARMIGA MUSIC BY ROB SIMONSEN COSTUME DESIGNER ABBY O'SULLIVAN VFX SUPERVISOR ERIC PASCARELLI EDITOR ANDREW GROVES PRODUCTION DESIGNER KEITH P. CUNNINGHAM DIRECTOR OF PHOTOGRAPHY ALEX DISENHOF EXECUTIVE PRODUCERS JEFF SKOLL JONATHAN KING RON SCHMIDT ADAM SIMON PRODUCED BY DAVID CROCKETT p.g.a. RUPERT WYATT p.g.a. WRITTEN BY ERICA BEENEY & RUPERT WYATT DIRECTED BY RUPERT WYATT

MARCH 2019

Reclaim your domain.

Empire
FOX 0/00

EMPIRE - Season 5 - "Out Come the Wolves" | Fox Entertainment | **FBC Design**

CREATE
FOR THE
THRONE

SONS OF THE HARPY MASK

REIMAGINED BY

AJ FOSIK
#FORTHETHRONE

GAME OF THRONES HBO

"HBO GAVE SUPERFANS REAL
GAME OF THRONES PROPS
TO REIMAGINE AS MUSEUM-
QUALITY ART PIECES."

AJ Fosik was given a Sons of the Harpy Mask, only to reimagine it as a conceptual sculpture depicting the abolition of slavery in Meereen. This Sons of the Harpy Mask was first seen in Game of

Thrones Season 5, Episode 1. Fosik's piece was displayed at the final season, Radio City premiere, before it takes its permanent home at the Game of Thrones museum in Belfast.

GAME OF THRONES HBO

SYTYCD Season 15 Key Art Campaign | Fox Entertainment | FBC Design

Visit website to view full series

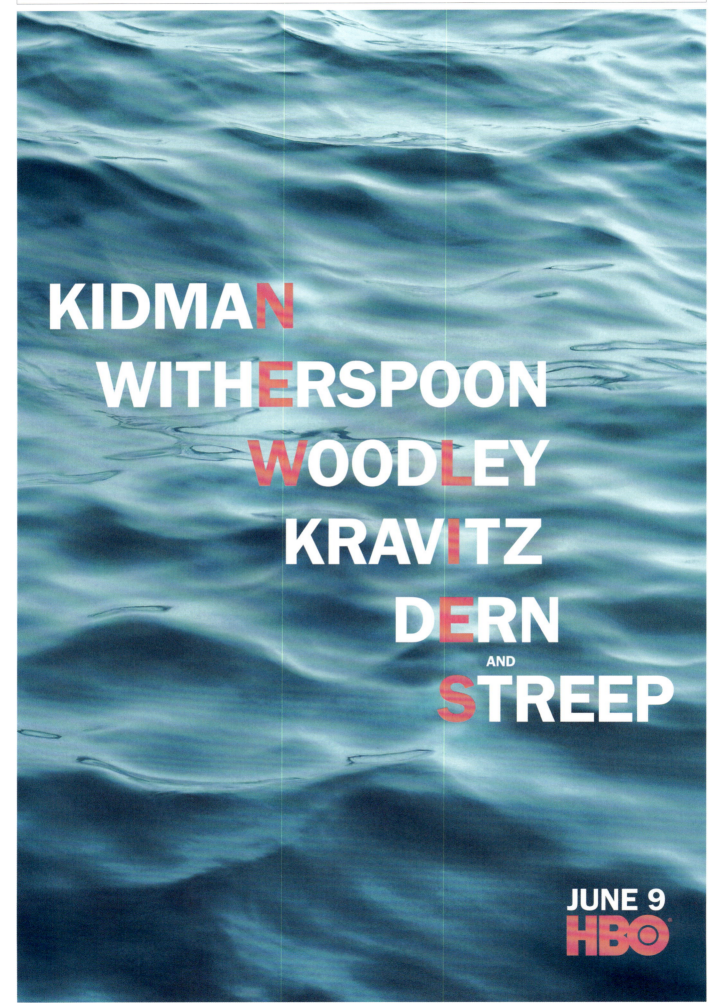

KIDMAN

WITHERSPOON

WOODLEY

KRAVITZ

DERN

AND

STREEP

JUNE 9
HBO

Big Little Lies (Season 2) - Teaser | HBO | Cold Open

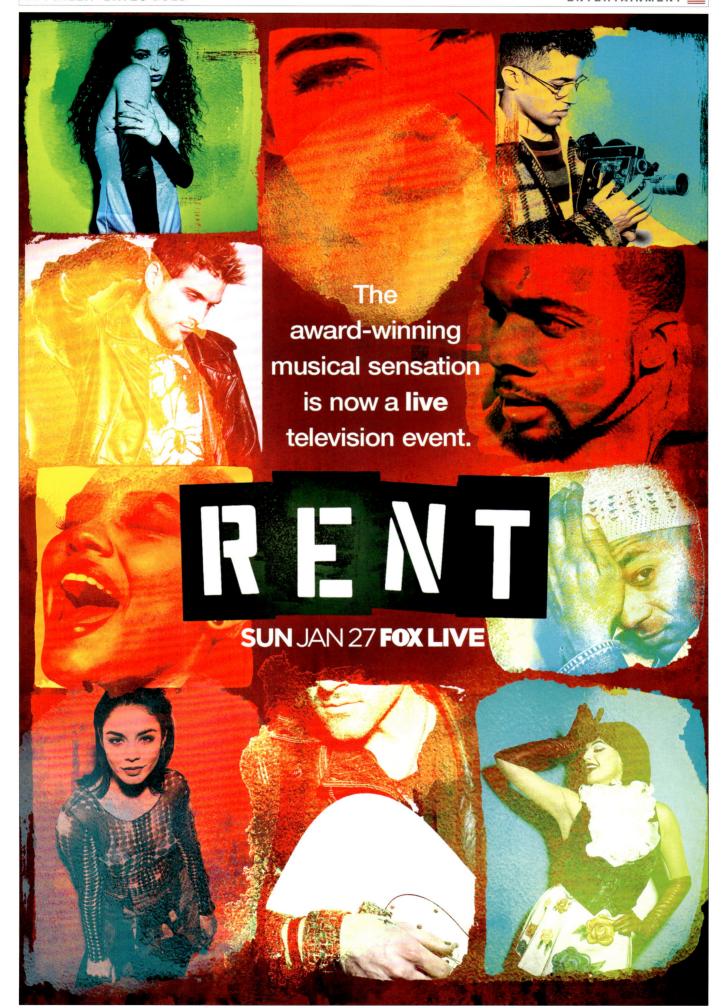

The
award-winning
musical sensation
is now a **live**
television event.

RENT

SUN JAN 27 **FOX LIVE**

04.06.2019
LAmicroLUX.com

04.06.2019

LAmicroLUX.com

WE'RE GOING TO FREEZE OVER

Holiday Fish Flakes | The Florida Aquarium | **PPK, USA**

Visit website to view full series

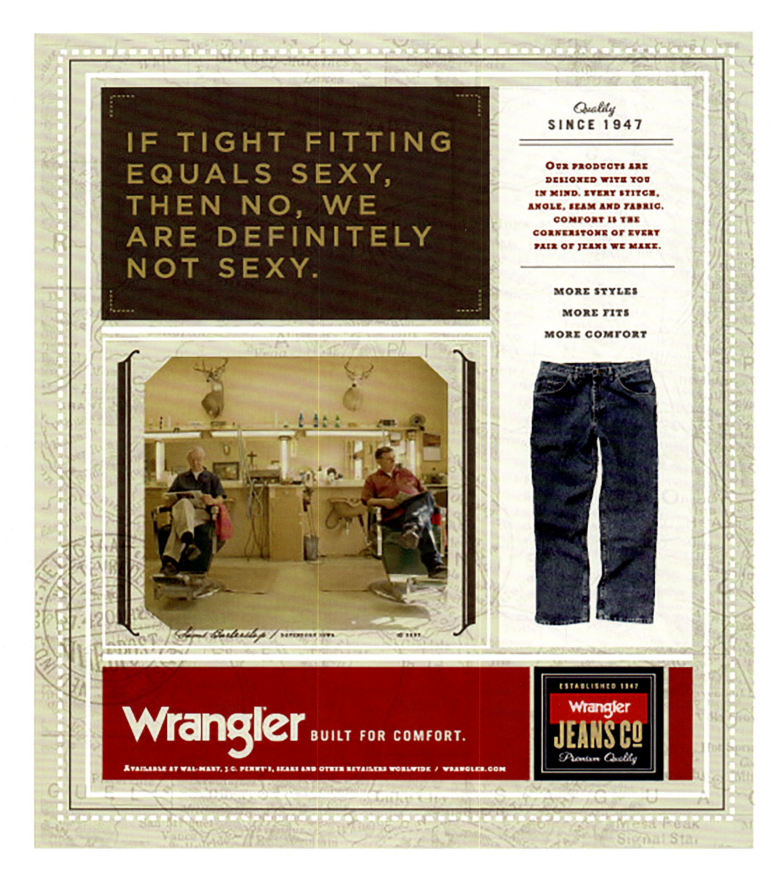

IF TIGHT FITTING EQUALS SEXY, THEN NO, WE ARE DEFINITELY NOT SEXY.

Quality SINCE 1947

OUR PRODUCTS ARE DESIGNED WITH YOU IN MIND. EVERY STITCH, ANGLE, SEAM AND FABRIC. COMFORT IS THE CORNERSTONE OF EVERY PAIR OF JEANS WE MAKE.

MORE STYLES
MORE FITS
MORE COMFORT

Wrangler BUILT FOR COMFORT.

AVAILABLE AT WAL-MART, J.C. PENNY'S, SEARS AND OTHER RETAILERS WORLDWIDE / WRANGLER.COM

ESTABLISHED 1947
Wrangler
JEANS CO
Premium Quality

Tough Jeans P.O.P. Poster Campaign | **Wrangler Jeans** | **Independent Copywriter** Visit website to view full series

FROM THE CO-CREATOR OF
WE GO ON AND **YELLOWBRICKROAD**

THE WITCH IN THE WINDOW

ONE BAD HOUSE FILMS PRESENTS A FILM BY ANDY MITTON STARRING ALEX DRAPER CHARLIE TACKER "THE WITCH IN THE WINDOW" WITH ARIJA BAREIKIS GREG NAUGHTON AND CAROL STANZIONE COSTUME DESIGNER ANGELA LAVALLA MUSIC BY ANDY MITTON PRODUCTION DESIGNER SAM HENSEN EDITOR ANDY MITTON DIRECTOR OF PHOTOGRAPHY JUSTIN KANE EXECUTIVE PRODUCERS ALVARO BENEDETTI SARAH MULHOLLAND EXECUTIVE PRODUCER CLARK FREEMAN

Film Seekers PRODUCER RICHARD W. KING WRITTEN AND DIRECTED BY ANDY MITTON

©2018 ONE BAD HOUSE FILMS, LLC. ALL RIGHTS RESERVED.

The Witch In The Window | One Bad House Films | **DOG & PONY**

NO A UN REGIONALISMO CHE DIVIDE

ITALIA
NON ABBANDONARCI
VOGLIAMO UNA SANITÀ UGUALE PER TUTTI

La Salute è un Diritto di Tutti. #SìalSSN

Ordine dei Medici Chirurghi e Odontoiatri
della Provincia di Bari
www.omceo.bari.it

MORE POWERFUL THAN THE BIG BAD WOLF

THIS IS POWERFOIL X3.0: A fan that reigns supreme in size and performance. Its patented airfoil system and maintenance-free NitroSeal Drive gearbox keep employees happily productive with cool and comforting airflow. Powerfoil X3.0. Rule the air.

BIG ASS FANS

EXCEPTIONALLY ENGINEERED

V FOR VICTORY

With an uninterrupted ink flow to let you keep the pace, the V Series comes in first.

PILOT V SERIES. OUTRUN THE COMPETITION. #VforVictory

TO BREAK *the* MOLD,
WE CAST *a* NEW ONE_

VETTIS™ CONCRETE
LIMITED EDITION FAUCET_

THE LIMITED EDITION VETTIS CONCRETE FAUCET
DEFIES CONVENTION. A FEAT OF ENGINEERING
FOUR YEARS IN THE MAKING, IT IS NOT MERELY
UNPARALLELED. IT IS UNPRECEDENTED.

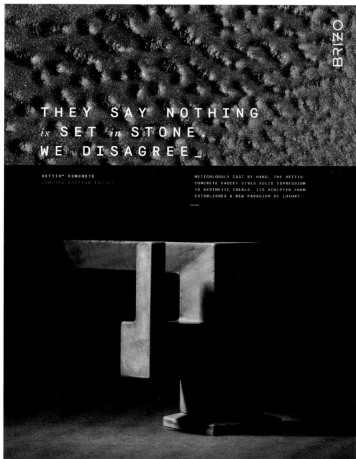

THEY SAY NOTHING
is SET *in* STONE.
WE DISAGREE_

VETTIS™ CONCRETE
LIMITED EDITION FAUCET_

METICULOUSLY CAST BY HAND, THE VETTIS
CONCRETE FAUCET GIVES SOLID EXPRESSION
TO AESTHETIC IDEALS. ITS SCULPTED FORM
ESTABLISHES A NEW PARADIGM OF LUXURY.

A COLLECTION *of* 500.
A CATEGORY *of* ONE_

VETTIS™ CONCRETE
LIMITED EDITION FAUCET_

LIMITED TO A RELEASE OF 500, THE VETTIS
CONCRETE FAUCET IS ALL THE RARER FOR ITS
PIONEERING USE OF NATURAL MATERIALS.
ITS STUNNING RAW AESTHETIC HAS NO EQUAL.

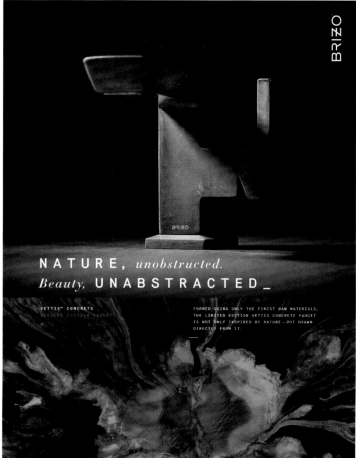

NATURE, *unobstructed.*
Beauty, UNABSTRACTED_

VETTIS™ CONCRETE
LIMITED EDITION FAUCET_

FORMED USING ONLY THE FINEST RAW MATERIALS,
THE LIMITED EDITION VETTIS CONCRETE FAUCET
IS NOT ONLY INSPIRED BY NATURE—BUT DRAWN
DIRECTLY FROM IT.

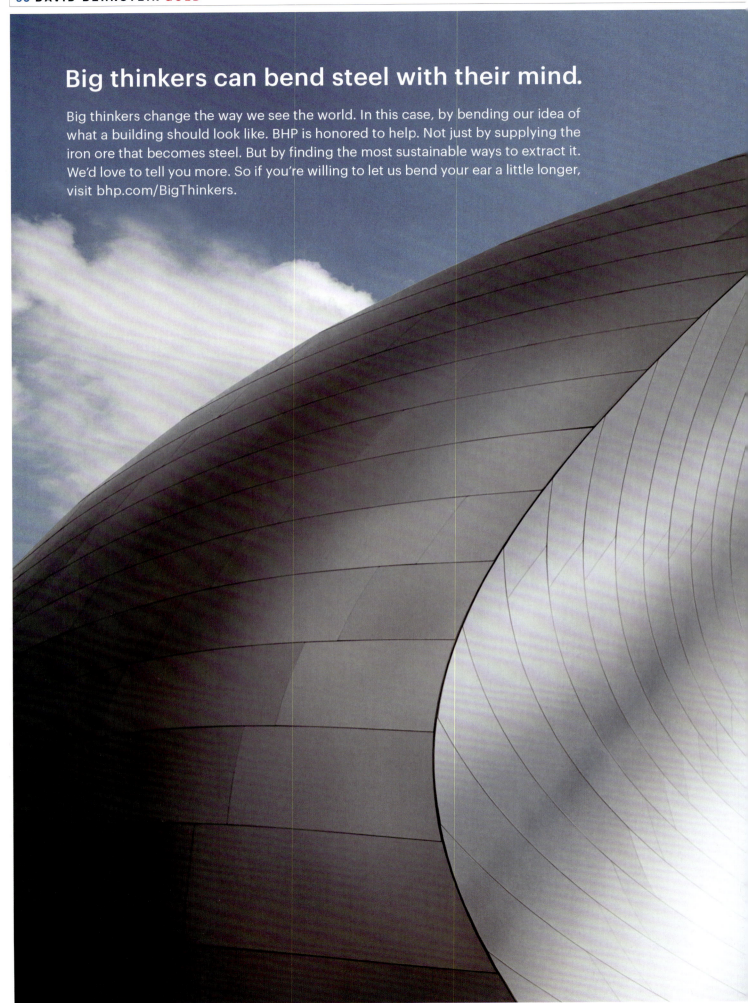

Big thinkers can bend steel with their mind.

Big thinkers change the way we see the world. In this case, by bending our idea of what a building should look like. BHP is honored to help. Not just by supplying the iron ore that becomes steel. But by finding the most sustainable ways to extract it. We'd love to tell you more. So if you're willing to let us bend your ear a little longer, visit bhp.com/BigThinkers.

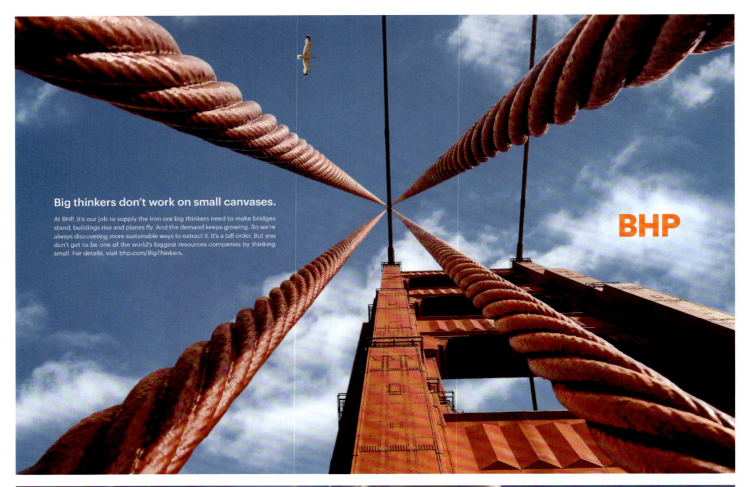

Big thinkers don't work on small canvases.

At BHP, it's our job to supply the iron ore big thinkers need to make bridges stand, buildings rise and planes fly. And the demand keeps growing. So we're always discovering more sustainable ways to extract it. It's a tall order. But you don't get to be one of the world's biggest resources companies by thinking small. For details, visit bhp.com/BigThinkers.

BHP

The true measure of a big thinker is how long their ideas last.

Ever wonder why people travel halfway around the world to see a monument? It's because the experience changes them. And BHP wants to play a part in the transformation. Not just by supplying the copper that today's big thinkers need. But by finding the most sustainable ways to extract it. It's not easy. But then, we've got our share of big thinkers too. For details, visit bhp.com/BigThinkers.

BHP

Monuments Campaign | BHP | The Gate | NY

Visit website to view full series

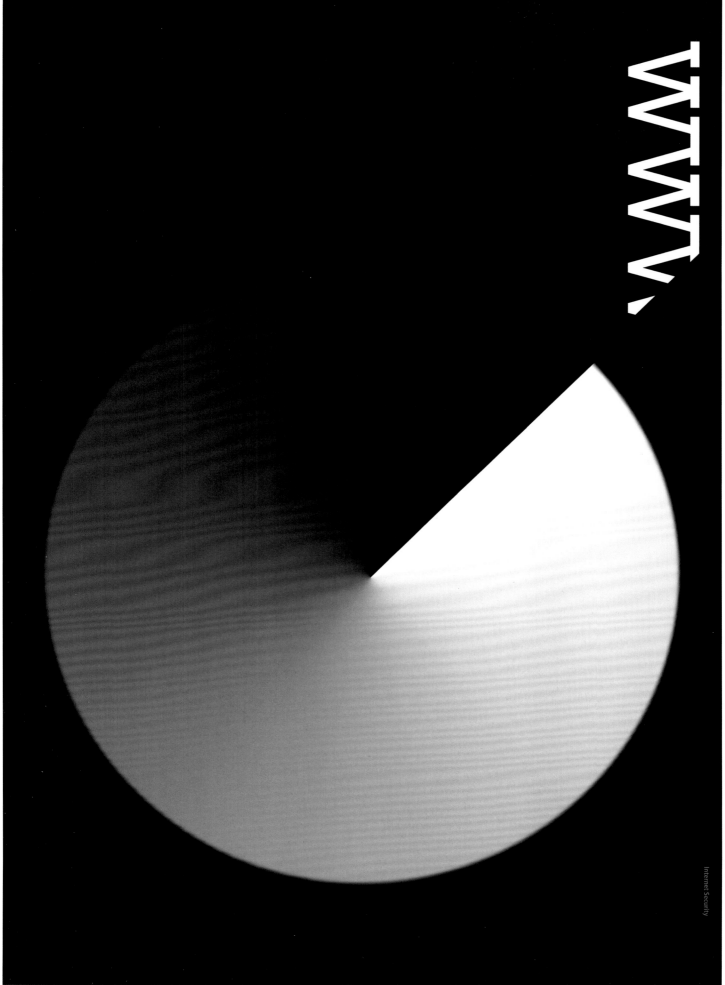

Internet Security | HK IPT | Dalian RYCX Advertising Co., Ltd.

Diversity Recruitment Campaign | Atlanta Fire Rescue Foundation | **Brunner**

Visit website to view full series

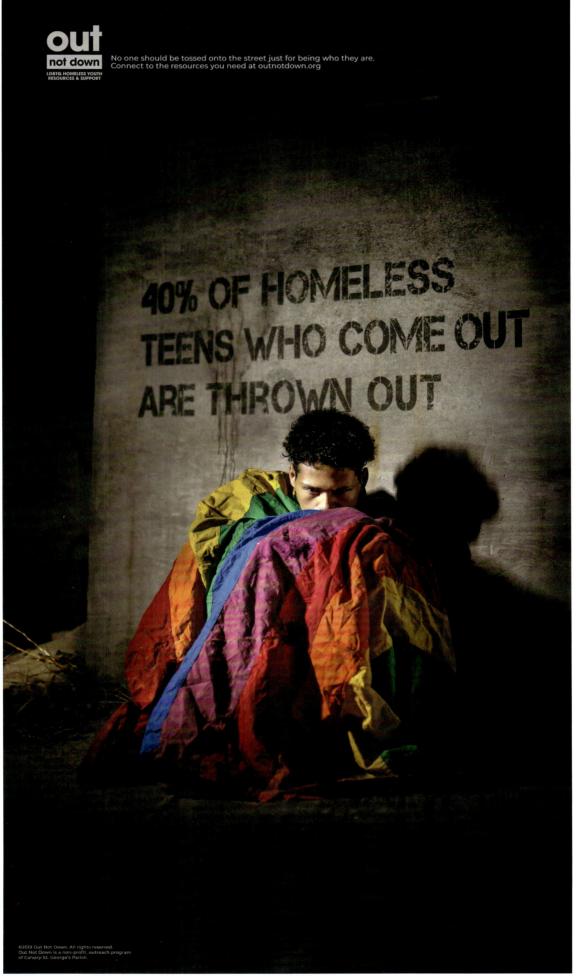

The Thrown Out Flag | Out Not Down, LGBTQ Homeless Youth Resources & Support
Saatchi & Saatchi Wellness

Visit website to view full series

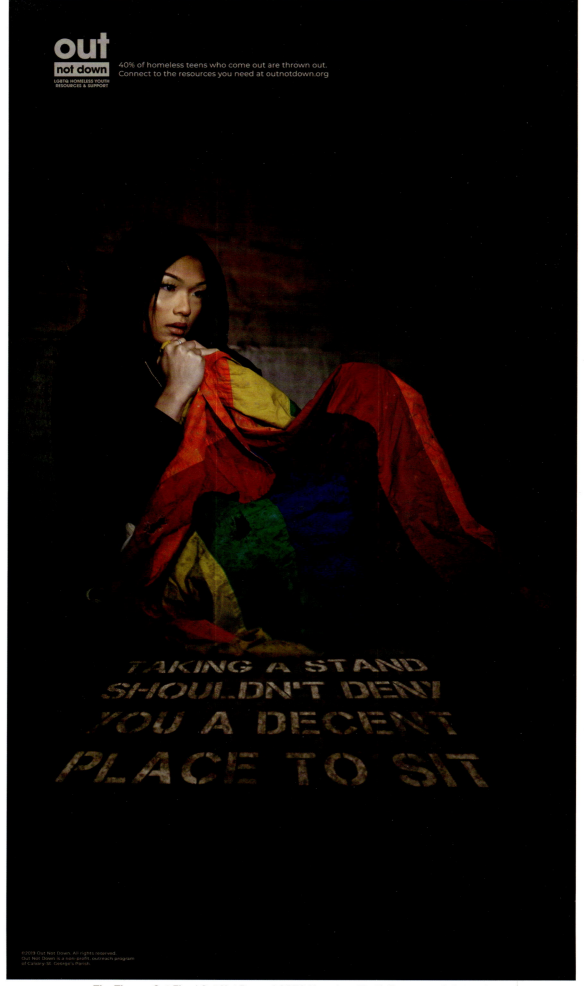

The Thrown Out Flag | Out Not Down, LGBTQ Homeless Youth Resources & Support
Saatchi & Saatchi Wellness

Visit website to view full series

Getting your photo with a tiger cub is like putti
they become too big for cub petting and pho

PETTING AND PHOTO OPS MAY BE MORE **DEADLY** THAN YOU THINK

to its head. That's because there is no tracking how many cubs are killed when get the real picture, before another little tiger dies. Visit **Cubtruth.com** today.

Gun Camera | Big Cat Rescue | **PPK, USA**

PLAY FASHION DESIGNER. THEN PLAY FAS

MODEL.

Goodwill

Shop Goodwill. Craft your look.

Mr. Right, g

Whether you use latex male or female condoms, they
STDs when used the right way every time. Visit your d

me something wrong.

HIV/AIDS.

very effective in preventing HIV and many other
clinic if you suspect you have a STD.

UseCondoms.org

Harden Vol. 3 | Self-Initiated | adidas Global Brand Design

Visit website to view full series

HARDEN VOL. 3

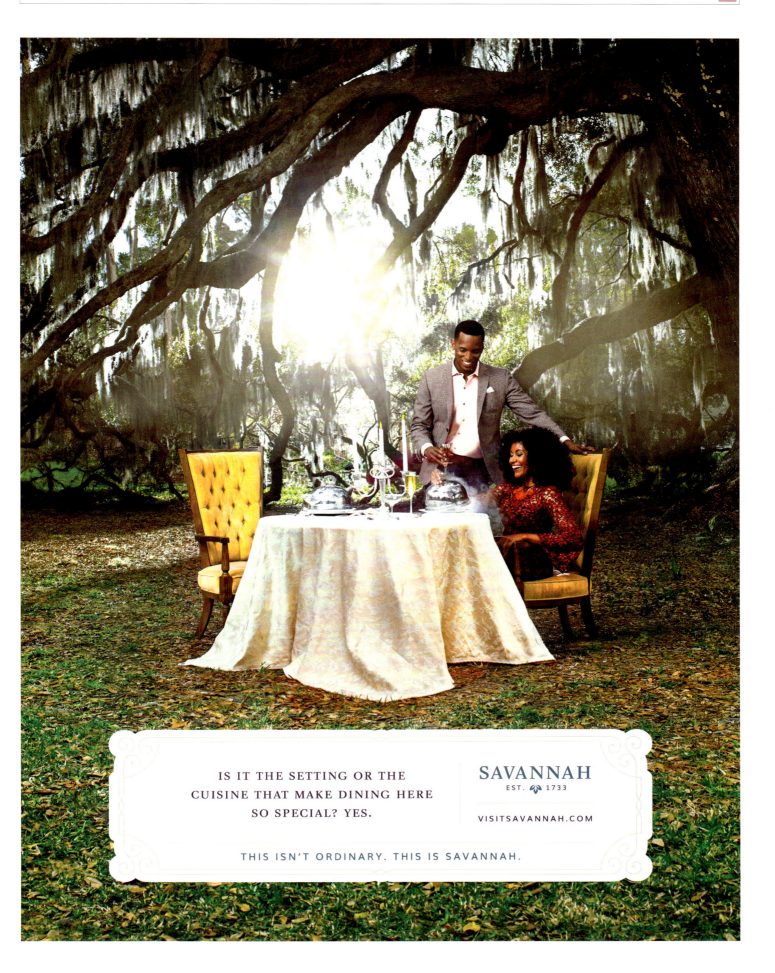

IS IT THE SETTING OR THE
CUISINE THAT MAKE DINING HERE
SO SPECIAL? YES.

SAVANNAH
EST. 1733

VISITSAVANNAH.COM

THIS ISN'T ORDINARY. THIS IS SAVANNAH.

POPULATION	2,400
SKI RUNS	127
FESITVALS	45
RIVERS	16

telluride is set in the heart of the san juan mountain range in the south west corner of colorado.

TELLURIDE COLORADO

ELEVATION 14,233 FT. WILSON PEAK

IMMEDIAT

TELLURIDE TOURISM BOARD

HIKING SKIING FISHING BIKING FESTIVALS

EATING BREAKFAST IN YOUR CAR -STOP

CARING WHAT THE NEIGHBORS THINK OF YOUR LAWN -STOP

FALLING ASLEEP IN FRONT OF THE TELEVISION -STOP

START LIVING AGAIN.

TIME OF RECEIPT- 245PM

3704

VENTURE OUT

VISITTELLURIDE.COM........

TELLURIDE COLORADO

POPULATION	2,400
SKI RUNS	127
FESITVALS	45
WATERFALLS	16

TELEGRAM

located just in the heart of the san juan mountain range in the south west corner of colorado.

TELLURIDE TOURISM BOARD

ELEVATION
14,233 FT.

WILSON
PEAK

SNOW FALL	309 in
12,000 + PEAKS	5
RESAURANTS	78
HOTELS	14

home to the best music, films, skiing, fishing, biking and climbing.

HIKING SKIING FISHING BIKING FESTIVALS

39746

SITTING IN MORNING TRAFFIC -STOP

SITTING AT A DESK -STOP

STANDING IN LINE
FOR LUNCH EVERY DAY -STOP

START LIVING AGAIN.

TIME OF RECEIPT- 348PM

VISITTELLURIDE.COM

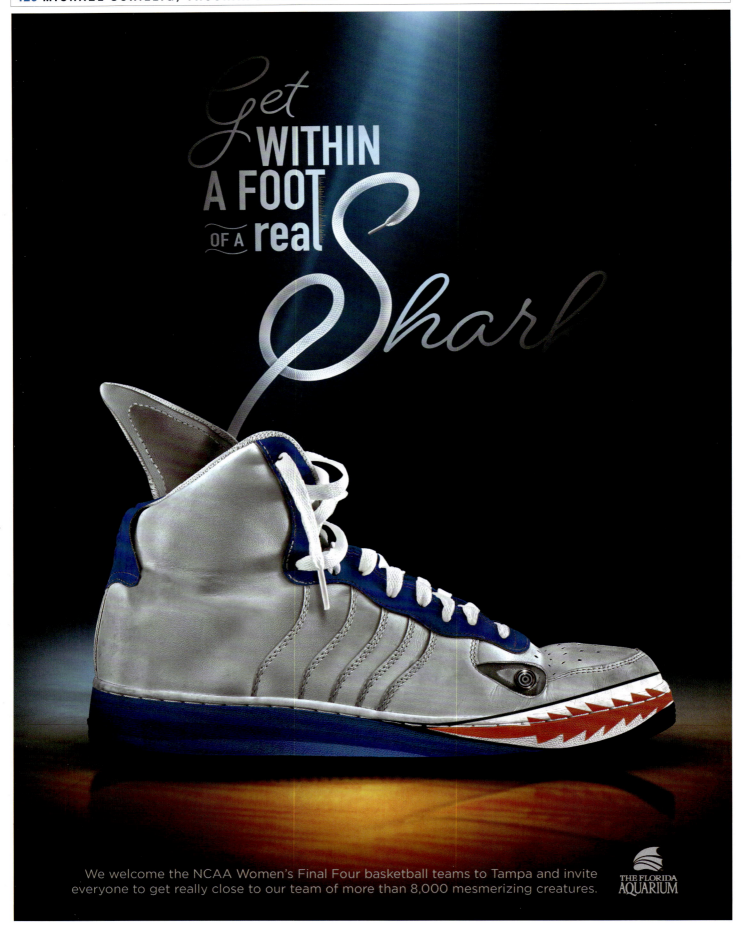

We welcome the NCAA Women's Final Four basketball teams to Tampa and invite everyone to get really close to our team of more than 8,000 mesmerizing creatures.

THE FLORIDA AQUARIUM

Spring Butterflyfish | The Florida Aquarium | PPK, USA

INNOCEAN USA

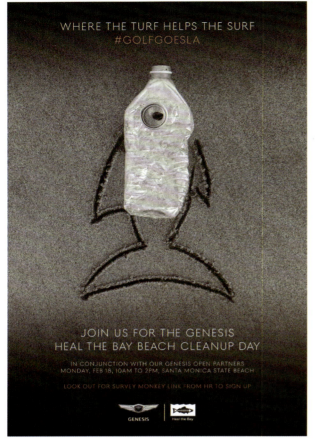

Genesis Heal The Bay Beach Clean Up Day Posters
Genesis Motor America & Heal The Bay | **INNOCEAN USA**

INNOCEAN USA

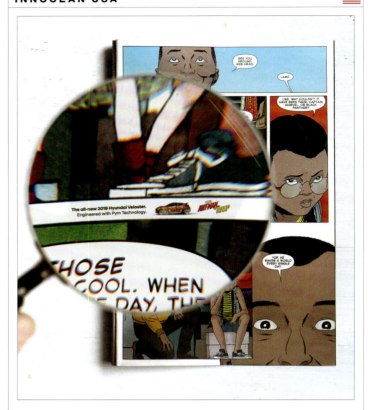

Ant-Ads - The Tiniest Print Ads in the Marvel Universe
Hyundai Motor America | **INNOCEAN USA**

COLIN CORCORAN

Sturgis F-Bombs | Harley-Davidson | **Camp3**

BILL KRESSE

ETE REMAN Print Ad | ETE REMAN | **Disrupt Idea Co.**

BRIAN ELLSTROM

Aveda Cruelty-Free Hair and Skincare Gifts for the Holidays
Self-Initiated | **Aveda Global Creative**

TIM OFCACEK

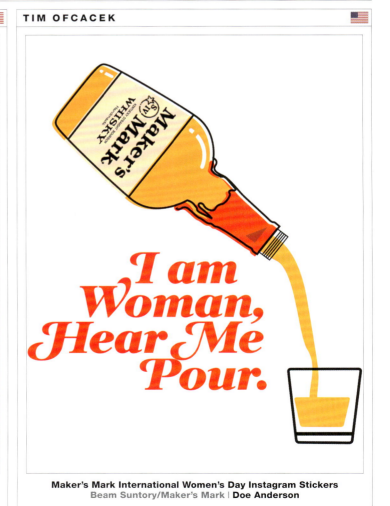

Maker's Mark International Women's Day Instagram Stickers
Beam Suntory/Maker's Mark | **Doe Anderson**

COLIN CORCORAN

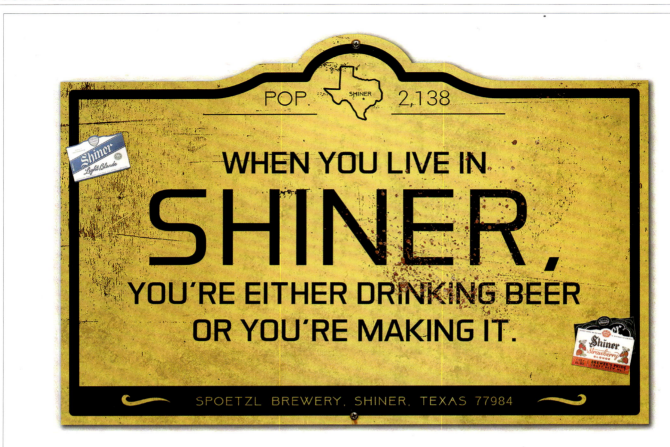

P.O.P.ulation Signs | The Gambrinus Company (Shiner Beers) | **Independent Copywriter**

COLIN CORCORAN

Fresh Bread Is Just The Start OOH Campaign
Boudin | **The Hive Advertising**

JASON SCHMIDT

THE GIFTED - Season 2 - "Dual Image Campaign"
FOX Entertainment | **FBC Design**

PHILLIP BATES

The Passage Key Art | Fox Entertainment | **FBC Design**

COLD OPEN

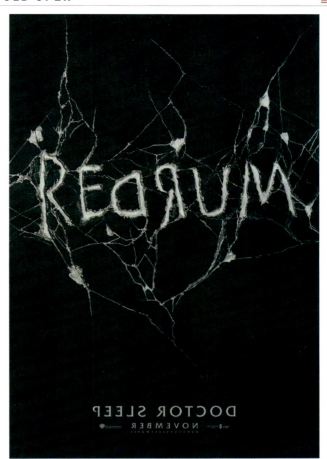

Doctor Sleep - Teaser | Warner Bros. Pictures | **Cold Open**

COLD OPEN

The Curse of La Llorona | Warner Bros. Pictures | **Cold Open**

COLD OPEN

Cobra Kai - Season 2 (Cobra) | YouTube Originals | **Cold Open**

MOISES CISNEROS

SYTYCD S16 Key Art | Fox Entertainment
FBC Design

ACADEMY OF MOTION PICTURE ARTS & SCIENCES

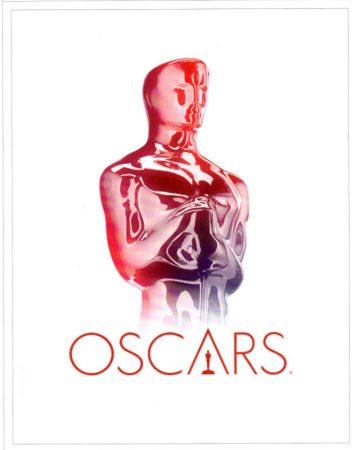

91st Oscars Key Art | Self-Initiated
Academy of Motion Picture Arts and Sciences

COLD OPEN

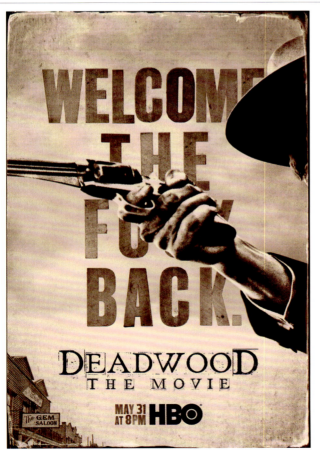

Deadwood - Teaser
HBO | Cold Open

COLD OPEN

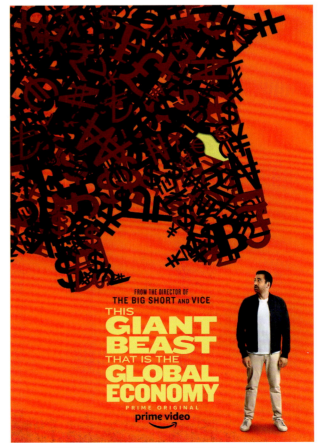

This Giant Beast That Is The Global Economy
Amazon Studios | **Cold Open**

COLD OPEN

The After Party | Netflix | Cold Open

COLD OPEN

Cobra Kai - Season 2 | YouTube Originals | Cold Open

PHILLIP BATES

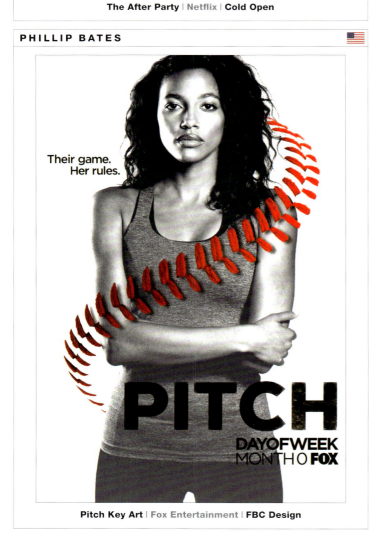

Pitch Key Art | Fox Entertainment | FBC Design

COLD OPEN

The Dirt | Netflix | Cold Open

ART MACHINE

BILL KRESSE

Shopko Special Events Posters | Shopko | Disrupt Idea Co.

9-1-1 Season 2 Key Art – "Marry Me" | Fox Entertainment | **Art Machine**

MICHAEL SCHILLIG, TRUSHAR PATEL

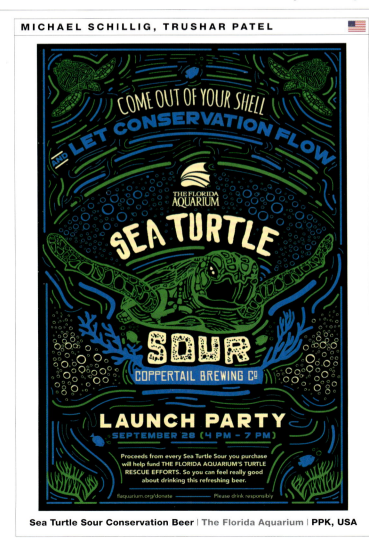

Sea Turtle Sour Conservation Beer | The Florida Aquarium | **PPK, USA**

MICHAEL SCHILLIG, -TRUSHAR PATEL

Sand Tiger Stout Conservation Beer | The Florida Aquarium | **PPK, USA**

COLIN CORCORAN

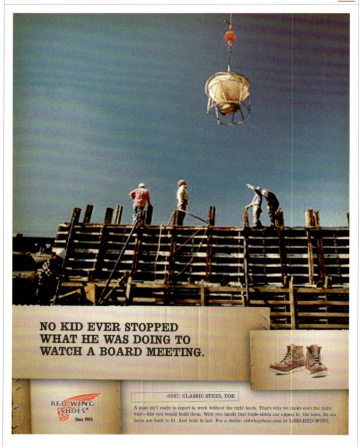

Blue Collar Salute Campaign | Red Wing Shoe Company | Colle + McVoy

SCOTT BAITINGER

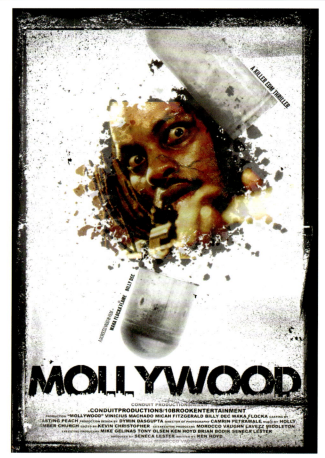

Mollywood Movie Title and Poster | Mollywood | Disrupt Idea Co.

JEN JOYCE, KATE BENTON

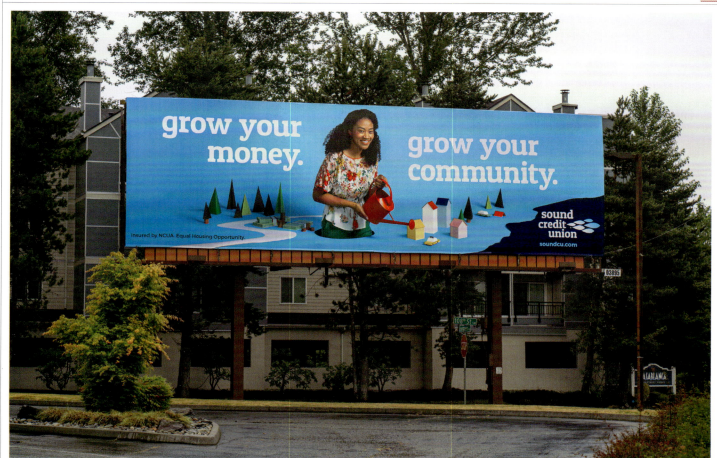

Grow Your Community | Sound Credit Union | WONGDOODY

JEN JOYCE, KATE BENTON

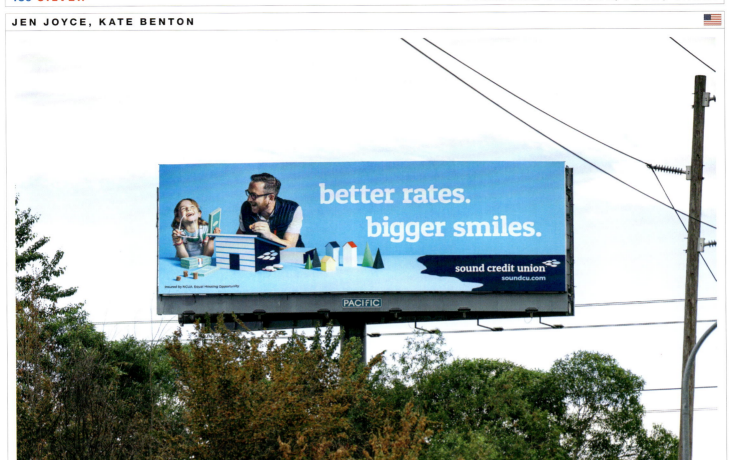

Grow Your Community | Sound Credit Union | **WONGDOODY**

HANNAH HOWARD

Sauce Like You Mean It
Texas Pete Hot Sauce | **Creative Energy**

COLIN CORCORAN

Metal Gear Solid V: Ground Zeroes Prologue Poster
Konami / Kojima Productions | **Ayzenberg**

GENARO SOLIS RIVERO

H.R.3670—Short-Term Detention Standards Act: This bill requires U.S. Customs and Border Protection (CBP) to make every effort to ensure that apprehended individuals are given access to appropriate temporary shelter, bathrooms and shower facilities, water, appropriate nutrition, hygiene, personal grooming items, and sanitation needs. Currently, CBP is only required to make every effort to provide food and water. H.R.3299—Promoting Respect for Individual Dignity and Equality Act of 2019: This bill amends the Internal Revenue to provide for equal treatment of same sex married couples. It permits such couples to amend their filing status to married filing jointly for tax returns outside of the statute of limitations and modifies tax rules relating to married couples to include same sex couples. H.R.20—No Taxpayer Funding for Abortion and Abortion Insurance Full Disclosure Act of 2019: Specifically, the bill prohibits the use of federal funds for abortions or for health benefits that cover abortion. The restrictions extend to the use of funds in the budget of the District of Columbia. Additionally, abortions may not be provided in a health care facility or by a federal employee. H.R.282—Safer America for Everyone through Now Act or the SAFER Now Act: This bill addresses certain restrictions and requirements regarding the sale, transfer, and possession of firearms. H.R.1145—Advanced Nuclear Energy Technologies Act: This bill amends the Energy Policy Act of 2005 to direct the Department of Energy (DOE) to advance the research and development of domestic advanced, affordable, and clean nuclear energy. H.R.806—Ozone Standards Implementation Act of 2017: This bill amends the Clean Air Act to revise the National Ambient Air Quality Standards (NAAQS) program. H.R.928—Fracturing Regulations are Effective in State Hands Act: This bill gives states the sole authority to promulgate or enforce any regulation, guidance, or permit requirement regarding hydraulic fracturing on or under any land within their boundaries. Hydraulic fracturing or fracking is a process to extract underground resources such as oil or gas from a geologic formation by injecting water, sand (or similar particulates), and chemical additives into a well under pressure to fracture the geological formation. H.R.1044—Fairness for High-Skilled Immigrants Act of 2019: This bill increases the per-country cap on family-based immigrant visas from 7% of the total number of such visas available that year to 15%, and eliminates the 7% cap for employment-based immigrant visas. It also removes an offset that reduced the number of visas for individuals from China. H.R.1296—Assault Weapons Ban of 2019: This bill makes it a crime to knowingly import, manufacture, sell, transfer, or possess a semiautomatic assault weapon or large capacity ammunition feeding device. S.874—Dream Act of 2019: To authorize the cancellation of removal and adjustment of status of certain individuals who are long-term U.S. residents and who entered the U.S. as children, and for other purposes.

VOTE is a non-partisan initiative to increase voter discussion and participation in local, regional and national elections.

vote-vote.org

VOTE | VOTE-VOTE | **Genaro Design, LLC**

YOUNG & LARAMORE

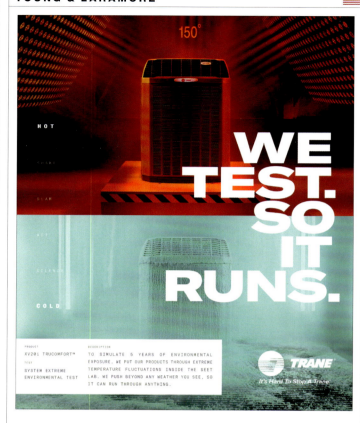

Trane Relentless Testing Print | Trane | **Young & Laramore**

SHINE UNITED

Powerfully Small
Surefire | Shine United

YOUNG & LARAMORE

American Standard Better Problems Print
American Standard | Young & Laramore

JOHN FAIRLEY

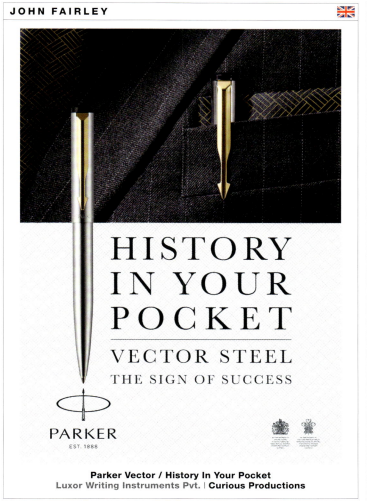

Parker Vector / History In Your Pocket
Luxor Writing Instruments Pvt. | Curious Productions

STEWART JUNG

Gandy Couch Potato Ad
Gandy Installation | Ag Creative Group

DAVID HADLEY

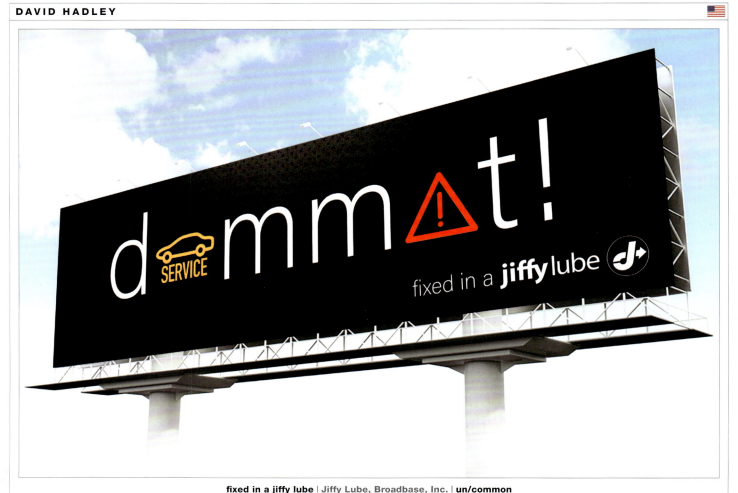

fixed in a jiffy lube | Jiffy Lube, Broadbase, Inc. | **un/common**

KRISTA KARLEN

Courage to Win | ALS Association Wisconsin Chapter | **Traction Factory**

ROGER ARCHBOLD

Voglwalpole.

It's Swedish for 'we love our jobs!'

Karen Vogl and Donna Walpole have a combined 30 years of real estate experience and their specialist knowledge of both the market and the Maroondah area means they can talk-the-talk and walk-the-walk. By accessing a large buyer base they continually achieve exceptional results with high clearance rates and repeat business.

Voglwalpole is not a franchise, which means Karen and Donna are not distracted by corporate interests. All of their attention is focused on their clients. Karen and Donna keep it real so that selling your home doesn't have to be overwhelming.

realestate made real

voglwalpole

voglwalpole 'Swedish' | Voglwalpole | **Roger Archbold**

COLIN CORCORAN

IT'S NOT AN 80'S RESTAURANT UNLESS YOU CAN SNORT YOUR DINNER THROUGH A STRAW

Lake & Bryant
restaurant **MIAMI**
Where the 80s never ended
612.823.1985

REALLY good food
REALLY strong drinks
REALLY thick straws
REALLY.

Onion Newspaper Mini-poster Insert Campaign
Restaurant Miami | **Independent Copywriter**

COLIN CORCORAN

...our old couch doesn't match our new house so...

CB2
the rescue.

C What's Possible Print Campaign
CB2 | **Phenomenon**

CRAIG BROMLEY

Lenticular Kiss | Self-Initiated | **Craig Bromley Photography**

DALE ATKINSON

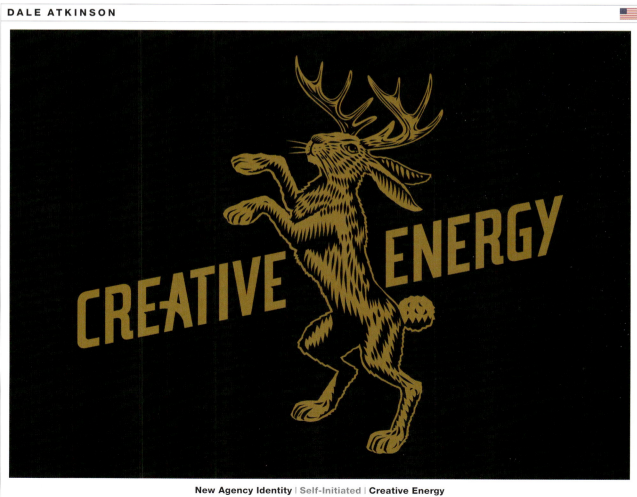

New Agency Identity | Self-Initiated | **Creative Energy**

COLIN CORCORAN

The sun rises. The sun sets. If only shoes were made to be so simple.

Simply Beautiful.

THIS WOULD BE COPY THAT WOULD GO IN THIS AREA AND IT WOULD LIKELY TALK ABOUT AS LITTLE MORE COPY WILL GO HERE FOR THE PRODUCT AND THE BRAND SOME MORE COPY WOULD GO IN THE AREA AS WELL AS SOME CONTENT WERE SOME COPY AS WAS BE COPY THAT WOULD GO IN THIS AREA AND IT WOULD LIKELY TALK ABOUT AS LITTLE MORE THE WEBSITE WILL FIND.

K·SWISS.COM

Simply Beautiful 1 | K-Swiss | Independent Copywriter

COLIN CORCORAN

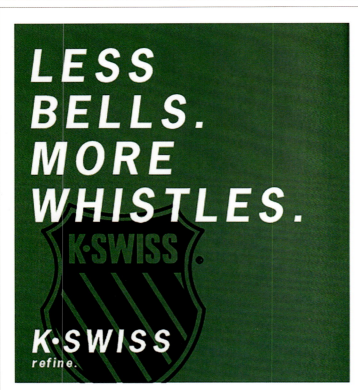

LESS BELLS. MORE WHISTLES.

K·SWISS

K·SWISS

refine.

World Class Sailer

THE RANNELL / CROSS TRAINER

IN A WORLD WHERE EXCESS IS LAUDED AND MORE IS WHAT EVERYONE LINES FOR, WE SOUGHT TO TRY AND MIX THINGS UP A BIT. WHAT ABOUT LESS? WHERE LESS IS A GOOD THING, WHERE SIMPLE THINGS CAN BE BETTER. THIS IS THE NEW K-SWISS. LEARN MORE AT KSWISS.COM.

kswiss.com

Simply Beautiful 2 | K-Swiss | Independent Copywriter

COLIN CORCORAN 🇺🇸

Ownership Firesale Wild Postings Campaign
Non-Passive Aggressive Timberwolves Fans | Independent Copywriter

COLIN CORCORAN 🇺🇸

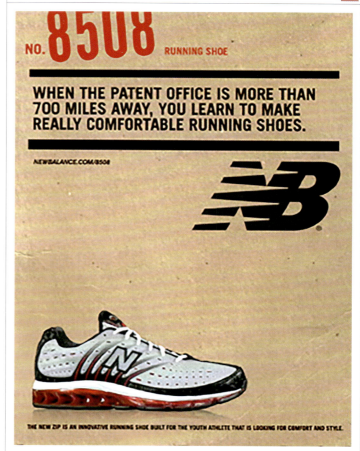

Balanced Reasoning 8508 Print Campaign
New Balance | Independent Copywriter

VANESSA WITTER 🇺🇸

Rams to the Bone | Cedars-Sinai | WONGDOODY

COLIN CORCORAN 🇺🇸

Man Montage | VS. (Versus) Network | Independent Copywriter

TOM MAHER

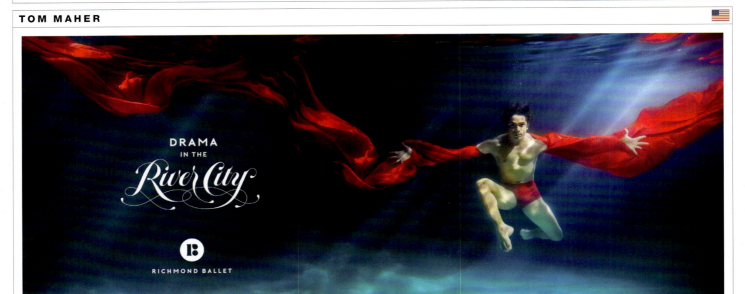

"In the River City" | Richmond Ballet | **Karnes Coffey Design**

LEILA SINGLETON

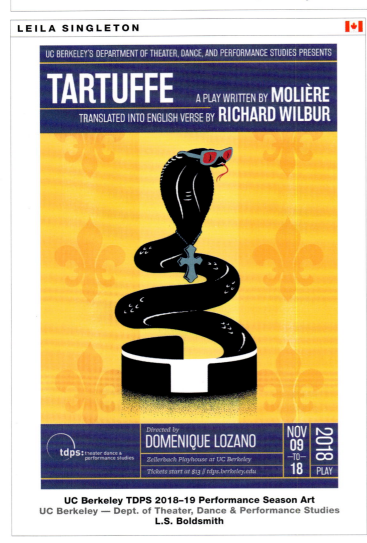

UC Berkeley TDPS 2018–19 Performance Season Art
UC Berkeley — Dept. of Theater, Dance & Performance Studies
L.S. Boldsmith

JOE SCHNELLMANN

Catch the #beechlife
Beech Mountain Resort
Creative Energy

I often think of ideation as being like archeology: the amazing idea is buried under the surface someplace. You just have to know where to dig.

Carter Weitz, *Chairman & Chief Creative Officer, Bailey Lauerman*

The Slowest Art We've Ever Built | Audi of America | Audi USA

Assignment: There wasn't one per se. I just knew that the 10 year anniversary of the V10 engine in the R8 was coming and was thinking of ideas on how to celebrate. A friend showed me Fabian's work with his and I knew right away it was something to pursue.

Approach: Once I had Fabian on board to let him do his great work, I thought about how I wanted to capture it. Being it was a 10 year anniversary, there happened to be a 10-year-old original spot for the same car that is one of my favorite car commercials of all-time. That spot called "The slowest car we've ever built" romances the building of an R8 that's all done by hand and takes about 7 days to do. I knew our project would be the exact inverse of that process so I thought it would be cool to do an homage to that original spot. Music played a major role in the feel of that spot so I actually got the original artist to re-record the song as a new version we worked on together and began work on what was

the final piece. The most important reason to even do the content piece was I knew people would see the final poster and just say, "Oh that's just CG, or a little Photoshop job," and it would be written off as fake. I needed people to understand, no, this crazy guy painstakingly takes every single piece apart and meticulously photographs them all and reassembles it in his vision. This process is hardcore. I wanted to make sure people felt and appreciated what Fabian does. I hope it did provide at least some justice.

Results: Well I can tell you that the first one of the posters sold out in literal minutes, which was entirely unexpected. I think even some six months on they've had trouble keeping up with demand. Audi Germany was proud of the work and it's been seen more globally than I ever expected. Hopefully a larger piece of the world got to appreciate Fabian's brilliant talent. As long as that happened, I think it was a total success.

STYLE WIT

CHROME MIRROR CAPS

WHEELS

WHEELS

Infiniti Styling Accessories Video | Infiniti USA | The Designory

Assignment: Infiniti was looking for authenticity and a sense of the real-world application of accessories. They were also launching a new brand platform meant to demonstrate that luxury can be in sync with real life.

Approach: Designory developed video artfully shot in stills to capture the real-world moments when accessories make a difference, using a "reportage" style with attention to the subtle cues of real life.

Results: The small subdivision of Infiniti has led the visual reinvention of the brand in the United States, with the content quickly getting repurposed for the mainstream marketing.

U T

PRETENSE

RBON FIBER MIRROR CAPS

Long Distance | Hyundai Motor America | INNOCEAN USA

Assignment: We wanted to introduce Hyundai's "My Hyundai" app in a big way. And what's bigger than space? The fun thing is, you could actually unlock your car from space with this app, if you happen to be in space. Which is exactly where our astronaut finds herself. And lucky for her husband, she's got her Hyundai app handy to help him out.

Approach: As we read a loving husband's texts of "I miss you" to his wife who is away for work, James Vincent McMorrow's cover of "Higher Love" really helps build the tender feelings they share. However, we soon discover that his loving texts are actually a request for her to unlock his car from outer space using the "My Hyundai" app on her phone. That's where the meaning of the song, "Higher Love" changes from a love ballad to a requirement for patience as an astronaut who is in the middle of her spacewalk is interrupted so that she can unlock his car. Now that's the definition of higher love.

Results: A lonely husband is missing his wife while she is away for work. He texts her a loving message, "I miss you". We cut to the wife, an

astronaut, in space on her "work trip." The husband's text interrupts her spacewalk but she takes the time to respond to his loving message. We soon discover that the husband's loving texts are a clever way for him to ask for her help unlocking his car. He has locked his keys in the car and needs her to use the "My Hyundai" app on her phone to unlock his car door. Which is something you could do if you happen to have that app on your phone, even in space.

Steve Winwood's song, "Higher Love" is a 1980s American classic. The meaning of higher love both in the context of literally being higher (in space), and the love between a husband and wife fit nicely for this spot. The original song has an 80s vibe to it, so we picked McMorrow's recent cover of the song to give the spot a more contemporary and sentimental feel while keeping the meaning of the original lyrics. By the end of the spot, you could feel the astronaut's higher love for her husband when she helps him fix his mistake even though it's interrupting her far more important spacewalk.

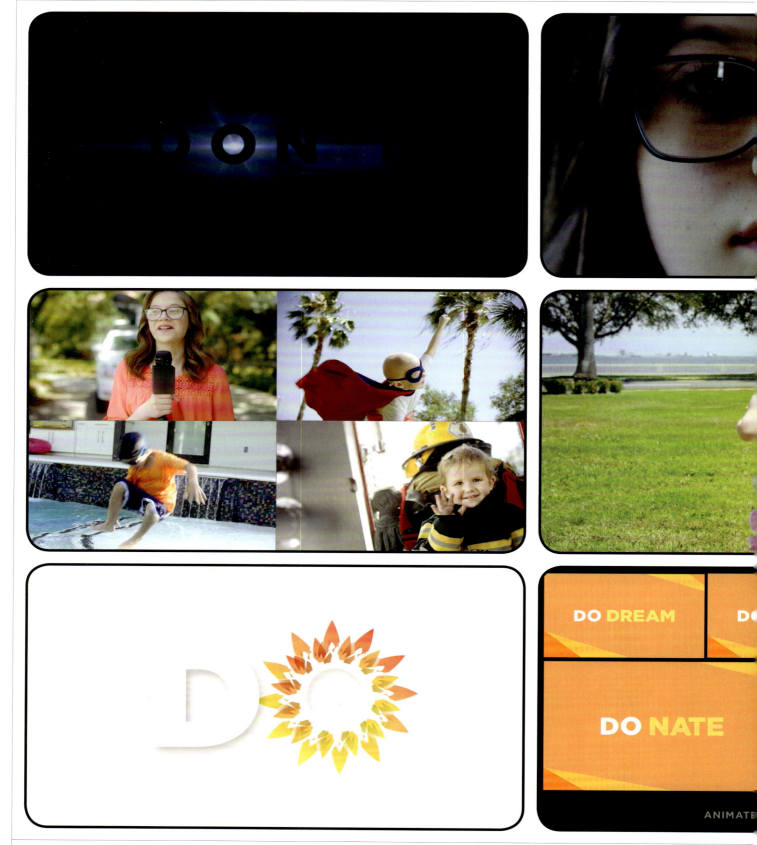

DO Give | National Pediatric Cancer Foundation | **PPK, USA**

Assignment: The National Pediatric Cancer Foundation wanted us to create a video that would be driven by kids who are battling cancer and stress how the NPCF funds collaborative research nationwide to fast track a cure. We wanted to pull at the heart strings and "DO" whatever we could to get people to donate.

Approach: Our goal was to create a very dramatic and touching video that would show different children's brave fights against cancer and how truly beautiful their courage is. To accomplish this, we used real kids (not actors) who were actually undergoing chemotherapy treatments

DO GIVE DREAM

DONATE
Now at NationalPCF.org

ACTION

NATIONAL
PEDIATRIC CANCER
FOUNDATION

PLEASE
GIVE
NationalPCF.org

during the filming of the video. Additionally, we wanted to convey how the NPCF is collaborating with hospitals across the nation to fast track less-toxic, more targeted treatments that are saving many kids' lives.

Results: This heartfelt spot was very well-received by the National Pediatric Cancer Foundation's marketing team. It was first unveiled at Fashion Funds The Cure in Tampa Bay and helped the NPCF surpass all their fundraising goals at this event. They will continue to play this video at various fundraising events, which they host all over the country to gain more support and donations for the kids.

Only you Fybeca | Fybeca | daDá

Plateau | Upwork | Duncan Channon

Assignment: Upwork is a global network of freelance talent. Our challenge was to inspire middle managers in need of help to see the site as much more than some indiscriminate mob of freelancers from here, there and everywhere, but rather a unified movement of motivated people — freelancers and managers alike — here to roll up collective sleeves and make stuff happen.

Approach: The spots portrayed an experience familiar to us all in the workaday world: the "oh shit, how am I going to get this done?" moment when an ambitious goal or daunting project lands on our desk. In a colorful, quirky world that's hip to Upwork's freelance platform, managers transform their nagging anxiety into the thrill of making things happen.

Results: Compared to earlier campaigns, the ad dramatically increased site visits and generated record signups among first-time corporate users.

Butcher | Festival Foods | Shine United

Assignment: Increase awareness of Festival Foods via one of their core, top-of-the line fresh departments: the Meat & Seafood department.
Approach: Festival Foods grocery stores are committed to serving the best and freshest meat and seafood. The talented team of butchers cut and hand-trim products daily. The TV spot worked to highlight these fresh, better products in a bold and mouthwatering way.
Results: The TV spot had effective recognition and recall in research.

DAVID CHANDI — AUTOMOTIVE 🇪🇨

The best option is BAIC. The best Chinese option is BAIC.

La nueva potencia China es Baic | Baic Ecuador | **daDá**

INNOCEAN USA — AUTOMOTIVE 🇺🇸

CAR SHOPPING

SHOPPER ASSURANCE

HYUNDAI

Elevator | Hyundai Motor America | **INNOCEAN USA**

THE DESIGNORY AUTOMOTIVE 🇺🇸

2019 Nissan Intelligent Mobility | Nissan | **The Designory**

INNOCEAN USA AUTOMOTIVE 🇺🇸

Escape | Hyundai Motor Company | **INNOCEAN USA**

THE DESIGNORY

AUTOMOTIVE 🇺🇸

INNOCEAN USA

AUTOMOTIVE 🇺🇸

2019 Nissan Altima All-Wheel Drive | Nissan | **The Designory**

Dad, Look | Hyundai Motor America | **INNOCEAN USA**

THE DESIGNORY AUTOMOTIVE 🇺🇸

Infiniti Cargo Accessories Video | Infiniti USA | The Designory

JOHN FAIRLEY AUTOMOTIVE PRODUCTS 🇬🇧

Rolls-Royce Ghost — Bridge
Rolls-Royce Motor Cars Limited | **Curious Productions**

KEVIN PRICE BEVERAGE 🇺🇸

Maker's Mark Virtual Reality Game
Beam Suntory/Maker's Mark | **Doe Anderson**

M. SCHILLIG, T. PATEL, C. CHANTHALANSY BEVERAGE 🇺🇸

Mass Hysteria | Wichita Brewing Company | **PPK, USA**

DANIEL COOKSON BEVERAGE 🇦🇺

OMDESIGN BEVERAGE 🇵🇹

How to Make the Perfect Four Pillars G&T
Four Pillars Gin | Interweave Group

Honore Port film | Quinta do Crasto | **Omdesign**

MARTINA SOLAKOVA COMMUNICATIONS

SHINE UNITED EVENTS

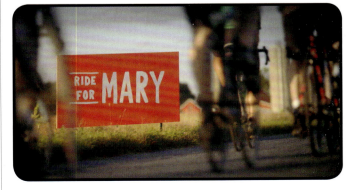

Real Wishes Do Come True | A1 Bulgaria | **Saatchi & Saatchi Sofia**

The Ride | The Ride | **Shine United**

PPK, USA FINANCIAL SERVICES

PPK, USA FINANCIAL SERVICES

Philanthropist — Tea Time | GTE Financial | **PPK, USA**

Philanthropist — Mechanic | GTE Financial | **PPK, USA**

PPK, USA FINANCIAL SERVICES

Philanthropist — Golf | **GTE Financial** | **PPK, USA**

BOB GUNIA FINANCIAL SERVICES

Food Fright | **Physicians Mutual** | **Intermark Group**

BOB GUNIA FINANCIAL SERVICES

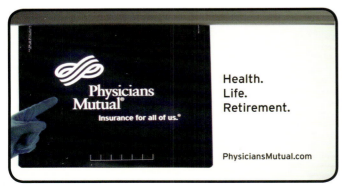

Dr. Acula | Physicians Mutual | **Intermark Group**

BOB GUNIA FINANCIAL SERVICES

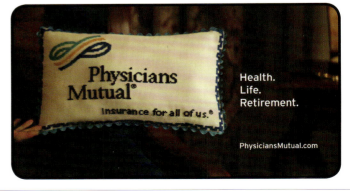

Nightmares | Physicians Mutual | **Intermark Group**

MADAY PRODUCTIONS FOOD

THE VILLAINS HEALTHCARE

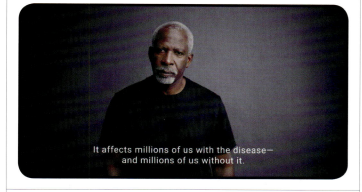

Be the Differents — Embrace Your Punch
Sour Punch — American Licorice | 50,000feet

Every Move is Extraordinary
New England Baptist Hospital | **Proper Villains**

CONCETTA PASTORE HEALTHCARE 🇮🇹 **SILVER CUELLAR** PRODUCT 🇺🇸

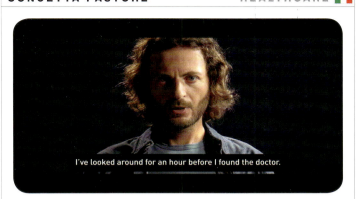

I've looked around for an hour before I found the doctor.

I've been working for 12 hours.

We are asking for more health resources

Together.

Più risorse, più salute.

More resources, better health.

Doctors & patients, two sides of the same discomfort | Ordine dei Medici Chirurghi e degli Odontoiatri della Provincia di Bari | **Kibrit & Calce**

Heist | YellaWood | **Brunner**

SILVER CUELLAR PRODUCT 🇺🇸

Lumberyard | **YellaWood** | **Brunner**

SILVER CUELLAR PRODUCT 🇺🇸

No Yella tag.

Control Room | **YellaWood** | **Brunner**

YOUNG & LARAMORE PRODUCT 🇺🇸

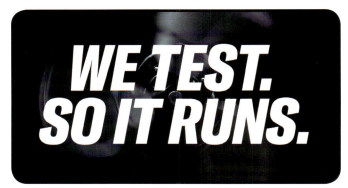

Trane Relentless Testing TV | **Trane** | **Young & Laramore**

MARK BRAUTIGAM PUBLIC SERVICES 🇺🇸

MDA Sense of Freedom
Muscular Dystrophy Association | **Traction Factory**

THE VILLAINS

Alzheimer's is the slow destruction of the brain.

It affects millions of us with the disease—
and millions of us without it.

250,000
Alzheimer's caregivers
are children

20 years
before symptoms appear

Research is
the only path to a cure.

The Face of Alzheimer's Anthem
Cure Alzheimer's Fund, Barbara Chambers | **Proper Villains**

SHINE UNITED

Bakery | Festival Foods | **Shine United**

SHINE UNITED RETAIL

Deli | Festival Foods | **Shine United**

BURTON RUNYAN RETAIL

Pool Dad — Interruption | Pinch A Penny Pool Patio Spa | **PPK, USA**

RETAIL 🇺🇸

Pool Dad — Thing of Beauty
Pinch A Penny Pool Patio Spa | **PPK, USA**

RETAIL 🇺🇸

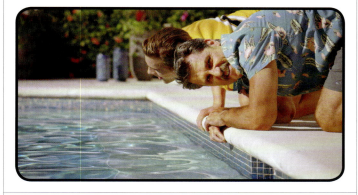

Pool Dad — Closer
Pinch A Penny Pool Patio Spa | **PPK, USA**

INNOCEAN USA AUTOMOTIVE 🇺🇸

Not Flying | Hyundai Motor America | **INNOCEAN USA**

INNOCEAN USA AUTOMOTIVE 🇺🇸

Million Mile Elantra | Hyundai Motor America | **INNOCEAN USA**

INNOCEAN USA AUTOMOTIVE 🇺🇸

Stoplight Standoff | Hyundai Motor America | **INNOCEAN USA**

INNOCEAN USA AUTOMOTIVE 🇺🇸

Ref to the Rescue | Hyundai Motor America | **INNOCEAN USA**

INNOCEAN USA AUTOMOTIVE

Bold Never Blends | Hyundai Motor Company | **INNOCEAN USA**

DAVID VAWTER & KEVIN PRICE SELF PROMOTION

Doe Anderson Shareholder's Video | Self-Initiated | **Doe Anderson**

TIM OFCACEK SPORTS

Louisville City Football Club :30 TV | Louisville City Football Club | **Doe Anderson**

nikkeisha, inc.

FBC Design

Cold Open

Jorel Dray

WONGDOODY

STIR

Ayzenberg

Pivot Design

Disrupt Idea Co.

nikkeisha, inc.

Buitenkant Adv. & Design

Doe Anderson

The Designory

Doe Anderson

Doe Anderson

Independent Copywriter

ICOR@Acorda

Traction Factory

Independent Copywriter

Independent Copywriter

AG Creative Group

50,000feet

It's a real honor to have your work featured in Graphis.
Jimmy Bonner, *Creative Director & Art Director, The Richards Group*

The work was excellent and very inspirational.
Jin-soo Jeon, *Representative Director & Chief Creative Director, Brand Directors*

2019 PLATINUM AWARD-WINNING ADVERTISING INSTRUCTORS:

Larry Gordon
Miami Ad School

Frank Anselmo
School of Visual Arts

Mel White, Kevin O'Neill
Syracuse University, The Newhouse School

Patrik Hartmann
Miami Ad School Europe

Josh Ege
Texas A&M University Commerce

Eileen Hedy Schultz
School of Visual Arts

Hank Richardson
Miami Ad School

Dong-Joo Park, Seung-Min Han
Hansung University of Design & Art Institute

"McDonald's—Hold Onto Happiness" Student: Chase Harris

Q&A: **Larry Gordon** Miami Ad School New York

In starting your class, what is the criteria that you set for what you want to achieve?
The main goal of my class is to teach students brainstorming tools and techniques so they can become effective idea generators.

What are the most important requirements for students to qualify in your class?
Ideas, ideas, and more ideas.

What are your specific methods of teaching that may set you apart?
I still teach from a book. For majority of the class there are no computers and students present their work with simplified marker comps with headlines.

Do you dismiss students from your class, and if so, for what reason?
I used to but that is now frowned upon for some reason. But I only dismiss students when they show up to class without completed work. I don't think its fair for them to remain in class and benefit from the hard work of others.

What advice do you give your students upon leaving your class?
To be themselves and bring that into their work. Their voices, stories and opinions matter and their work should be an expression of that.

What is an important lesson you want to continue to achieve with your students?
That ideas can change the world and that we need a lot of ideas to do it. Other than that, it's product benefits. What is the product benefit?

What's the most difficult challenge you've faced as an instructor?
Feeling like I've said the wrong thing or that I'm not teaching them the right way. I lose sleep thinking about if I've properly prepared them for what's ahead.

What are the rewards you have received having been an instructor?
Selfishly, I get to be surrounded by ideas. But it's a great feeling to see the students improve from week to week.
It's also great to see the students get awards and recognition for their thinking and hard work.

What inspired you to become a teacher?
My mother is a retired teacher. I now have a better understanding and appreciation for her. But I also wanted more people who look like me to be in the classroom leading and teaching.
Now we need more students who look like me in the classroom learning and excelling. In short, the lack of diversity inspired me to do something about it.

Larry Gordon "I exist." That's what Larry wants the caption under his photo to read if he ever runs into the Humans of New York guy. He's originally from Virginia, but he started his advertising career in Miami. He currently resides in Harlem, New York. When he is not Art Directing, he is usually busy gaming, rapping, reading, painting, Ancient Alien traveling, Pokémon Mastering, and taking pics of his dirty kicks with his Holga. During the day, Larry's 2Pac at an ad shop. That ad shop is currently 360i, where he's a Associate Creative Director working on Champion, Oreo, and United Airlines. At night, he teaches at Miami Ad School NY, where he turns students into Idea Generators.

ANYONE CAN TEACH — BUT TO TRULY INSPIRE YOUNG TALENT, IT'S CRUCIAL THAT TEACHERS FIND WAYS TO AWAKEN THEIR SOULS. ONLY THEN WILL FAMOUS WORK BE BORN.

A GREAT STRATEGY IS A MAP TO THE UNDISCOVERED IDEA. HOW YOU GET THERE IS THE CREATIVE PART, BUT IF WHERE YOU'RE TRYING TO GO IS NOT INTERESTING, WHO CARES HOW YOU GET THERE CREATIVELY?

Frank Anselmo, *Instructor, School of Visual Arts*

Q&A: Frank Anselmo School of Visual Arts

What is your advice to your students?

A school is only as good as its instructors, just as a sports team is only as good as its players. The most successful advertising people are usually awful instructors mainly because mentorship sensibilities are rare talents seldom found in advertising people with lots on their mind from their day job.

I've known numerous ad creatives who have done a class for a semester then called it quits. It's a huge commitment very few are equipped with the relentless stamina and perseverance to do triumphantly. I'm talking about a concept-to-execution class where the instructor puts in overtime to assure the work is pixel-perfect.

Great ad instructors are an insanely rare breed and becoming rarer since there's even more on their plate in today's industry. That's why it's more important than ever to seek out the few, great instructors out there before applying to any school. Then you'll get the amount of face time you'll never receive from that same person at an agency. A single dedicated instructor is worth more than years of tuition for mediocre instructors. Create work you can't picture anyone else in the world coming up with.

If you're reading this book, odds are you've got bigger dreams than just landing a job at just any ad agency. Good work might get you into many agencies, but how do you up your chances of getting into top agencies? The best way is showing something they've never seen the likes of. An idea that's more than just another print or digital piece. An idea that defies and/or reinvents the medium.

Maybe your idea invents a completely new medium altogether. There's a big difference between being referred to as "The guy with a strong portfolio," as opposed to "The guy or girl who did BLANK." You must have something that defines who YOU and ONLY you are. When you do something truly unconventional, you'll be remembered as more than just the next talented creative. Everyone knows the name of the man who invented the lightbulb, the woman who refused to get up on the bus, and the guy who did the moonwalk dance. No one will remember the guy who did another mobile app that uses GPS so you can bla bla bla.

Whether you call these ideas unconventional, ambient, non-traditional, guerrilla, experiential, or a stunt, just make it a priority to push your thinking to the point you think up a completely different animal of an idea that defies being categorized. For a second, make the Creative Director with the huge ego feel like even he could not have come up with that. Graduate from simply "creating" into an "inventing" state of mind.

Agencies are not what they were a decade ago. It used to be that if you did not get into the top 5 creative agencies, your job was less than ideal. The best people were only working at the best places. Bigger agencies were frowned upon by top creatives–for good reasons. But today talented people are sprinkled everywhere. So don't chase agencies just because you wanna see it on your resume. Getting hired under great people regardless of what agency is what will lead to you producing great work.

Frank Anselmo His unconventional thinking garnered every prestigious, global award during a ten year stint–rising to Creative Director at BBDO New York. Anselmo has since been hired by over 75 companies in the world including Apple. As a Creative Leader, Frank cemented his place in history by leading more young creatives to globally-awarded work in his very own "Unconventional Advertising" college program at SVA that's globally recognized as "The Most Awarded Ad Class In History". In 2018, The One Show ranked Anselmo #1 most awarded CD/Professor in the world. Frank's natural leadership skills and passionate ability to mentor, motivate, and inspire creatives to innovative work has landed those working under him jobs at Weiden+Kennedy/Portland, Google, Droga5, Disney, Apple, etc. Anselmo's work has been featured on Fast Company's "100 Most Creative People In Business" issue.

SEASON 1

SEASON 2

SEASON 3

SEASON 4

SEASON 5

SEASON 6

NETFLIX
Binge On.

"NETFLIX Binge On" Students: Huiwen Ong, Yuran Won

"FUJIFILM Instax: Catch the moment" Student: Zhixin Fan

Q&A: Mel White The Newhouse School, Syracuse University

In starting your class, what is the criteria that you set for what you want to achieve?

The Portfolio I course that I teach at Syracuse University's Newhouse School is the first creative advertising course that Newhouse creative advertising students take. I ask the students in the first class, "is there a secret to creating compelling ad campaigns?" Most of the students respond no, but even the ones who respond yes, don't know why. Then, I reveal that there is a secret – it's insights. By letting them know that there actually is a method to creativity that can be learned and repeated, the students realize that being an advertising creative is attainable. Taking the fear out of the creative process, frees up the students to explore.

At Newhouse, a substantial part of my creative advertising pedagogy has been dedicated towards answering this question through my developing a formulaic, yet creative, process which students can employ with each new assignment in order to regularly and consistently create ads and campaigns that work. A creative process which students can use in school, as well as, when they are working at ad agencies – it involves concepting in teams in order to generate synergy which typically leads these advertising teams towards stronger and deeper ideas. And it involves focusing on relatable insights and universal truths about both the product and about peoples' behavior which ultimately results in connections with the consumer on deeper, more insightful and relatable levels – which is where the magic of successful advertising always lies.

I work to create learning atmospheres where it is okay to fail while taking bold risks to create amazing ideas, because that is where some of the best learning can occur. Sometimes, I will send creative teams "back to the drawing board", from which they almost always return with deeper, more unexpected, and more relatable ideas. These students get a sense of accomplishment from being able to solve the creative problem on briefs using such breakthrough ideas. And that is when, as an educator, I know that they are "getting it", and are on the road towards being able to replicate this creative process when they intern or get hired into the ad industry.

A basic maxim that I convey to my students is that an ad should not feel like an ad. An ad needs a big idea and something meaningful or of value that consumers would want to share with others because it is so funny, so moving, so inspiring, so engaging, so hard to believe, etc. Employing this process and maxim, paired with feedback from me to help them narrow down their best ideas and to push their ideas even further, is excellent preparation for being able to meet the creative expectations and deadlines of the ad industry. It resembles the feedback their future agency Creative Directors would give them.

When my students are in their internships and first industry jobs, they have told me repeatedly that they consider themselves well prepared for the challenges of the industry as a result of the instruction that they have received through my courses.

After spending over 25 years in the industry, with the last 17 at top NYC ad agencies Y&R, Ogilvy, Publicis, and D'Arcy – and through which I established, and now maintain, constant contact with the industry and keep current on the latest campaigns, trends, and technologies – I teach what is currently being done and expected in the industry, and what ad agency Creative Directors and Creative Recruiters want to see in student portfolios.

What are the most important requirements for students to qualify in your class?

Concept every day. Put in the hours. Think of crazy ideas. Leave your cell phones in the front of the class.

What advice do you give your students upon leaving your class?

If they do not pass the ADV Department Portfolio Review at the end of Portfolio I but are still passionate about creating compelling advertising, they can create a new portfolio of work on their own and resubmit that portfolio the next semester. And/or if they show particular talent(s) in any of our other advertising sequences such as strategy, account, digital, and/or production, I will encourage them to consider pursuing one of these options.

*What is an important lesson you want
to continue to achieve with your students?*
Continue to discover who you are as creatives. Zach Canfield, Associate Partner & Director of Talent, at Goodby Silverstein & Partners wrote "Leave behind all the crap you think you're supposed to be and fight to discover who you are as a creative." This is the road for creatives to travel to be original. And to fuel that journey, students can: go to art museums, see performance art, read, see art films, volunteer in a homeless shelter, climb a mountain, etc. The key is to keep enriching yourself. And finally, find non-advertising ways to express your creativity. Find something (other than advertising) that you are passionate about and create something – then continue to explore and create even more. This life-long exploration of creativity will fuel the journey towards originality.

What are the rewards you have received having been an instructor?
I find it very rewarding when I see the "a-ha moments" with the Portfolio I students as they finally understand and embrace the process of how to create unexpected ideas for brands. In Portfolio III, the students continue to amaze me with their unexpected use of digital and experiential mediums, as well as, with their use of new technologies for brands. And then, seeing the tangible outcomes of student award-wins and them receiving top internship and job offers, is extremely rewarding & satisfying for me. Also rewarding is when I provide my students with briefs that provide opportunities to envision how new technologies can be used to solve real-world problems – and occasionally, some of the world's most pressing problems. These brief-based challenges often result in exponential creative growth in my students, which is invaluable in preparing them for their future work in the industry.

What inspired you to become a teacher?
A dream of mine was to one day return to my alma mater, Syracuse University, and somehow facilitate the Advertising Art Director students in Syracuse University's College of Visual and Performing Arts to begin working with the Advertising Copywriter students in Syracuse University's Newhouse School. So, in 2014 when Dr. James Tsao, the Advertising Chair of the Newhouse School, actively recruited me to apply for a newly-created Creative Advertising Art Direction position in the Newhouse School, I seized the opportunity – believing that I could use what I had learned from being in the field for 26 years, 17 of those years as a veteran of the New York City advertising scene where I worked as a creative director/art director at top agencies such as Young & Rubicam, Ogilvy, Publicis, and DMB&B. Now in my fifth year of teaching at Newhouse, I find that I absolutely love the process of continually learning how to improve my teaching in order to inspire and elicit the very best in creativity from my students.

What new programs have you implemented?
One of the most noteworthy new programs that I have implemented is the Portfolio III Creative Advertising Mentor Program for art director and copywriter students. First envisioned by Advertising Chair Dr. James Tsao, the Creative Advertising Mentor Program idea was significantly expanded by me from exclusively utilizing local Syracuse-area ad agency creatives into a much more robust program that pairs student teams with international award-winning Creative Director mentors from several of the world's top ad agencies with these mentors giving feedback to the student teams on their student ad campaigns throughout the semester. Initially using my agency contacts from my years in the industry, I have since personally recruited an impressive cohort of Creative Director mentors. To ensure that each student team receives a similar level of mentoring, all the Creative Director mentors have won top industry awards and currently work or have worked at top-tier ad agencies.

Each student team will Skype with their Creative Director mentor three-to-five times during the semester to get feedback on their ad campaigns. The students learn how to push their ideas even further conceptually through the valuable feedback that they receive from their award-winning Creative Director mentors, while also giving them extremely influential contacts in the industry. Students often will gasp and are awestruck when they first hear their names paired with their mentors' names – knowing the prestigious agencies that their mentors hail from and the award-winning and well-known campaigns created by these mentors. Most students are nervous about those first Skype meetings with their mentors, however over the course of the semester as the mentors' feedback increases and students' understanding of advertising grows, so do their relationships. Through this Creative Advertising Mentor Program, student ideas are pushed much further and their thinking is challenged and opened up in ways that they could never have imagined. When students receive positive feedback from their mentors on the progress of their ideas, they start to envision themselves as having the potential to work at the world's top-tier ad agencies.

Here is a sampling of student written comments about their experiences with their mentors: "The advice you shared improved the way we approached projects... We truly appreciate all the words of wisdom you shared with us and for inspiring us to always think bigger and ask more out of this industry." "You've given us great advice. Our skills were sharpened by your kind critiques."

Another new program I implemented in 2017 was an Annual NYC Newhouse Portfolio Review. Now, in its fourth year, it is the highlight and crescendo of Portfolio III – a venue where the students showcase their portfolios with Creative Recruiters and Creative Directors from top NYC ad agencies resulting in countless follow-up interviews, numerous internship offers, and several full-time job offers.

THIS LIFE-LONG EXPLORATION OF CREATIVITY WILL FUEL THE JOURNEY TOWARDS ORIGINALITY.

Mel White, *Instructor, The Newhouse School, Syracuse University*

Mel White is currently a Professor of Practice of Advertising-Creative at The Newhouse School at Syracuse University. Since Mel's arrival at Syracuse University in Fall 2015, there has been a significant increase in the number of creative students winning awards and in the overall number of awards being won. Prior to her foray into advertising academia, Mel put in more than 25 years of advertising experience – the last 17 of those years in New York City as a Creative Director/Art Director at Young & Rubicam, Ogilvy, Publicis, and DMB&B. She has worked on a range of accounts such as Microsoft, Land Rover, MINI Cooper, Sony, Crest, Dannon, and American Express. Having won several industry awards, Mel excels at creating strong visual solutions, and focuses on that in her student instruction. She began her advertising career after earning a B.F.A. in Advertising Art Direction from Syracuse University's College of Visual and Performing Arts.

FIGHTS TOUGH STAINS

"Tide to Go Print Ad" Student: Keren Mevorach

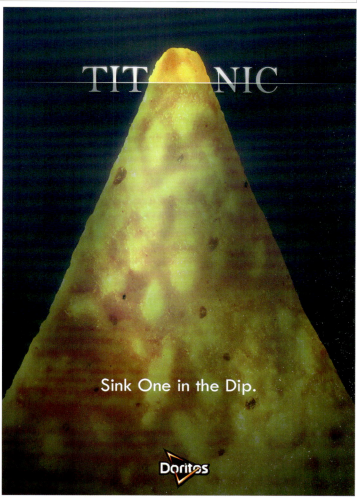

"Dorito Poster" Student: Yuxin Xiong

ONCE YOU GET INTO THE BUSINESS, DON'T LET ANYONE OUTWORK YOU.

Kevin O'Neill, *Instructor, The Newhouse School, Syracuse University*

Q&A: **Kevin O'Neill** The Newhouse School, Syracuse University

In starting your class, what is the criteria that you set for what you want to achieve?
The Portfolio program at the Newhouse School of Syracuse University has a single ambition: to graduate students whose portfolios emphatically meet the demands of the marketplace. Our record of achieving that is dramatic and enduring. The creative departments of America's leading agencies are filled with our graduates.

What are the most important requirements for students to qualify in your class?
Provocative powers of invention, a relentless strategic sense, and a powerful work ethic.

What are your specific methods of teaching that may set you apart?
Despite our digital and modern moment, I include a lot of review/discussion of historic advertising (the 1950s forward) in my curriculum. You can learn a lot from old stuff that sold stuff.

Do you dismiss students from your class, and if so, for what reason?
Sloth is among the deadly sins that isn't tolerated. So is screwing around on your phone during class.

What advice do you give your students upon leaving your class?
Once you get into the business, don't let anyone outwork you. Your talent is not enough. Agencies value people who have an inexhaustible energy for solving problems. Be one of those people.

What are the rewards you have received having been an instructor?
After 30 years in the NYC advertising business, this 12-year chapter of my career has been incredibly satisfying. Newhouse students are uniformly smart and highly motivated. Giving them the tools to succeed and then watching them succeed is a thrill.

Kevin O'Neill Kevin O'Neill has fashioned a communications career of unusual dynamism and diversity: news reporter, fiction writer, award-winning copywriter and creative director, advertising agency president, creative consultant to leading corporations and, now, Professor at the Newhouse School of Public Communications at Syracuse University. He is a graduate of Princeton University and earned an M.A. at Hollins College on a fiction-writing fellowship. He has been the senior creative executive at both globe-straddling networks and creative boutiques on a glittering array of world-class brands including IBM, Johnson & Johnson, Sara Lee, Hanes, Panasonic, Lego, AT&T, Maybelline and Bacardi. His work has been recognized by virtually every creative award competition and he was featured in the Wall Street Journal's Creative Leaders Series, a distinction limited to the advertising industry's most accomplished practitioners.

Superchip.

"Dorito Poster" Student: Yuxin Xiong

Naturally Adaptive.

FABER-CASTELL

"Faber-Castell - Naturals" Students: Abdelrahman Galal(Art Director), Samar Singh (Copywriter)

Q&A: Patrik Hartmann Miami Ad School Hamburg

*In starting your class, what is the criteria that
you set for what you want to achieve?*
There are no golden rules in advertising where you apply formulas like in maths, or open boxes with solutions which are ready to go. I try to equip my students with tools, techniques, and theories which in combination should give them the ability to solve every brief which they might be facing, no matter what it is, no matter where they live. They should become professionals where conceptual work as well as visual execution become an excellent unity, creating work that leaves you with goosebumps, ideally with sustainability and added value to people's lives.

*What are the most important requirements
for students to qualify in your class?*
Passion and the ability to accept the challenge of not being satisfied with average work.Instead, polishing the raw idea into an outstanding diamond which will shine and leave an impression on the public.

What are your specific methods of teaching that may set you apart?
The class has to be rich in variety. I try to not bore the students with stuff they won't need for their professional career. It's good to know the past, but the future is much more exciting. I try to
bring some of this excitement into my course. In combination with not just traditional design and layout tools, but also using for example Instagram stories for assignments. It has everything like the traditional Software. Pictures, typography, and even gifs and a timeline. It opens new possibilities of creating fresh work using the tools the students have on their hands every day. It's stunning what they come up with, if they push the technology.

Do you dismiss students from your class, and if so, for what reason?
I would only if they don't show interest in the lecture by not showing up. But honestly, this never happened. Hope it will stay like this.

So I might be doing something right.

What advice do you give your students upon leaving your class?
Stay passionate, stay curious, never give up, don't take criticism too personal. In Adland it's sometimes tough, but take the best out of every failure, it will make you better. There is a good film on advertising with Dennis Hopper. It's old, but there is lots of wisdom in it. It's called the "Golden Age of Advertising."

*What is an important lesson you want
to continue to achieve with your students?*
The influence of social media on traditional advertising and how to deal with it in the best possible way, and how to push traditional techniques into the new era.

What's the most difficult challenge you've faced as an instructor?
My first day, when I started. Preparing the whole quarter. What are the expectations. Will the topics be exciting enough. Am I at the pulse of time. Lots of questions when you are back at school again. Lucky me, it went well.

What are the rewards you have received having been an instructor?
Honest feedback from the students, giving me advice on what they missed in my class, but also what they like. So it's not only them improving, but also my class. I mean they are the guys of tomorrow, so we need to listen to their thoughts.

What inspired you to become a teacher?
I remember my time at the university in London, and I loved the classes that were taught by professionals. It was always a lively, dynamic, fresh, hands-on, and tough, interesting assignments. I try to implement this kind of teaching into my lecture, giving the students an experience they hopefully will remember even after 10 years.

Patrik Hartmann After finishing his studies at the University of East London and an internship at two:design studio in London, Patrik decided to go back to Germany in 2005 where he joined Jung von Matt/Elbe for 5 years. He worked his way up to an Art Director, working on clients like BMW Motorsport F1, BOSCH, Konzerthaus Dortmund, Sixt, Lemonaid and Arte. In 2010 he moved on to LeagasDelaney working on SKODA Motorsport, Skoda international and national, Deutsche Schauspielhaus. He also won a major client with PARSHIP. In 2012 he joined FCB Hamburg as a Creative Director, dealing with international and national clients. The portfolio covers clients like NIVEA MEN, YAMAHA, Philharmonisches Staatsorchester Hamburg, WWF, Held Vodka and many more. With more than 100 national and international awards he joined the Art Directors Club Germany in 2014 and is a lecturer at the Miami Ad School in Hamburg since 2015.

CONCEPT IS KEY, BUT TO UNLOCK THE POTENTIAL, THE CONCEPT MUST BE EXECUTED WELL.

Joshua Ege, *Instructor, Texas A&M University Commerce*

Q&A: Joshua Ege Texas A&M University Commerce

What are the most important requirements for students to qualify in your class?
Adequate drawing skills, an open mind, willingness to research and a burning desire to create good ideas through hard work.

What are your specific methods of teaching that may set you apart?
I am not sure I do anything that sets me apart, but this is what I try to do: I tend to impart knowledge through my own life experiences. I am a storyteller. I share professional triumphs and embarrassments from throughout my career with my students. I have been told that it helps students to know that I am human and that I too have made mistakes and worked through them. I think it gives them permission to take creative chances.
I encourage my students to speak up and challenge any feedback, direction or lessons I give. It leaves great room for growth all around when students feel empowered.
I do not look for the perfect solution to the problem presented. I look for the best solution the student can come up with and we walk through options to help it communicate effectively.
I challenge them to have empathy for who they are speaking to creatively. I want students to experiment with what they can do to make the experience they are working on memorable. I believe great work comes from thinking about the problem through the audience's eyes. I lock my door when class starts. If a student arrives late, they must wait until there is a stopping point in the flow of the class to be let in. I will always let them in, but I believe that no one person's time is worth more than someone else's and being on time shows respect for everyone involved.

What advice do you give your students upon leaving your class?
I have three main things I share with students.
1. No one thinks like you. Everything you have ever done and ever will do informs the creative decisions you make. Keep experiencing new events, places, foods, people and culture. Stretch yourself past what you are comfortable with. When you are an active participant in life and all it has to offer, it makes you a better creative problem solver.
2. You will not win an award for not sleeping. Work hard, enjoy life and get as much rest as possible so you can keep doing it over and over again. There will be times when you have to work overtime and push yourself to the wee hours of the night, but keep those times few and far between so you stay in love with what you do. Burnout is real and infects many creative people because they struggle with a work/life balance. You are here because you like/love design or art direction. If you are smothered by what you love most, you will not love it for long.
3. Not everything you work on is a portfolio piece. Some projects just need to be done well within set guidelines. Give those projects the attention and care needed, but don't fight battles over them. When real opportunities to stretch yourself appear, give it your all and have fun doing it.

What are the rewards you have received having been an instructor?
The best part of teaching is being there when the light bulb goes off for a student. It is different for each person, so I find myself contin-

uously rewarded. When I see a student find a love for design and/or art direction and get "it," the look on their face paired with the self confidence that comes after makes all the extra work I do worth it. After graduation, many alumni share their stories of success in life and their career with me and I consider that the biggest reward I receive. I feel it means I made a real difference in their life and they actively want to include me. These moments are touching.

What's the most difficult challenge you've faced as an instructor?
Getting past the hurdles I have no control over. I deal with many students who have to work full-time jobs while they are full-time students. Some of them have great potential, but due to outside obligations they have a hard time getting a project to the level of craftsmanship I would like to see.
I can make myself available to talk or walk through what any project needs, but some students often have the talent to get there, but not the time. Finding ways to help these students be successful has been the toughest challenge I have faced. That being said some of these students have been featured in the New Talent Annual and that helps me know we are conquering these challenges.

What inspired you to become a teacher?
I ran the Dallas Society of Visual Communications National Student Show & Conference for a couple of years and found my interest in design education expanded. I met so many design influencers during those years and I was encouraged by their willingness to give so selflessly to students wanting to enter the industry.
Shortly after running the conference I was approached by the Director of Visual Communication at Texas A&M University-Commerce about coming in and teaching a design course as an adjunct. After the first night of the first class, I knew this would be my future. My wife Deeanna convinced me to go back to school to get my MFA, and that is when my new journey began.

What can students do outside of the classroom to help in their success?
Find great mentorship. When I was a young creative, my biggest influence in the business was my mentor, Duane King. He helped inspire me in work and in life. His generosity with his time and advice made a big difference in my approach to design.
You are never too old to have a mentor. Even today, I have a teaching mentor, Lee Hackett. Her influence in the way I teach is really obvious in the classroom.

Any last thoughts to leave us with?
I love being an educator, designer, and art director. I hope I always will. I consider myself lucky to work with really talented educators. Our students successes are a result of the student's drive, every class in our building pedagogy and each professional at the front of the room. We have dedicated people teaching throughout the entire department. Each class sets up students for success and by the time they enter my class they are ready to hit the ground running. I just take the talent they have and do my best to lead and inspire them to solve problems with thoughtful and well crafted ideas.

 Joshua Ege is an Assistant Professor of Visual Communication at Texas A&M University-Commerce. He has served on the board of directors of the Dallas Society of Visual Communications for 13 years and is the current President of the DSVC Foundation. Through his 17-year career as creative problem solver, Josh has produced work for many clients including Fossil, BMW, Orrefors/Kosta Boda, Operation Kindness and Dallas Center for Performing Arts. His work has been recognized by Print & HOW Magazines, American Institute of Graphic Arts, Graphis, American Advertising Federation, Communication Arts, and Harper Collins publications, among others.

"Screamfest" Student: Nicole Glenn

"The Campbell Soup" Student: Jae Wook Baik

BE PASSIONATE ABOUT WHAT YOU DO.
IT WILL SEE YOU THROUGH YOUR MOST DIFFICULT HOURS.

Eileen Hedy Schultz, *Instructor, School of Visual Arts*

Q&A: Eileen Hedy Schultz School of Visual Arts

In starting your class, what is the criteria that you set for what you want to achieve?
After an initial first class lecture and a visual review of past student and professional samples, I hope to inspire students to do the very best work possible, in order to achieve comparable work to what I've shown and discussed.

What are the most important requirements for students to qualify in your class?
Passion for our profession and a desire to concentrate and learn from the basics onward.

What are your specific methods of teaching that may set you apart?
I'm not sure it sets me apart, since I believe we professors are all dedicated to producing another generation of "Golden Era" designers.

What advice do you give your students upon leaving your class?
To stay strong and have a purpose in their lives. I share John F. Kennedy's inspiring words: "One person can make a difference and every person should try."

What is an important lesson you want to continue to achieve with your students?
That they have a sincere desire to do the very best they can do. We can ask no more.

What's the most difficult challenge you've faced as an instructor?
I find each critique a challenge and look for positives rather than dismissing a work completely.

What are the rewards you have received having been an instructor?
The warm affection between students and myself.
They continue to stay in touch which is indeed heartwarming. And of course, I'm most gratified to hear that they're doing so well in our profession and in their lives.

What inspired you to become a teacher?
My love for my profession, my concern for the future of my profession, and my concern for youngsters needing guidance when preparing to enter my profession.

Eileen Hedy Schultz is President and Creative Director, Design International; Creative Director, The Depository Trust Company. Formerly, Creative Director, Hearst Promotions; Creative Director, Advertising and Sales Promotion, Good Housekeeping. B.F.A., School of Visual Arts; Art Students League; Columbia University. President, Society of Illustrators. Past Chairman, The Joint Ethics Committee. Past President: Art Directors Club (only woman President in 96 years). The School of Visual Arts Alumni Society. Board of Trustees, School Art League. Board of Directors, School of Visual Arts; Advisory Board, F.I.T.; Advisory Commission, New York Community College. Former columnist, Art Direction. Art Director, Designer, Editor, The 50th Art Directors Club Annual. National and International lecturer. Awards: Outstanding Achiever Award, School of Visual Arts Alumni Society; innumerable professional awards and honors. Currently graphic, interior and fashion designer and photographer.

"NATURAL WHITENESS" Student: Alana Vitriar.

Q&A: Hank Richardson Miami Ad School

In starting your class, what is the criteria that you set for what you want to achieve?
What's important isn't the subject we are on, nor the amount of work, but on all of their projects. I want them to learn — TO AUTHOR THEIR VALUES — to develop a style, vocabulary, a form, that's theirs. Then go out and share it. Establish a unique identity that makes them stand out in this homogenous world.

What are your specific methods of teaching that may set you apart?
I push each student to my style of teaching. But this doesn't make them more like me, but a more explored and discovered version of themselves. My classroom experience is a spectacle in itself. In teaching every subject from typography to product design, the focus in the classroom is around integrating design and real-world business scenarios. In a round-about way this is unique. I give lectures and answer questions for students with as much information and context as possible, while miraculously tying things together in the end. Perhaps my most well-known class, Design History, has for years produced chair designs as an exercise in form where students combine a personal narrative and an era of art history. This class has become iconic to Miami Ad School at the Portfolio Center and is often considered the turning point in a student's life and their design capabilities. Giving every student a feeling of new possibilities for what can be accomplished or reimagined. A simple mantra for each student has an opportunity to change the world.

Do you dismiss students from your class, and if so, for what reason?
No. I rather try to lead them through a sense of imagination, not obedience. Dismissal is a context for poor teaching. I look for the incorrigible, the misfit, the student who thinks for themselves a little bit differently. Then I challenge them, and conversely they challenge me. I look for the hell-raiser instinct, someone who pushes. The best kind of student fights to disrupt the status quo— that is the student I make the lieutenant, and inevitably it is that student who becomes not only the general- but the great general. That is the student who ultimately will go out and succeed beyond anyone's wildest dreams.

What's the most difficult challenge you've faced as an instructor?
The biggest challenge I face as an educator is nudging each student to their personal threshold, that existential edge, where their best work is conceived. For the edge always defines. This involves asking them to draw from private experience, requiring them to handle subject matter outside their comfort zone, and expecting them to learn about subjects absolutely foreign to them. The legendary TV anchor Dan Rather once imagined, "The dream begins, most of the time, with a teacher who believes in you, who tugs and pushes and leads you on to the next plateau sometimes poking you with a sharp stick called truth." I am fortunate that our school is small, following the Bauhaus archetype, wherein we truly get to know our students, wherein my stick has a sharper aim. I often work with them one-on-one in addition to class time. My office policy has always been open door. Students hover, working on their laptops, waiting their turn.

Hank Richardson is the Director of Opportunities and Outreach and Design Coach at Miami Ad School at the Portfolio Center. He is an AIGA FELLOW, recipient of the NY Art Director's Club 2010 Grandmaster Teacher's Award, and 2018 recipient of the Educator of the Year, Golden Apple Award from the Dallas Society of Visual Communicators, National Student Conference. He is a Director of the Museum of Design Atlanta and has served on the AIGA National Board and board of The Society of Typographic Aficionados. Hank brings strategic design-thinking into his teaching, integrating design, business, and technology. He advises student leadership teams that translate design-led business development for start-up companies and products within a real-world context. He has contributed to such books as Design Wisdom, The Education of a Graphic Designer, Becoming a Graphic Designer, Design for Communications, and The Education of a Typographer.

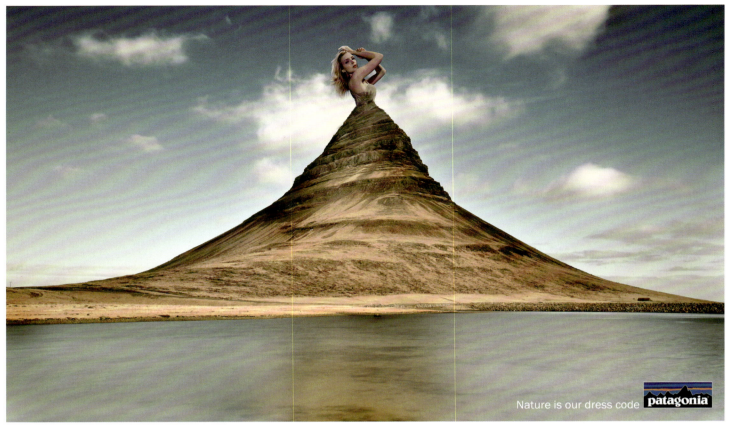

"OUR DRESS CODE IS NATURE" Students: Su Bin Kim, Hong Ye Rim

Q&A: **Dong-Joo Park** Hansung University Design & Art Institute

*In starting your class, what is the criteria that
you set for what you want to achieve?*
To freely expand visual expression, explore experimental expression based on theoretical concept and experience the process.
When expressing subject matter, it makes you think of the aesthetic value of design from various perspectives.
Try various expressions freely in experimental ways through visual thinking. Try to understand the basic design expression for the discovery of each design code and learn to approach the overall visual representation of the design.

*What are the most important requirements
for students to qualify in your class?*
Understanding the basic concept of visual design and the process of exploring the visual identity of the student individual is the most important requirement.

Do you dismiss students from your class, and if so, for what reason?
There is too little will to aim for class participation, or there is a very low participation in the class.

What advice do you give your students upon leaving your class?
Instead of finding the right answer to the design, we're going to need to figure out how to solve the problem. The process of unraveling design will further enhance your skills.

What are your specific methods of teaching that may set you apart?
It proposes a study of communication with society, design thinking, thinking to solve problems, design principles, and methodical visual representation to communicate design concepts and new messages.
Freely propose individual ideas through one-on-one student teaching the process for solving design problems.
Through research materials, storytelling, and thumbnail courses, they share ideas and communicate so that they can carry on extended ideas.

*What is an important lesson you want
to continue to achieve with your students?*
Discussing the role of designer, the significance and meaningful value of design, and exploring the potential as value. I want to discuss and explore meaningful values for creative design process. I want to suggest a way and try something new.

What's the most difficult challenge you've faced as an instructor?
How to make students find meaningful values, how to communicate messages with creative expression of design, and how to feel about the experience of being able to see through many things. I always think about these things.

What are the rewards you have received having been an instructor?
When I see students growing up, I feel rewarded. I also think it's a reward for teaching when I hear that students are going out into society and doing well in their field.

What inspired you to become a teacher?
I majored in visual design and had extensive experience through design practice. While working as a corporate designer, I recognized the importance of the necessity and role of the design field.
I think that activities such as visual expression, brand development, communication, and advertising have the power to contribute to society. Knowing the importance of working-level design education required by society, I wanted to pass on the know-how of practical experts to design scholars.

Dong-Joo Park was born in Korea in 1979 and is a graphic designer based in Seoul. Professor of Hansung University Design & Art Institute, she received her MFA in Visual Communication Design at Ewha Womans University in Korea. She attended the Ph.D. program in IT Design Fusion Program at Seoul National University of Science & Technology in Korea. She also worked as a marketing director for KT & G affiliate Youngjin Corporation and Ilshin New Drug Corporation Advertising Department. Dong-Joo Park was awarded 'Faculty Platinum Award' Graphis New Talent Annual 2018, the Creativity Awards-silver, the IDA design Awards-Gold and more.

Nature is our dress code

I LOVE BEING AN EDUCATOR, DESIGNER, AND ART DIRECTOR.

Seung-Min Han, *Instructor, Hansung University of Design & Art Institute*

Q&A: Seung-Min Han Hansung University Design & Art Institute

In starting your class, what is the criteria that you set for what you want to achieve?

The criteria for achieving a class that I talk to students in every first class of graphic design expression study are as follows:

1. To have a clear purpose, subject and problem-consciousness of visual language. It is to make sure that you always think about whether what you are trying to say through visual language is an important language. This is because I believe that these concerns are the beginning of some capabilities and skills that every designer should have.

2. To explore the essence of a topic, to have in-depth analysis of certain clues. To find out what the differentiated essential core what you are trying to say is to look closely at the clues of possibility. When the essential meaning of the clue can be interpreted, the essential concept can be structured and simplified. This is because when the concept is simplified, the essence of what you are trying to say can be understood and powerful core values can be seen.

3. It is to have the skills to create interpretable visual logic. And it is to have objective creativity that draws empathy with a special visual code that is not familiar. The written language has a logical system. So I believe that linguistic frameworks can provide a contextual visual framework. Therefore, it is believed that when a contextual visual framework is in place, visual logic can be expressed and empathy can be drawn into an interpretable visual language. However, a typical visual language system would be boring and distracting. It also emphasizes that it should be expressed in a special visual element or structure based on empathy.

4. It is also an important achievement to have a high level of aesthetic expression to create the maximum of harmony, balance, contrast, change and unity underlying the construction principle. This is because even if communication is clear and creative, without aesthetic stability and aesthetic interest one can quickly turn one's eyes away. I believe that if we ignore the aesthetic perfection, we cannot get close to each other.

What are the most important requirements for students to qualify in your class?

The most important qualifications that students should have in my class are passion and interest in design, sense of purpose, and will for constant effort. Visual design and graphic design are areas in which constant thinking and new creative expression should be involved. So my most important requirement for qualifications is a strong will to explore and analyze new possibilities and a process-oriented experimental spirit.

What are your specific methods of teaching that may set you apart?

To improve the abilities and skills as mentioned earlier in question 1, I try to do a one-on-one conversation method in which all students participate in my class. Just like having one-on-one conversations, I ask questions to students and encourage them to experience step-by-step, over-the-top thinking when answers to questions are blocked. With the collected data that the students researched, I keep talking with them to bring out the possibilities of a clue. There is no set answer. I just talk to each other about what different possibilities there will be and think from a variety of perspectives. And I induce the concept of possible ideas to be structured in notes.

More systematize structured thinking with students. And, to make them realize the essential core, I continue to talk and guide them so that they can simply draw a conceptual map of their thoughts. It also encourages finding common image cues to replace key keywords. Then, they continue to talk to each other to find unfamiliar image cues with similar semantic structures. In the process of visualizing the core concept, it is also required to keep the concept map of structured ideas and key word notes on the side and keep looking. In the course of visualization experiments, it also induces the possibility of visual logic and new perspectives by talking in mid-term so that the concept or emotional characteristics are related, are not off the center axis of the thought, and can be continuously checked. In terms of technical expression or aesthetic expression by the construction principle, similar design materials are conversed with students in a close glance. We continue to talk and guide how we can improve our aesthetic perfection in this way, so that we can analyze and explore technical and aesthetic structures.

For the diverse perspectives and thoughts of students, it encourages them to form a structural framework of ideas through free dialogue. And a participatory, one-on-one dialogue effort that allows students to experience a new potential methodological process and to pioneer themselves is a method of teaching my class to create a creative graphic visual language.

Do you dismiss students from your class, and if so, for what reason?

I think there is a possibility if all students have strong will. One of my educational goals is 'I won't let anyone give up.' I want to give each person a chance not to give up and try until the end. Exceptions are made for industrial-academic cooperation projects, but no other cases are dismissed.

What advice do you give your students upon leaving your class?

I believe that everything has the potential to have new values and meanings. So it is advised to constantly try this process of possibility of exploring, analyzing and experimenting.

What are the rewards you have received having been an instructor?

When students discover their own individuality, develop their abilities, and grow, it is a great reaward to my mind.

What inspired you to become a teacher?

There are students whose whole interests and development are particularly focused on visual acuity. These students have their own potential to excel as design professionals in society. Having visual sensitivity is a special ability. There are various areas in the field of visual design, and it is a field that requires various expertise. In addition to the visual abilities that each student has in common, they also have their own unique strengths. There are many talented students who can fully demonstrate their unique abilities by developing individual differentiation. I thought it was meaningful to help these students find out how likely they are. This thinking was a great inspiration for me to become a professor.

Seung-Min Han was born in Korea in 1976 and is a graphic designer and Fine Art Illustrator based in Seoul. Professor of Hansung University Design & Art Institute, he received an MFA in Visual Communication Design at Kookmin University in Korea and a BFA in Visual Communication Design, Digital Media at Raffles College of Design and Commerce in Sydney, Australia. He was awarded more than 20 prizes including the Graphis Poster Annual 2018 (2 Silver) Graphis Design Annual 2019 (2 Silver) 'Faculty Platinum Award' Graphis New Talent Annual 2018, the Creativity Awards (3 silver/2 Bronze) and more. He had 20 solo exhibitions and more than 60 selected exhibitions and served as Editorial Committee Member of Asia-Pacific Design N0.12 in Guangzhou, China.

PLATINUM PRINT WINNERS:

36 AMERICAN HORROR STORY: APOCALYPSE | Ad Agency: ARSONAL
Art Directors: ARSONAL, Michael Brittain, VP (FX Networks) | Client: FX Networks
Creative Directors: ARSONAL, Stephanie Gibbons, President (FX Networks), Todd Heughens,
SVP (FX Networks) | Designers: ARSONAL / FX Networks
Photographer: Frank Ockenfels | Production Manager: Lisa Lejeune (FX Networks)
Design Manager: Laura Handy (FX Networks)

Assignment: The creative direction of the advertisement was to play with
the theme of the antichrist and his potential connections to past seasons
of *American Horror Story*.
Approach: We landed on art that represented the birth of this season's
central figure, the antichrist, hinting at the evil to come.
Results: This campaign mirrored the same bold palette of the iconic Sea-
son 1 *American Horror Story* poster and was equally provocative.

37 EMPIRE – "COILED IN DECEPTION" | Ad Agency: FBC Design
Art Director: Moises Cisneros | Client: Fox Entertainment

Assignment: Our goal was to create key art for *Empire* that addressed the
complicated relationship of the two main characters, Cookie and Lucious.
Approach: Cookie and Lucious' relationship has never been easy or
straightforward. The things that divide them – money, power, lies – are
also the things that unite them. The snake, coiled around their bodies,
represents the drama and wealth that envelopes them.
Results: We succeeded in creating a piece that is visually striking, while
speaking to the deep and complex connection between two iconic char-
acters from the show.

38, 39 PRIDE BANNER | Ad Agency: Brunner | Art Director: Silver Cuellar
Client: Atlanta Fire Rescue Foundation | Creative Director: Jeff Shill
Associative Creative Director: Silver Cuellar | Account Executive: Erich Meier
Copywriter: Jonathan Banks

Assignment: To create content to drive the Atlanta Fire Rescue Depart-
ment's diversity initiative.
Approach: One particularly under-resourced recruitment group is the
LGBTQ community. Pride 2018 presented a great opportunity to speak
to them with a message of acceptance and solidarity.
We created an AFRD Pride banner for the fire engine used during the
department's procession in the parade. We reminded the crowd that it
doesn't matter how you identify; all that matters is you step forward and
answer the call.
Results: Though we can't ask applicants about their sexual identity, the
earliest reports indicated over 160 women and 80 Latinos have fabu-
lously applied. The numbers are growing.

40, 41 FATHER'S DAY TOOL FISH | Ad Agency: PPK, USA
Art Director: Trushar Patel | Client: The Florida Aquarium | President: Tom Kenney
Creative Director: Michael Schillig | Associative Creative Director: Trushar Patel
Assistant Account Executive: Brenna Wenger | Copywriter: Michael Schillig

Assignment: Our assignment was to come up with a memorable con-
cept for the Florida's Aquarium's special Father's Day promotion, which
offered free admission to dads over that weekend. We felt like this was a
really great gift idea and excellent value. With this in mind, our challenge
was to develop an image that would get people's attention and bring this
offer to life in a very compelling way through posters, billboards, social
media and web assets.
Approach: We wanted to play up just how terrific this distinctive Father's
Day gift idea was, especially in comparison to your typical unimagina-
tive gifts. Like tools. So, we created a one-of-a-kind fish made out of
tools and encouraged people to "think outside the tool box." In the copy,
we further drove home how "priceless" this gift truly was since all dads
were to receive free admission on Father's Day weekend.
Results: These posters were definitely seen and talked about, especially
since the dramatic "tool fish" image really stood out from other more
traditional Father's Day gift offerings. The Aquarium liked the creative
so much that they used it in everything, including outdoor, digital ads and
web assets. Thanks to the impactful imagery and messaging, as well as
the fabulous free offer, there was a very strong turnout at the Aquarium
for this Father's Day Weekend promotion.

GOLD PRINT WINNERS:

44 ACURA ILX | Ad Agency: MullenLowe LA | Art Director: Christian Perez-Morin
Client: Acura | Design Director: Florencio Zavala

Assignment: Our assignment was to create an ad campaign for the 2019
Acura ILX. The goal was to attract successful millennials who were pur-
chasing their first luxury automobile.
Approach: Acura is a luxury car brand with a focus on performance and
design. Millennials are redefining luxury and are fusing their interests
in street culture—art, music, fashion—into every aspect of their pro-
fessional and personal lives. The TOTAL (CONTROL) campaign is all
about movement and voice. The typography and graphic pattern is both
a tire tread and computer code. A bold gesture that speaks to the vehicles
style, performance, and digital connectability.
Results: Acura's General Manager Jon Ikeda looked at the 3 different
options presented and said "That's the one. It's loud and aggressive."

I want to wear that on a T-shirt" The campaign was approved and built
out to print, digital, point of purchase, and out of home domestically.

45-47 THE ART OF THE MOTORCYCLE | Ad Agency: Animal - San Diego
Art Director: Colin Corcoran | Client: Confederate | Creative Director: Colin Corcoran
Copywriter: Colin Corcoran

Assignment: The assignment was to advertise Confederate's full line of
motorcycles in the brand's first national print campaign.
Approach: The approach was to position the motorcycles as works of art
for display rather than for actual riding.
Results: The company was recently purchased by a French investor.

48-50 LA NUEVA POTENCIA CHINA ES BAIC | Ad Agency: daDá
Art Director: David Chandi | Client: Baic Ecuador | Design Firm: daDá ad
Designer: David Chandi

Assignment: To launch the new Chinese car brand in Ecuador, we high-
lighted the features to the fullest.
■ Lanzamiento de la nueva marca de automóviles chinos en Ecuador,
resaltamos las características al máximo.
Approach: We launched the campaign "The new Chinese power is Baic,"
which entered the Ecuadorian market. We highlighted its attributes and
included an additional element of a 100% technological character that
takes the brand to the future.
■ Lanzamiento dela campaña "La nueva potencia China es Baic", entra al
mercado Ecuatoriano, resaltando sus atributos y con un elemento adicional
un personaje 100% tecnológico que lleva la marca al fututo.
Results: We see the tangible results with knowledge of the brand and in
sales. In less than a year, we managed to be within the first four in market
share with respect to Chinese cars, one of the best brands nationwide.
■ Los resultados los vemos tangibilizados en conocimiento de la marca
y en ventas, en menos de un año logramos estar dentro de los 4 primeros
en participación de mercado con respecto a autos chinos, siendo ya una
de las mejores marcas a nivel nacional.

51 ABSOLUT STRAWS | Ad Agency: 360i
Art Directors: Jenna Zink, Erika Kohnen, Brian Gartside | Client: Absolut Vodka

Assignment: Committing to sustainability, one straw at a time. On Earth
Day, Absolut became Planet Earth's Favorite Vodka. Absolut recom-
mitted itself to sustainability efforts big and small. This includes going
straw-free company-wide.
Approach: For the announcement, this six-foot-tall piece, made of more
than 60,000 plastic straws saved from the landfill, helped them turn
waste into wonderful.
Results: The project made its debut at Bar Recycle in NYC, an interac-
tive event designed to encourage consumers to practice sustainability by
exchanging recyclables for Absolut cocktails.

52,53 REDEMPTION RYE WITS | Ad Agency: The BAM Connection
Art Director: Phebe de Guzman | Client: Redemption Rye Whiskey
Chief Creative Officer: Rob Baiocco | Executive Creative Director: Steve Krauss
Copywriters: Manas Paradkar, Alex Levy

Assignment: Create posters and social media posts to elevate the brand
along with the whiskey drinking experience.
Approach: The use of sophisticated and insightful dry humor to be the
aspirational voice for whiskey aficionados.
Results: The most engaging content the brand has done in years.

54,55 BOTTLE CAP BRAND CAMPAIGN | Ad Agency: Independent Copywriter
Art Directors: Colin Corcoran, Lindy Taylor | Client: The Gambrinus Company (Shiner Beers)
Chief Creative Officer: Joel Clement | Copywriter: Colin Corcoran

Assignment: The objective was to communicate that while Shiner Beers
are now distributed in all 50 states, the brand still maintains its small-town
charm, original factory, commitment to craftsmanship and local legacy.
Approach: We employed a hand-made approach to the ads to visually
convey the brand still puts the craft in craft beer, despite distributing over
20 different beer brands in all 50 states.
Results: Shiner Light Blonde has become its fastest growth brand, and
the brewery recently released two new beers.

56-58 MAKER'S MARK HAND PAINTED OOH MURALS
Ad Agency: Doe Anderson | Art Director: Zach Stewart | Client: Beam Suntory/Maker's Mark
Chief Creative Officer: David Vawter | Graphic Designer: Tim Kennedy
Copywriter: Jonathan Bell

Assignment: Extend the new Maker's Mark brand campaign, "The Mark
of the Maker," into OOH – historically one of the brand's most popular
and effective media platforms.
Approach: Created a series of installations that were hand-painted on site,
in broad daylight, to underscore the handmade essence of Maker's Mark.
Results: The brand campaign as a whole has driven volume gains for the
brand well above category and competitors; the installations were widely
celebrated and shared by consumers who encountered them on the street.

59, 60 GET IT? | Ad Agency: nikkeisha, inc. | Art Director: Hiroyuki Nakamura
Client: Japan Advertising Agencies Association | Creative Director: Hidetaka Sugiyama
Designer: Hiroyuki Nakamura | Photographer: Tetsuro Ikejima | Copywriter: Naoto Miyazaki

Assignment: Japan Advertising Agencies Association (JAAA) aims to ensure that consumers fully understand advertisements. They publish ads and posters themed "Advertisement of Advertising" every year.

Approach: As we considered that advertisements are a kind of gift from advertisers to consumers, we replaced many types of ad spaces (full-page, horizontal, vertical, small spaces, etc.) with various wrapped gift boxes.

Results: Increase of awareness and online traffic.

61-63 FEDEX "GYM" PRINT & POSTER CAMPAIGN
Ad Agency: Independent Copywriter | Art Director: Lindy Taylor | Client: FedEx
Creative Director: Colin Corcoran | Copywriter: Colin Corcoran

Assignment: The assignment was to work with FedEx's recruitment department to come up with a more effective way to fill hundreds of open package handler positions across the United States.

Approach: The creative approach was to re-position part-time package handler jobs at FedEx warehouses as "gyms", where people can get paid $15-$20hr. + full-time benefits to exercise by loading and unloading thousands of boxes during 3-4 hour flexible work shifts. The work ran in major fitness magazines and as posters hung outside popular gym chain locations like Anytime Fitness, 24-Hour Fitness, LA Fitness and Planet Fitness. (Basically all of the Fitnesses.)

Results: Number of applications nationwide increased 34% since the beginning of the campaign. Because the hiring process can take up to two months to complete between heightened government security background checks and training, net hiring results are still pending.

64 NO LOSS OF SUCTION | Ad Agency: Independent Copywriter
Art Director: Colin Corcoran | Client: Dyson Vacuums | Copywriter: Colin Corcoran

Assignment: The assignment was to communicate Dyson's brand promise of no loss of suction power in a fresh, new way than merely using just words to describe its main product benefit.

Approach: By turning a print ad into an interactive product demonstration experience for magazine readers, we delivered on the brand's promise of no loss of suction in an unexpected way.

Results: Dyson has disrupted the vacuum category so much, that entrenched legacy brands such as Hoover has started trying to copy its patented root cyclone product design.

65 APPLE SLICE | Ad Agency: Independent Copywriter
Art Director: Colin Corcoran | Client: Motorola (RAZR) | Creative Director: Colin Corcoran
Copywriter: Colin Corcoran | Typographer: Graham Clifford

Assignment: The assignment was the promote the re-launch of Motorola's RAZR series of smartphones, featuring a 4th generation product design so thin, it can be folded in half like a wallet.

Approach: The creative approach was to take a literal slice at Apple by visually demonstrating Motorola had now surpassed the category leader in both product design and innovative technology.

Results: The results are pending. Apple's smartphone market share in both of the world's most populous countries (China & India) has recently declined 30-40%, respectively, making this a particularly advantageous time for the client to re-launch the RAZR line.

66, 67 YOU TOUCH IT, YOU BUY IT. | Ad Agency: Goodby Silverstein & Partners
Art Director: Cris Logan | Client: HP | Creative Director: Will McGinness
Copywriter: Colin Corcoran

Assignment: To advertise the first touchscreen desktop display.

Approach: We highlighted online shopping. This was chosen to demonstrate the benefits of the product, since it is the most difficult to do in terms of number of steps.

Results: HP was successfully first to market with touchscreen technology.

68 THE MAN IN THE HIGH CASTLE S3 | Ad Agency: ARSONAL
Art Directors: ARSONAL, Aaron Goodman, Sr. Art Director (Amazon Prime Video)
Clients: Amazon Prime Video, Mike Chen, Sr. Brand Manager, Andrew Meengern, Brand Manager, Jean Ly, Campaign Manager | Creative Directors: ARSONAL, Sarah Hamilton, Group Creative Director (Amazon Prime Video), Patrick Raske (Amazon Prime Video)
Designer: ARSONAL | Photographer: Frank Ockenfels

Assignment: As the campaigns for S1 and S2 did the heavy lifting to setup the dark and oppressive world of Man in the High Castle, the campaign for S3 provided an opportunity to evolve the tone to be more hopeful and positive. A key focus of the campaign was to be the rebirth of the Resistance, thereby providing viewers with something to root for. While previous seasons embraced the provocative nature of Nazi imagery, this campaign needed to evolve past that and paint a picture of hope to keep viewers engaged and to avoid negative sentiment amid the recent insurgence of neo-Nazis in the media and public.

Approach: To counter the complex nature of the show itself, we were looking to create a simplified message focused on the key themes of hope and rebellion. Transforming the Nazi flag of past seasons' campaigns into a peace flag symbolizes not only the rise of the Resistance but also provides a glimmer of hope in a dark world.

Results: The art received a lot of positive feedback from the client and buzz on social media.

69 TRUE DETECTIVE S3 | Ad Agency: ARSONAL
Art Director: ARSONAL | Clients: HBO Program Marketing, Zach Enterlin, EVP, HBO Marketing, Sono Mitchell, VP, HBO Marketing, Alex Diamond, Director, HBO Marketing, Zach Krame, Manager, HBO Marketing | Creative Director: ARSONAL | Designer: ARSONAL

Assignment: Inspired by what made critics and audiences resonate so strongly with the first season of True Detective, we were tasked with designing a beautiful piece of creative that was unique to the story, setting, and characters of season 3, while still ensuring the core fan base that they were in store for a True Detective familiar to what they knew and loved. We relied on unit and stock images to paint a picture of star Mahershala Ali in a story that promised mystery, crime, and larger evils at play. For storytelling implementation, we focused heavily on textures and palette to ground the art both in its Arkansas Ozark setting as well as highlight key themes of time, memory, and truth.

Approach: True Detective season 3 follows Detective Wayne Hays in a murder investigation that spanned three decades. The dripping technique was an abstract approach to this man's disintegration over time. His mind and memory were eroding; his body washing away as he progressed over the span of 30 years.

Results: It's always rewarding to see a campaign come to life, especially one as ubiquitous as True Detective. Backed by a sizable media buy, the campaign had a massive outdoor presence in major markets. Not only did True Detective show creator Nic Pizzolatto and lead actor Mahershala Ali personally approve the artwork, but they felt it was a successful representation of the show.

70 THE EXORCIST SEASON 2 - "DEMON WITHIN" | Ad Agency: FBC Design
Art Director: Jason Schmidt | Client: Fox Entertainment

Assignment: For Season 2 of The Exorcist, our goal was to amp up the horror by creating a terrifying piece of art representing the physical and metaphorical experience of demonic possession.

Approach: We set out to create an image that felt familiar enough to be part of The Exorcist brand, but fresh enough to still intrigue and entice viewers.

Results: Avoiding conventional "possession" tropes, we created a shocking image whose darkly disturbing visual aesthetic fully expresses the series' themes of evil and horror.

71 THE DARKEST MINDS - INT'L KEY ART | Ad Agency: Cold Open
Art Director: Cold Open | Client: 20th Century Fox

72 BASKETS S4 | Ad Agency: ARSONAL | Art Directors: ARSONAL, Michael Brittain, VP (FX Networks), Keath Moon, Director (FX Networks) | Client: FX Networks
Creative Directors: ARSONAL, Stephanie Gibbons, President (FX Networks), Todd Heughens, SVP (FX Networks) | Designers: ARSONAL / FX Networks
Photographer: Pamela Littky | Production Manager: Lisa Lejeune (FX Networks)
Design Manager: Sarit Snyder (FX Networks)

Assignment: The creative direction was to explore the season's themes of Chip attempting to become more professional and also the bullet train coming to Bakersfield.

Approach: We leaned into the client's style inspiration of vintage postcards and went with a painterly retro-future inspired illustration technique and a playfully warped title.

Results: The key art feels very rooted in the show's Bakersfield setting and the suit alludes to Chip's newfound professionalism while still retaining elements of his clown essence.

73 GREAT SAGE EQUALLING HEAVEN | Ad Agency: Dalian RYCX Advertising Co., Ltd.
Art Director: Yin Zhongjun | Client: Heiwa Court | Executive Creative Director: Yin Zhongjun
Copywriter: Yin Zhongjun

Assignment: Monkey King is a world-famous classical mythological figure in China's four famous works. In China, the monkey king is a household name.

Approach: The symbolic face of Chinese Peking Opera combines the dyeing of Paper-cut Art, which sets off the mysterious and aloof oriental charm of the protagonist Handsome Monkey King. The fit of the font enriches the diversity of the dramatic faces.

Results: This work got good reviews, since the monkey king is always the central figure.

74 LUCIFER SEASON 3 COMICCON ART - "DEVIL WINGED CHAIR FROM HELL"
Ad Agency: FBC Design | Art Director: Jason Schmidt | Client: Fox Entertainment

Assignment: To promote the new season of this lighthearted supernatural procedural, our goal was to extend Lucifer's established brand with another playfully devilish image.

Approach: Like the comic-book character the series is based on, our key art always displays a bit of tongue-in-cheek humor. For this execution, we chose a simple yet symbolic image of Lucifer on his throne. He's evil, but you gotta love him.

Results: The poster resonated with the series' audience, promising another season of sinful fun with a handsome devil.

75 CAPTIVE STATE | Ad Agency: ARSONAL | Art Director: ARSONAL | Client: Focus Features
Creative Directors: ARSONAL, Blair Green (Focus Features) | Designer: ARSONAL
Copywriter: Linda Castillo | Photographer: Parrish Lewis

Assignment: The goal for the payoff art was to really show what the world of this film looks like and highlight the scope.

Approach: Although the central image is a classic dashboard hula girl, it becomes clear that this world is filled with ruin. The glitch overlays hint at both the lo-fi technology of the film's world and the surveillance aspect, while a subtle alien ship can be seen in the distance.

Results: The payoff felt just as intriguing as a teaser and very uniquely embodied the world of the film.

76 EMPIRE - SEASON 5 - "OUT COME THE WOLVES" | Ad Agency: FBC Design
Art Director: Jason Schmidt | Client: Fox Entertainment

Assignment: For Season 5, our creative goal was to capture fans' attention by hinting at the potential downfall of the King and Queen of *Empire*.

Approach: In Season 2 of *Empire*, our key art showed the triumphant Cookie and Lucious as royalty among lions. This time, Lucious and Cookie, elegant yet dangerous, are surrounded by wolves. They stand their ground ready to fight back against the many foes who are out to destroy them and their empire.

Results: This striking, dramatic poster creates excitement for the upcoming season. The focus is on the strength and power of Lucious and Cookie, provoking engagement with a clear concept and a beautifully bold image.

77 LEGION S3 | Ad Agency: ARSONAL | Art Directors: ARSONAL, Michael Brittain, VP (FX Networks), Rob Wilson, VP (FX Networks) | Client: FX Networks
Creative Directors: ARSONAL, Stephanie Gibbons, President (FX Networks), Todd Heughens, SVP (FX Networks) | Designers: ARSONAL / FX Networks | Illustrator: Zack Atkinson (ARSONAL) | Photographer: Pari Dukovic | Production Manager: Lisa Lejeune (FX Networks)
Design Manager: Laura Handy (FX Networks)

Assignment: The creative direction was to present psychedelic-inspired illustrated concepts that would contain Easter eggs from the previous two seasons for fans of the show. The ultimate goal was to have a multi-piece campaign where each piece had a different style.

Approach: We explored a variety of illustration styles and color palettes and integrated multiple options for ways to represent elements and characters from the series.

Results: This piece has a moodier palette and leaned heavily into the hippie counter-culture vibe of the upcoming season while still representing a wide variety of Easter eggs from past seasons. This piece also fulfilled the ultimate campaign goal by feeling wildly different from our other illustrated piece in both style and palette.

78 LEGION S3 | Ad Agency: ARSONAL | Art Directors: ARSONAL, Michael Brittain, VP (FX Networks), Rob Wilson, VP (FX Networks) | Client: FX Networks
Creative Directors: ARSONAL, Stephanie Gibbons, President (FX Networks), Todd Heughens, SVP (FX Networks) | Designers: ARSONAL / FX Networks | Illustrator: Jesse Vital (V1TAL World Creative) | Photographer: Pari Dukovic | Production Manager: Lisa Lejeune (FX Networks)
Design Manager: Laura Handy (FX Networks)

Assignment: The creative direction was to present psychedelic-inspired illustrated concepts that would contain Easter eggs from the previous two seasons for fans of the show. The ultimate goal was to have a multi-piece campaign where each piece had a different style.

Approach: We explored a variety of illustration styles and color palettes and integrated multiple options for ways to represent elements and characters from the series.

Results: This piece is ultra vibrant and eye-catching while representing the full circle journey of the series by incorporating elements not only from the past two seasons but also the upcoming final one. This piece also fulfilled the ultimate campaign goal by feeling wildly different from our other illustrated piece in both style and palette.

79 CREATE #FORTHETHRONE | Ad Agency: 360i
Art Directors: Doug Murray, Sarah Arrington | Client: HBO

Assignment: Over the past eight years, *Game of Thrones* has become a global phenomenon, amassing an army of over 30 million fans. Within this massive fanbase are the world's most creative fan artists. They've done everything, from creating portraits of their favorite characters using table salt, to whittling the tip of a lead pencil into a Stark wolf, to building an entire scene from the show using carved fruit. They've done cross-stitch, fine-art painting, cartoon drawing, tattoo, cosplay, illustration, song-writing, and much more. For the final season, HBO wanted to thank this engaged, creative fanbase and give them a creative opportunity that would raise the bar on fan creation.

Approach: To do so, HBO went into its archives and unearthed some of the show's most iconic props, including Jaime's golden hand, Beric's flaming sword, a White Walker ice blade, and Kingsguard Armor. They gave 18 of these props to 18 different fan creators from the world of visual arts and design. The artists were given the opportunity to impact the show's history itself, delivering on the prompt: What will you Create #ForTheThrone? Each official prop presented a different challenge, prompting fans to freeze, burn, sew, break and craft museum-quality art. The artists rose to that challenge, spending an aggregate 2,500+ hours honing their pieces.

Results: The resulting series of commissioned works formed the basis of a multichannel outreach effort encouraging *Game of Thrones* fans everywhere to show off their creativity and skill by posting their own original *Game of Thrones* artwork online.
HBO used its platform to highlight the incredible resulting works, turning them into murals in Brooklyn and Venice Beach, sharing them to their tens of millions of social followers, editorial sites, and even displaying them at the Final Season Premiere Party in NYC.
After eight seasons of cultivating a legion of creative and digitally engaged super fans, HBO raised the bar on user generated content – and how brands engage their fandoms.

80 SYTYCD SEASON 15 KEY ART CAMPAIGN | Ad Agency: FBC Design
Art Director: Moises Cisneros | Client: Fox Entertainment

Assignment: For Season 15 of *So You Think You Can Dance*, we were challenged to create key art that was fresh, fun, and distinctly different from the past 14 seasons.

Approach: We know that our fans love the art of dance, so we took that passion literally and created a complex, visually stunning design that blended fine art with movement.

Results: The result was key art that was vibrant, imaginative and unique but still in line with the established brand.

81 GET SHORTY - SEASON 2 | Ad Agency: Cold Open
Art Director: Cold Open | Client: Epix

82 BIG LITTLE LIES (SEASON 2) - TEASER | Ad Agency: Cold Open
Art Director: Cold Open | Client: HBO

83 RENT KEY ART CAMPAIGN | Ad Agency: FBC Design
Art Director: Phillip Bates | Client: Fox Entertainment | Creative Director: Mitchell Strausberg
Group Creative Director: Tom Morrissey | Photographer: Pamela Littky

Assignment: Create key art for live television event of musical.

Approach: Create an updated version of the original broadway musical advertising art.

Results: Everyone loved the updated vibe and bright colors.

84 LITTLEST FISH WINS BIG | Ad Agency: PPK, USA | Art Director: Trushar Patel
Client: National Pediatric Cancer Foundation | President: Tom Kenney
Executive Creative Director: Dustin Tamilio | Creative Director: Michael Schillig
Associative Creative Director: Trushar Patel | Account Director: Jess Vahsholtz
Assistant Account Executive: Brenna Wenger | Account Supervisor: Elizabeth Knight
Copywriter: Michael Schillig

Assignment: PP+K has been a longtime supporter of the National Pediatric Cancer Foundation. We were tasked with creating an ad for the Yerrid Foundation Grand Slam Celebrity Fishing Tournament program in order to show our support and participation in the event.

Approach: Since this ad was running in the Grand Slam Celebrity Fishing Tournament program, we decided to show a trophy fish displayed on the wall with a "little" twist. Instead of showcasing a typical huge stuffed fish, we featured a really tiny one and revealed how at this fishing tournament it was the littlest ones who mattered the most. In the process, we revealed how those small children and their immeasurable courage should inspire everyone to support the National Pediatric Cancer Foundation.

Results: People couldn't help but notice this unusually tiny trophy fish. Many applauded how we brought to light the real heroes at this fishing competition. That is, the littlest ones who exhibit the strongest spirit and most bravery of all.

85, 86 LAMICROLUX EVENT POSTERS | Ad Agency: Disrupt Idea Co.
Art Director: Scott Baitinger | Client: LAmicroLUX
Creative Director: Bill Kresse | Designer: Kris Ender

Assignment: Our assignment was to drive attendance and sponsor interest in a new show concept from LAmicroLUX where watch enthusiasts could meet with, speak to, and even purchase from brands they've seen online and supported on Kickstarter.

Approach: Tap into the aspirational visions watch enthusiasts have of themselves with promotional materials that highlight the functionality of tool watches and the ability to meet directly with the brand owners and designers. We designed and developed lamicrolux.com; built social media accounts and deployed content to them with a content calenda; created a FaceTime campaign and deployed media via promoted posts to drive traffic to Instagram, the website, and the Eventbrite page; created unique assets for 24 watch brands, Ablogtowatch, and other partners; and developed all collateral for the event, including these posters.

Results: We established and grew the Instagram audience to 18,000 followers in one month; achieved over 48,000 Instagram likes with 127 posts; earned a total organic campaign reach of over 1.5M from partner posts; drove 139,766 impressions via Facebook, with a CTR of 6%; achieved a total registration of 1,945 on Eventbrite; and attracted 17 new watch brands to participate in the event via social media. Due to the event's success, a Chicago show will be held in October 2019.

87 HOLIDAY FISH FLAKES | Ad Agency: PPK, USA | Art Director: Trushar Patel
Client: The Florida Aquarium | President: Tom Kenney | Executive Creative Director: Dustin
Tamilio | Creative Director: Michael Schillig | Associative Creative Director: Trushar Patel
Account Supervisor: Rachel Jensen | Copywriter: Michael Schillig

Assignment: We created some on-site out of home posters and magazine
ads to promote the Aquarium's real Snow Play Area – an exciting week-
long event for the kids over the holidays.

Approach: We wanted to emphasize just how cool and unique this attrac-
tion would be, especially for typically hot Tampa, Florida. At the same
time, we also wanted to give it a unique Aquarium twist. Hence, our fish
snowflake concept was born and we created some very distinctive snow-
flakes out of different fish.

Results: The Florida Aquarium's marketing director loved these artistic
creations and used the images in all their advertising. They definitely stood
out and captured people's attention, making this special week-long event
very successful and especially popular among families with younger kids.

88 TOUGH JEANS P.O.P. POSTER CAMPAIGN | Ad Agency: Independent Copywriter
Art Director: Tom Riddle | Client: Wrangler Jeans | Creative Director: Tom Riddle
Copywriter: Colin Corcoran

Assignment: The assignment was to help defend sales in major department
store chains like J.C. Penney, Sears and Walmart as other retailers like Tar-
get have started to create their own in-house, private label owned brands.

Approach: We combined a new, bold no nonsense brand voice with
authentic lifestyle photos of farmers, cowboys and ranch hands who wear
jeans for work reasons instead of trying to make a fashion statement.

Results: The declines in sales from previous years have decreased.

89 THE WITCH IN THE WINDOW | Ad Agency: DOG & PONY
Art Director: Jen Sparks | Client: One Bad House Films | Managing Director: Bridget Jurgens

Assignment: We were tasked with creating a poster that would set the tone
for this eerie, atmospheric film without giving away too much of the story.

Approach: While we wanted to show a hint of a creepy witch, we did not
want to show her completely. The rain-streaked glass serves to obscure
her face a bit. Combined with the trees, it evokes the remote location.

Results: The clients and viewers were thrilled with the art, and the poster
was used for screenings, festivals, and social media. The film and the
poster can now both be seen on Shudder.

90 ITALY DO NOT LEAVE US. | Ad Agency: Kibrit & Calce | Art Director: Maria Favia
Client: Ordine dei Medici Chirurghi e degli Odontoiatri della Provincia di Bari
Creative Director: Concetta Pastore

Assignment: In Italy some regions have requested greater management
autonomy, including in the healthcare sector. Faced with these requests,
the Order of Physicians has expressed concerns about a process that risks
denying citizens' equality in terms of health, especially for the regions of
Southern Italy, where patients already experience lower levels of assis-
tance than the rest of the country and are often forced to go to the north
to get treatment. The Order then asked the agency for a communication
campaign aimed at raising public attention to the possible consequences
of regionalism on the unity of the country and on the equality of citizens
in accessing the right to health.

Approach: The agency has developed the "Italy do not leave us" cam-
paign that is posted locally and on social media. The protagonist of the
posters is a woman suffering from cancer, wrapped in a tricolor flag,
accompanied by a request for help: "Italy do not leave us. We want an
equal health for all. Health is everyone's right."

The campaign is accompanied by the hashtag #SialSSN (Yes to the
National Healthcare System), which recalls the national healthcare
service and its values of fairness, equality and solidarity as a bulwark
against a situation where there would be Italian first class citizens and
Italian second class citizens in some areas such as healthcare, depending
on the region in which they live.

Results: The campaign has managed to capture the attention of traditional
media at national level; online newspapers, press and TV such as: Corri-
ere della sera, LaRepubblica, La7, ANSA, Tgcom24, Huffingtonpost.it.
Even on social media, the campaign was widespread, reaching over 155
thousand people and receiving over 18 thousand interactions.
The result was a greater attention of public opinion with respect to the
ongoing debate on the political process of autonomy and on the possible
consequences on the national healthcare system.

91 PEACE OF MIND | Ad Agency: Shine United | Art Director: John Krull
Client: Mossberg | Creative Director: John Krull | Copywriter: James Breen
Photographers: Scott Lanza, Adam Ryan Morris

Assignment: Drive consideration and sales of O.F. Mossberg & Sons'
new MC1sc Subcompact 9mm Pistol with consumers concerned about
their personal safety.

Approach: Many people have found themselves in unsafe situations
where their safety was in danger. Shine United's print ad messaging
offers peace of mind when it comes to their personal defense. The MC1sc
combines optimal reliability with superior ergonomics to ensure they
will be prepared and protected.

Results: The advertisement contributed to one of the most successful
new product launches in company history.

92, 93 BIG BAD WOLF | Ad Agency: Shine United
Art Director: Eric Cook | Client: Big Ass Fans | Creative Director: Michael Kriefski
Copywriter: Theo Harris | Photographer: Scott Lanza

Assignment: Position Big Ass Fans as the preeminent high-volume, low-
speed fan manufacturer.

Approach: Big Ass Fans' high-volume, low-speed (HVLS) fans are
unlike any other ceiling fans, purpose-built for industrial environments.
In oder to boost awareness and consideration of their best-selling Power-
foil X3.0 fan, Shine United featured the fan's powerful performance and
presence through sleek, impactful imagery and bold copy.

Results: This print ad has garnered awareness among 370,000+ profes-
sionals within the Manufacturing, Distribution and Automotive industries.

94 PILOT PENS / V FOR VICTORY | Ad Agency: Curious Productions
Art Director: John Fairley | Client: Luxor Writing Instruments Pvt.
Creative Director: John Fairley | Copywriters: John Fairley, Nick Harman
Photographers: Dan Humphreys, Charlotte Oldman | Photo Retouching: Rob Lanario
Studio: Dan Murray | Head of Production: Tom Gibson | Account Director: David Norman
Agency Producer: Chloe Cunningham

Assignment: To create a key visual in the promotion of the Pilot Pen V
Series. The visual was used across print ads and posters, as well as OOH
advertising across India. The target audience was students aged 15-20.

Approach: We placed emphasis on the pen range and showed a variety
of pen colors. The pen's formation creates a graphic V shape. Using 'V
for Victory' as the main headline enables us to link the pens to success.
'V' also stands for the Pilot V Series. We added the image of a runner
'breaking the tape' to the execution in order to reinforce a winning vic-
tory. The pens have drawn the running lanes!
The ad copy talks about the V series ink flow being uninterrupted and
the final sign-off supports the idea that using the pens will ensure you
always come first.

Results: There were multiple executions across print and poster through-
out India and the campaign has seen sales of the Pilot V-Series increase.

95 BRIZO VETTIS CONCRETE PRINT | Ad Agency: Young & Laramore
Art Director: Dan Shearin | Client: Brizo | Executive Creative Director: Carolyn Hadlock
Creative Director: Scott King | Group Creative Director: Trevor Williams
Designer: Mitchell Brown | Writer: Jane Brannen

Assignment: When you think luxury, concrete probably isn't the first
thing that comes to mind. But this humble material took center stage
in the limited edition Vettis Concrete faucet by luxury fittings brand
Brizo. Handcrafted from small-batch concrete, this unprecedented faucet
pushes the boundaries of product design, and Brizo asked us to help use
its launch to make an impression with high-end interior designers.

Approach: We faced the challenge of convincing designers that such an
industrial material could be elevated to the heights of luxury. Not only
that, but the faucet's deceptively simple aesthetic hid the sophisticated
engineering and craftsmanship behind its creation. So to change their
perceptions, we treated concrete like a work of fine art in a campaign we
called "The Beauty of Concrete."
As part of the campaign, these print ads showcase stunning photography
of Vettis Concrete alongside macro shots of the stone, sand and water that
make up its signature concrete formulation. The exquisite visuals pair
with copy that speaks to the craftsmanship behind each one-of-a-kind
faucet—inviting viewers to reconsider their perceptions about concrete.

Results: The campaign and launch event did exactly what we hoped:
scoring more than 16 social million impressions in just over three weeks,
generating buzz from high-profile tastemakers such as Jason Wu, Vanessa
Deleon and Tommy Zung, and landing headlines on leading design out-
lets, including Design Milk. Most importantly, we helped our client earn
credibility as a design pioneer—proving once again that Brizo doesn't
follow trends. It sets them.

96-98 MONUMENTS CAMPAIGN | Ad Agency: The Gate | NY
Art Directors: John Doyle, Charlie Williamson | Client: BHP
Chief Creative Officer: David Bernstein | Copywriter: David Bernstein

Assignment: Adapt the Australian "Think Big" advertising campaign for
parts of the world that aren't familiar with who BHP is or what they do.

Approach: The campaign is an ode to what Big Thinkers can create when
they use the resources BHP mines. It centers on unexpected photographs
of iconic structures such as the Statue of Liberty, the Golden Gate Bridge
and the Chrysler Building.

Results: We rolled out the U.S. campaign to both the UK and Asia. So it
seems to be working.

99 INTERNET SECURITY | Ad Agency: Dalian RYCX Advertising Co., Ltd. | Art Director:
Yin Zhongjun | Client: HK IPT | Creative Director: Yin Zhongjun | Copywriter: Yin Zhongjun

Assignment: As the cornerstone of human scientific and technological
civilization, the Internet is changing people's concept and life day by day.

Approach: The Internet is like an open window that brings the world's
scenery. Internet information security is just like a door of security pro-

tection, regardless of national information security or personal privacy, the same respect and protection is essential.

Results: Poster as a carrier of information, triggering audience resonance is the real meaning of its existence.

100-102 DIVERSITY RECRUITMENT CAMPAIGN | Ad Agency: Brunner
Art Director: Silver Cuellar | Client: Atlanta Fire Rescue Foundation
Creative Director: Jeff Shill | Associative Creative Director: Silver Cuellar
Account Executive: Erich Meier | Copywriter: Jonathan Banks | Photographer: Jonathan Banks

Assignment: Becoming a firefighter has some of the most demanding physical and moral requirements, so finding qualified applicants is particularly difficult. As one of the busiest departments in the country, Atlanta Fire Rescue's force doesn't come close to reflecting the city's diverse populations. Our goal was to use feelings of pride, honor, and a sense of duty to inspire women, Latinos, and LGBTQ candidates to become the next generation of Atlanta's bravest.

Approach: Potential candidates needed to know it doesn't matter who you are, where you come from or how you identify, if you can step forward and pass the tests, you instantly earn a place in a close-knit family of elites.

Results: The earliest report indicated that over 160 women and 80 Latinos have applied to be some of Atlanta's bravest. To date, these unprecedented numbers continue to climb.

103, 104 THE THROWN OUT FLAG | Ad Agency: Saatchi & Saatchi Wellness | Art Director: Carolyn Gargano | Client: Out Not Down, LGBTQ Homeless Youth Resources & Support
Chief Creative Director: Kathy Delaney | Creative Directors: Scott Carlton, Carolyn Gargano
Photographer: Luke Gargano

Assignment: The Rainbow Flag has been the symbol of freedom, unity and pride for millions of LGBTQ people worldwide. And more recently, they've been embraced by a wider community with great fanfare.

But not everyone is celebrating. The fact is 40% of homeless teens in the United States who come out of the closet are thrown out onto the streets by their parents. Abandoned. Alone. In desperate need of housing, counseling and health care.

Our charge was to communicate the real truth. That we're not there yet with compassion and love. To reach the thousands of homeless LGBTQ teens, aged 15-19, living on the streets of New York City through a message of authenticity. Then directing them to an online repository of services and hotlines called Out Not Down.

Approach: That meant creating a new visual icon that brought them together in solidarity to forge ahead with determination and hope. We created The Thrown Out Flag. Made of discarded scraps of fabric and designed with the traditional rainbow colors, it represents the struggle, conviction and solidarity of LGBTQ homeless youth.

With each tater, fray, and tear, the flag symbolizes the determination of being true to yourself no matter what the price. It also builds upon the insight that only through acknowledging suffering can we rise up to take on the challenges life throws at us.

As depicted in outdoor posters, we present the teens wrapped in the flag in all its tattered glory. Tragic yet heroic, these young people hide not their troubles but own them with each grasp of the fabric.

Results: In just a few short months, the flag established a powerful symbol of awareness, interest and connection. Challenging prejudices and initiating discussions around LGBTQ homelessness, our campaign produced significant results. From January 2019 through April 2019, the poster campaign utilized outdoor media channels that created over 68M impressions for NYC Bus Shelters & Times Square Digital Billboards.

As of mid-April 2019, we saw the following substantial increases: 33% increase in online site visits, 31% increase in users going to one or more pages, and 17% increase in site sign-ups

105 SOCIAL SMOKING | Ad Agency: Duncan Channon | Art Director: Anne Elisco-Lemme
Client: California Tobacco Control Program | Studio: Scott Whipple
Lead Designer: Shannon Burns | Copywriter: Derek Taylor Art Buyers: Renee Hodges,
Diana Courcier | Senior Producers: Eric Kozak, Keenan Hemje, Christine Gomez
Producer: Emily Sarale | Art Producer: Porsche Michelle | Print Producer: Julie Mastalerz
Chief Strategy Officer: Andy Berkenfield | Account Director: Kumi Croom
Strategy Director: Kelleen Peckham | Strategy: Brandon Sugarman, Adam Flynn
Account Management: Jamie Katz, Davis Wolfe | Account Supervisor: Rachel Smutney

Assignment: California Tobacco Control has spent the last three decades making tobacco less acceptable. And a generation of social norm change has helped push the cigarette into a state of slow decline. But tobacco companies, and Silicon Valley-backed "disruptors" like Juul, have responded with products that don't look, smell or taste like cigarettes. So despite the steady reduction of identified "smokers," poly-tobacco usage among Californians 21 to 34 has actually increased.

Our job was to wake these social smokers up to the fact that low and intermittent smoking still carries great risk and that e-cigarettes aren't a safe alternative. Research showed that only 28% of social smokers believed that Juul even contained nicotine. So armed with the info that they don't think they're smokers and they don't think vaping is smoking, we had to reimagine our entire approach.

Approach: In print and outdoor, we depicted social smoking scenarios real enough that our target could have that "Aha" moment and see themselves for what they are: smokers in denial.

Results: Our tracking study showed awareness of nicotine's presence in Juul products increased by 32%. Most importantly, a social smokers' likelihood to identify as a smoker increased by 26%. Of those that did identify, nearly 50% were compelled to stop using tobacco products.

106,107 GUN CAMERA | Ad Agency: PPK, USA
Art Director: Xavier Rivera | Client: Big Cat Rescue | President: Tom Kenney
Creative Director: Michael Schillig | Associative Creative Director: Trushar Patel
Account Director: Jess Vahsholtz | Copywriter: Michael Schillig

Assignment: Our assignment was to come up with a way to change the public's perception of tiger cub petting and photo ops. We wanted to educate people on why it's not as cute and innocent as they might think or may have been previously told. We aimed to show them how it could actually lead to a tiger's death once they got too big to be petted and photographed. That's because there is no tracking how many tigers ultimately end up being killed in order to sell their valuable fur, bones and other parts on the black market.

Approach: Our client, Big Cat Rescue, is one of the world's largest accredited sanctuaries for exotic cats and is home to over 100 abandoned, abused and orphaned cats, including lions, tigers and other species. They give daily guided tours of their 67-acre sanctuary and are on a mission to save wild cats from extinction. We came up with this really compelling image, merging the barrel of a gun with a camera lens, in order to convey the real picture -- that getting your photo with a tiger cub is like putting a gun to its head.

Results: This powerful poster was placed in a high traffic area at Big Cat Rescue and is stimulating a lot of talk and discussion. It is enticing people to visit CubTruth.com to learn the real truth. This has brought more attention to the issue of cub petting and helped educate the public on this deceptive way of exploiting exotic animals for a profit. In addition, we are also running digital banner ads, pre-roll video, and PSA spots that further bring the evils of cub petting to light. Ultimately, we want people to support a ban on cub petting and help pass the Big Cat Public Safety Act -- the most important piece of legislation ever introduced to protect exotic wild cats.

108 FIRE SIDE AD | Ad Agency: Jacob Tyler Brand + Digital
Art Director: Richard Truss | Client: ANI / Fire Side

Assignment: Create an ad that reflects the unique, hand-crafted properties of this restaurant and their menu items.

Approach: This is a kick-off ad to a campaign centered around their made-from-scratch breakfasts. The entire ad was hand lettered detailing their recipe allowing the reader to see the care that is put into their menu items. Ad the ad needed to reflect the same care.

Results: Very well received by both the client and public and has since been a part of a larger campaign.

109-111 TRANSIT CAMPAIGN | Ad Agency: Shine United
Art Director: Eric Cook | Client: Festival Foods | Creative Director: John Krull
Copywriter: James Breen | Photographer: Chris Hynes

Assignment: Increase awareness of Festival Foods via their top-of-the line fresh departments.

Approach: Festival Foods grocery stores make fresh products every day. Their talented team of bakers, butchers and deli chefs create hand crafted items. The outdoor campaign worked to highlight these fresh, better products in a bold and mouthwatering way.

Results: The outdoor ad campaign generated a significant increase in awareness of Festival Foods.

112-114 GOODWILL CRAFT YOUR LOOK CAMPAIGN | Ad Agency: Young & Laramore
Art Director: Carolyn Hadlock | Client: Goodwill of Central & Southern Indiana
Executive Creative Director: Carolyn Hadlock | Designer: Daniel Vuyovich
Writer: Charlie Hopper | Photographer: Polina Osherov

Assignment: To make Goodwill interesting to younger women who want to craft a "look."

Approach: To lend Goodwill fashion credibility, we partnered with Pattern, a national fashion magazine published in our city. Through them we found six designers and asked them to make clothing from Goodwill finds. We then staged a fashion photo shoot with the designer's outfits, and used those photos in ads and social media aimed at our target. Then we published an article in Pattern giving Goodwill the credit for inspiring the designers.

Results: 6.2M impressions overall. This is a lot for the local Goodwill, with nearly 10,000 landing page visits. Almost 5,000 verified store visits attributed to mobile marketing, which is a dramatic increase. The press took notice too, including extensive coverage of the campaign in Adweek, The Muse, and The Drum. Now, a lot of young women think of Goodwill as a resource for "fashion."

115 WE CAN BE THE LIFE SUPPORT SYSTEM FOR YOUR BRAND!
Ad Agency: Darkhorse Design, LLC | Art Director: Robert Talarczyk | Client: Self-Initiated
Assignment: Graphic Design Studio Promotion
Approach: Strategic Thinking & Design To Improve Your Brand
Results: Outcomes To Be Determined

116-118 USECONDOMS | Ad Agency: DarbyDarby Creative | Art Director: Keith L. Darby
Client: Self-Initiated | Copywriter: Keith L. Darby
Assignment: Implement a Business-to-Business direct mail campaign; an agency self-promotion that isn't self-serving.
Approach: Demonstrate our conceptual thinking by executing a Public Service Advertising (PSA) campaign. The "UseCondoms" campaign cleverly uses endearing terms and romantic images to promote the sometimes fatal risks of "not" using a condom.
Results: The PSA campaign brought awareness to an important issue and PSA as one our creative services.

119-121 HARDEN VOL. 3 | Ad Agency: adidas Global Brand Design
Art Director: Mark Dayao | Client: Self-Initiated | Design Directors: Eric Vellozzi, Mark Dayao
Senior Designer: Jonah Nolde | Designer: Ryan Schroeder
Illustrator/Designer: Corbin Portillo | Environmental Designer: Starch Creative
Project Manager: Jake Cham | Copywriter: Brian Hamilton
Photographers: Atiba Jefferson, Shaun Mendiola
Assignment: Create excitement for our consumer and communicate the story of how the Harden Vol. 3 was built to enhance James Harden's supernatural ability to slow down quickly and create space.
Approach: We brought this idea to life through different visual techniques - experimenting with photography, collage, illustration, time and motion to create a remixed reality that visually demonstrate one of Harden's most devastating moves on the court.
Results: We created a cross-platform campaign born from insights about James Harden's game with a bold, progressive creative direction designed to disrupt the basketball marketplace.
We expanded the concept of "SLOW DOWN FAST" through digital, social and retail executions.

122, 123 "THIS ISN'T ORDINARY. THIS IS SAVANNAH." CAMPAIGN
Ad Agency: Paradise Advertising | Art Director: Glenn Bowman | Client: Visit Savannah
Chief Strategy Officers: Barbara Karasek, Tom Merrick | Account Director: Rudy Webb
Copywriter: Tom Merrick | Photographer: Cade Martin
Assignment: Savannah, Georgia is considered one of America's "Bucket List" cities – a place you simply have to visit if you love to travel. It's a city so beautiful that even Sherman couldn't bring himself to destroy it in his 1864 March to the Sea, instead gifting it to President Lincoln as a Christmas present.
But Savannah's one-of-a-kind beauty is only part of the city's appeal. So Savannah's CVB turned to Paradise to create a campaign that captured and conveyed the true essence of their destination.
Approach: After spending time in the city and conducting extensive research with key stakeholders and longtime visitors, we realized that Savannah could be described in three adjectives: Authentic, Unexpected, and Evocative. We were surprised to discover that Savannah wasn't the genteel Southern city people expected it to be. It was elegant but unpredictable; classy but quirky; historic but hip. In other words, it was anything but ordinary. With that epiphany, the campaign came to life: This isn't ordinary. This is Savannah.
Results: Immediately upon presenting the campaign to the Visit Savannah CVB, the team stated they had the foundation for "Savannah 2.0" -- a sweeping new effort aimed at repositioning their destination in the minds of leisure and business travelers.
More importantly, after the first year of running the campaign, the destination saw upticks in every key travel and tourism metric: Occupany, ADR, and RevPAR increased every month on a year-over-year basis; overnight visitation was up by more than 2.5%; daytrip visitation was up by more than 3.3%; overall room tax revenue was $26.7 million in 2018 versus $25.5 million in 2017; average length of stay increased to 2.6 nights in 2018, as opposed to 2.4 in 2017; and direct visitor spending totaled $3.0 billion in 2018, a 3.1% increase over 2017.

124, 125 TELEGRAPHS | Ad Agency: Independent Copywriter | Art Director: Tom Riddle
Client: Telluride Summer Tourism | Creative Director: Tom Riddle | Copywriter: Colin Corcoran
Assignment: The objective was to re-position the ski town of Telluride, Colorado from a winter only destination to a summer spot boasting a variety of equally fun and relaxing warm-weather activities.
Approach: To utilize the old time telegraph's unique "Stop" language format to communicate to vacationers that they needed to start thinking about how to escape whatever routine rut(s) they were stuck in.
Results: Client requested results be kept confidential.

126 SHARK SNEAKER | Ad Agency: PPK, USA | Art Director: Trushar Patel
Client: The Florida Aquarium | President: Tom Kenney
Executive Creative Director: Dustin Tamilio | Creative Director: Michael Schillig
Associative Creative Director: Trushar Patel | Account Supervisor: Sarah Pierson
Copywriter: Michael Schillig

Assignment: Our assignment was to create a poster, print ad and social post that would welcome the Women's Final Four basketball teams to Tampa Bay. At the same time, we wanted to encourage them to visit the Aquarium and stress how close they could get to our many amazing sea creatures.
Approach: We gave a normal basketball sneaker some very distinctive shark features. We further played off the "foot" theme by emphasizing how you can get within a foot of over 8,000 captivating creatures.
Results: This eye-catching image was well-liked by the Aquarium marketing team. We were able to reach a sports-oriented audience in a fun way that they could really relate to and helped drive up attendance at the Aquarium while this Final Four tourney was in town.

127 SPRING BUTTERFLYFISH | Ad Agency: PPK, USA | Art Director: Trushar Patel
Client: The Florida Aquarium | Executive Creative Director: Dustin Tamilio
Creative Director: Michael Schillig | Associative Creative Director: Trushar Patel
President: Tom Kenney | Account Supervisor: Sarah Pierson | Copywriter: Michael Schillig
Assignment: Our assignment was to focus on the beauty of Spring and to use that as an over-arching theme to promote some fun Easter weekend activities at the Florida Aquarium.
Approach: We wanted to represent this Spring celebration of festivities in a visually compelling way – with a unique Aquarium twist. So, we created a truly distinctive butterfly, featuring wings formed out of multiple butterflyfish and then attached to a body of coral.
Results: The Florida Aquarium team thought the image really captured the essence of spring with an interesting aquarium spin on it. It led people to come out of their cocoon and experience the excitement.

128 SPRING IS IN THE SEA | Ad Agency: PPK, USA | Art Director: Trushar Patel
Client: The Florida Aquarium | Executive Creative Director: Dustin Tamilio
Creative Director: Michael Schillig | Associative Creative Director: Trushar Patel
President: Tom Kenney | Account Supervisor: Sarah Pierson | Copywriter: Michael Schillig
Assignment: Our assignment was to focus on the beauty of Spring and to use that as an over-arching theme to promote some fun Easter weekend activities at the Florida Aquarium.
Approach: We wanted to represent this Spring celebration of festivities in a visually dynamic way – with a unique Aquarium spin.
So, we created an eye-catching butterfly out of some colorful butterflyfish. Even using a piece of coral to form its body.
Results: The Florida Aquarium's marketing team thought the image was very clever. They liked how it captured the essence of Spring with the perfect Aquarium twist. All of which led to a very successful turnout.

SILVER PRINT WINNERS:
130 GENESIS HEAL THE BAY BEACH CLEAN UP DAY POSTERS
Ad Agency: INNOCEAN USA | Art Director: David Mesfin | Client: Genesis Motor America &
Heal The Bay | Executive Creative Director: Bob Rayburn | Account Director: Ivan Cevallos
Associative Creative Directors: David Mesfin & Chris DeNinno | Project Manager: Sara Little
Project Manager Supervisor: Maria Ortega | National Manager, Experiential: Kristi Hornickel
Art Buyer: Rachel Crain

130 ANT-ADS - THE TINIEST PRINT ADS IN THE MARVEL UNIVERSE
Ad Agency: INNOCEAN USA | Art Director: Christian Silva | Client: Hyundai Motor America
Print Producer: Charlles Osorio | Executive Creative Director: Barney Goldberg | Creative
Director: Ryan Scott | Associative Creative Director: Joe Reynoso | Senior Art Director: John
Turcios | Brand Director: Lester Perry | Account Manager: Tanner Ham | Copywriters: Alvaro
Soto & Robert Abasolo | Digital Artist: Konstantin Kozitsky

130 STURGIS F-BOMBS | Ad Agency: Camp3 | Art Directors: Colin Corcoran, Lindy Taylor
Client: Harley-Davidson | Creative Director: Tom Riddle | Copywriter: Colin Corcoran

131 ETE REMAN PRINT AD | Ad Agency: Disrupt Idea Co.
Art Director: Scott Baitinger | Client: ETE REMAN | Creative Director: Bill Kresse
Account Director: Greg Brown | Designer: Kris Ender

131 AVEDA CRUELTY-FREE HAIR AND SKINCARE GIFTS FOR THE HOLIDAYS
Ad Agency: Aveda Global Creative | Art Director: Shannon Grant | Client: Self-Initiated
Creative Director: Antoinette Beenders | Designer: Haley Crain
Other: Leana Less, Rachael Dillon, Al Mezo, Renee Valois, Amy Duhamel

131 MAKER'S MARK INTERNATIONAL WOMEN'S DAY INSTAGRAM STICKERS
Ad Agency: Doe Anderson | Art Director: Tim Ofcacek | Client: Beam Suntory/Maker's Mark
Chief Creative Officer: David Vawter | Copywriter: Natalie Weis

132 P.O.P.ULATION SIGNS | Ad Agency: Independent Copywriter
Art Directors: Colin Corcoran, Lindy Taylor | Client: The Gambrinus Company (Shiner Beers)
Chief Creative Officer: Joel Clement | Copywriter: Colin Corcoran

132 FRESH BREAD IS JUST THE START OOH CAMPAIGN
Ad Agency: The Hive Advertising | Art Director: Colin Corcoran | Client: Boudin
Creative Director: DeeAnn Budney | Copywriter: Colin Corcoran

132 THE GIFTED - SEASON 2 - "DUAL IMAGE CAMPAIGN" | Ad Agency: FBC Design
Art Director: Jason Schmidt | Client: Fox Entertainment

133 THE PASSAGE KEY ART | Ad Agency: FBC Design | Art Director: Phillip Bates
Client: Fox Entertainment | Creative Director: Mitchell Strausberg
Creative Group Head: Tom Morrissey | Copywriter: Art Machine

133 DOCTOR SLEEP - TEASER | Ad Agency: Cold Open
Art Director: Cold Open | Client: Warner Bros. Pictures

133 THE CURSE OF LA LLORONA | Ad Agency: Cold Open
Art Director: Cold Open | Client: Warner Bros. Pictures

133 COBRA KAI - SEASON 2 (COBRA) | Ad Agency: Cold Open
Art Director: Cold Open | Client: YouTube Originals

134 SYTYCD S16 KEY ART | Ad Agency: FBC Design
Art Director: Moises Cisneros | Client: Fox Entertainment

134 91ST OSCARS KEY ART | Ad Agency: Academy of Motion Picture Arts and Sciences
Art Director: Ford Oelman | Client: Self-Initiated | Creative Director: Ford Oelman
Designers: Brendan Baz, Mandy Eastley, Kaylynn Sheets
Design Manager: Drayton Benedict | Assistant: Kidist Mekonnen

134 DEADWOOD - TEASER | Ad Agency: Cold Open
Art Director: Cold Open | Client: HBO

134 THIS GIANT BEAST THAT IS THE GLOBAL ECONOMY | Ad Agency: Cold Open
Art Director: Cold Open | Client: Amazon Studios

135 THE AFTER PARTY | Ad Agency: Cold Open
Art Director: Cold Open | Client: Netflix

135 COBRA KAI - SEASON 2 | Ad Agency: Cold Open
Art Director: Cold Open | Client: YouTube Originals

135 PITCH KEY ART | Ad Agency: FBC Design | Art Director: Phillip Bates
Client: Fox Entertainment | Creative Director: Mitchell Strausberg
Creative Group Head: Tom Morrissey | Photographer: Warwick Saint | Copywriter: Amanda Raymond

135 THE DIRT | Ad Agency: Cold Open
Art Director: Cold Open | Client: Netflix

136, 137 9-1-1 SEASON 2 KEY ART – "MARRY ME" | Ad Agency: Art Machine
Art Director: Art Machine | Client: Fox Entertainment

136 SHOPKO SPECIAL EVENTS POSTERS | Ad Agency: Disrupt Idea Co. | Art Director:
Bill Kresse | Client: Shopko | Creative Director: Bill Kresse | Account Director: Greg Brown

137 SEA TURTLE SOUR CONSERVATION BEER | Ad Agency: PPK, USA
Art Director: Xavier Rivera | Client: The Florida Aquarium | President: Tom Kenney
Executive Creative Director: Dustin Tamilio | Creative Director: Michael Schillig
Associative Creative Director: Trushar Patel | Assistant Account Executive: Brenna Wenger
Account Supervisor: Sarah Pierson | Copywriter: Michael Schillig

137 SAND TIGER STOUT CONSERVATION BEER | Ad Agency: PPK, USA
Art Director: Xavier Rivera | Client: The Florida Aquarium | President: Tom Kenney
Executive Creative Director: Dustin Tamilio | Creative Director: Michael Schillig
Associative Creative Director: Trushar Patel | Assistant Account Executive: Brenna Wenger
Account Supervisor: Sarah Pierson | Copywriter: Michael Schillig

138 BLUE COLLAR SALUTE CAMPAIGN | Ad Agency: Colle + McVoy
Art Director: John Berends | Client: Red Wing Shoe Company
Creative Director: Dave Keepper | Copywriter: Colin Corcoran

138 MOLLYWOOD MOVIE TITLE AND POSTER | Ad Agency: Disrupt Idea Co.
Art Director: Scott Baitinger | Client: Mollywood | Creative Director: Bill Kresse

138, 139 GROW YOUR COMMUNITY | Ad Agency: WONGDOODY
Art Directors: Pam Fujimoto, Boone Sommerfeld | Client: Sound Credit Union
Studio: Jason Hall | Senior Producer: Carrie Blocher | Creative Director: Jennie Moore

139 SAUCE LIKE YOU MEAN IT | Ad Agency: Creative Energy
Art Director: Hannah Howard | Client: Texas Pete Hot Sauce
Creative Director: Greg Nobles | Account Executive: Trinity Lancaster

139 METAL GEAR SOLID V: GROUND ZEROES PROLOGUE POSTER
Ad Agency: Ayzenberg | Art Director: Colin Corcoran
Client: Konami / Kojima Productions (Metal Gear Solid V: Ground Zeroes)
Creative Director: Colin Corcoran | Designer: Fern Espinoza | Copywriter: Colin Corcoran

140 VOTE | Ad Agency: Genaro Design, LLC | Art Director: Genaro Solis Rivero
Client: VOTE-VOTE | Designer: Christopher Castillo

140 TRANE RELENTLESS TESTING PRINT | Ad Agency: Young & Laramore
Art Director: Dan Shearin | Client: Trane | Executive Creative Director: Carolyn Hadlock
Director: Joe Wright | Writer: Deidre Lichty | Group Creative Director: Bryan Judkins
Director of Photography: Peter Konczal

140 POWERFULLY SMALL | Ad Agency: Shine United | Art Directors: Eric Cook, John Krull
Client: Surefire | Creative Director: John Krull | Copywriter: Theo Harris

140 AMERICAN STANDARD BETTER PROBLEMS PRINT | Ad Agency: Young & Laramore
Art Director: Zac Neulieb | Client: American Standard
Executive Creative Director: Carolyn Hadlock | Creative Director: Scott King
Group Creative Director: Bryan Judkins | Photographer: Saverio Truglia | Writer: Deidre Lichty

141 PARKER VECTOR / HISTORY IN YOUR POCKET | Ad Agency: Curious Productions
Art Director: John Fairley | Client: Luxor Writing Instruments Pvt. | Studio: Dan Murray
Head of Production: Tom Gibson | Agency Producer: Chloe Cunningham
Creative Director: John Fairley | Account Director: David Norman
Photographer: Dan Humphreys | Copywriter: John Fairley | Photo Retouching: Rob Lanario

141 GANDY COUCH POTATO AD | Ad Agency: Ag Creative Group
Art Director: Stewart Jung | Client: Gandy Installation | Account Manager: Dave Ancrum

141 FIXED IN A JIFFY LUBE | Ad Agency: un/common | Art Director: David Hadley
Client: Jiffy Lube, Broadbase, Inc. | Chief Marketing Officer: Matt Graham
Chief Creative Officer: Brantley Payne

142 COURAGE TO WIN | Ad Agency: Traction Factory | Art Director: Kristina Karlen
Client: ALS Association Wisconsin Chapter | Executive Creative Director: Peter Bell
Account Director: Shannon Egan | Account Executive: Whitney Marshall
Copywriter: Steve Barlament

142 VOGLWALPOLE 'SWEDISH' | Ad Agency: Roger Archbold
Art Director: Roger Archbold | Client: Voglwalpole | Copywriter: Roger Archbold

142 ONION NEWSPAPER MINI-POSTER INSERT CAMPAIGN
Ad Agency: Independent Copywriter | Art Director: Colin Corcoran
Client: Restaurant Miami - 80's Dining Room & Speakeasy | Creative Director: Colin Corcoran
Copywriter: Colin Corcoran

142 C WHAT'S POSSIBLE PRINT CAMPAIGN | Ad Agency: Phenomenon
Art Director: Colin Corcoran | Client: CB2 | Copywriters: Colin Corcoran, Tom Riddle

143 LENTICULAR KISS | Ad Agency: Craig Bromley Photography
Art Director: Craig Bromley | Client: Self-Initiated | Models: Ivana and James

143 NEW AGENCY IDENTITY | Ad Agency: Creative Energy
Art Director: Dale Atkinson | Client: Self-Initiated | Co-Founder: Tony Treadway

144 SIMPLY BEAUTIFUL 1 | Ad Agency: Independent Copywriter | Art Director: Tom Riddle
Client: K-Swiss | Creative Director: Tom Riddle | Copywriter: Colin Corcoran

144 SIMPLY BEAUTIFUL 2 | Ad Agency: Independent Copywriter | Art Director: Tom Riddle
Client: K-Swiss | Creative Director: Tom Riddle | Copywriter: Colin Corcoran

145 OWNERSHIP FIRESALE WILD POSTINGS CAMPAIGN
Ad Agency: Independent Copywriter | Art Director: Colin Corcoran
Client: Non-Passive Aggressive Timberwolves Fans | Creative Directors: Colin Corcoran, Dave Damman | Copywriters: Dave Damman, Colin Corcoran

145 BALANCED REASONING 8508 PRINT CAMPAIGN | Ad Agency: Independent
Copywriter | Art Director: Tom Riddle | Client: New Balance
Creative Director: Tom Riddle | Copywriter: Colin Corcoran

145 RAMS TO THE BONE | Ad Agency: WONGDOODY | Art Director: Hunter Carr
Client: Cedars-Sinai | Studio: CJ Cantara | Senior Producer: Amy C. Wise
Account Supervisor: Michael Delgado | Copywriter: Drew Weber

145 MAN MONTAGE | Ad Agency: Independent Copywriter | Art Director: Tom Riddle
Client: VS. (Versus) Network | Creative Director: Tom Riddle | Copywriter: Colin Corcoran

146 "IN THE RIVER CITY" | Ad Agency: Karnes Coffey Design | Art Directors:
Christine Coffey, Jamie Mahoney | Client: Richmond Ballet | Photographer: Tom Maher
Digital Artist: Alice Blue (featuring Lena Pigareva) | Wardrobe: Richmond Ballet (Emily Morgan)

146 UC BERKELEY TDPS 2018–19 PERFORMANCE SEASON ART | Ad Agency: L.S.
Boldsmith | Art Director: Leila Singleton | Client: University of California, Berkeley —
Department of Theater, Dance & Performance Studies | Illustrator/Designer: Leila Singleton

146 CATCH THE #BEECHLIFE | Ad Agency: Creative Energy
Art Director: Joe Schnellmann | Client: Beech Mountain Resort
Executive Creative Director: Will Griffith | Account Executive: Jessica Lambert

PLATINUM VIDEOS WINNERS:
148,149 THE SLOWEST ART WE'VE EVER BUILT | Company: Audi USA
Client: Audi of America | Artist: Fabian Oefner | Director: Nicholas Kleczewski
Creative Director: Nicholas Kleczewski | Director of Photography: Stuart Holt
Producer: Stacy Murphy | Advertising Agency: Audi KreativWerk | Production Company: Tilt

Assignment: There wasn't one per se. I just knew that the 10 year anniversary of the V10 engine in the R8 was coming and was thinking of ideas on how to celebrate. A friend showed me Fabian's work with his and I knew right away it was something to pursue.

Approach: Once I had Fabian on board to let him do his great work, I thought about how I wanted to capture it. Being it was a 10 year anniversary, there happened to be a 10-year-old original spot for the same car that is one of my favorite car commercials of all-time. That spot called "The slowest car we've ever built" romances the building of an R8 that's all done by hand and takes about 7 days to do. I knew our project would be the exact inverse of that process so I thought it would be cool to do an homage to that original spot. Music played a major role in the feel of that spot so I actually got the original artist to re-record the song as a new version we worked on together and began work on what was the final piece. The most important reason to even do the content piece was I knew people would see the final poster and just say, "Oh, that's just CG or a little Photoshop job," and it would be written off as fake. I needed people to understand, no, this crazy guy painstakingly takes every single piece apart and meticulously photographs them all and reassembles it in his vision. This process is hardcore. I wanted to make sure people felt and appreciated what Fabian does. I hope it did provide at least some justice.

Results: Well I can tell you that the first one of the posters sold out in literal minutes, which was entirely unexpected. I think even some six months on they've had trouble keeping up with demand. Audi Germany was proud of the work and it's been seen more globally than I ever expected. Hopefully a larger piece of the world got to appreciate

150, 151 INFINITI STYLING ACCESSORIES VIDEO | Ad Agency: The Designory
Art Director: Bryan Kestell | Client: Infiniti USA | Jeff Ludes | Producer: Brenda Liz
Creative Director: Chad Weiss | Associative Creative Director: Jesse Echon | Project Manager:
Christine Oliva | Account Manager: Meagan Smith | Copywriter: Terry Orsland

Assignment: Infiniti was looking for authenticity and a sense of the real-world application of accessories. They were also launching a new brand platform meant to demonstrate that luxury can be in sync with real life.

Approach: Designory developed video artfully shot in stills to capture the real-world moments when accessories make a difference, using a "reportage" style with attention to the subtle cues of real life.

Results: The small subdivision of Infiniti has led the visual reinvention of the brand in the US, with the content quickly getting repurposed for the mainstream marketing.

152, 153 LONG DISTANCE | Ad Agency: INNOCEAN USA | Art Director: Jamin Duncan
Client: Hyundai Motor America | Director: Dave Laden, Bryan Buckley
Head of Production: Nicolette Spencer | Executive Producer: Brandon Boerner
Producers: Melissa Moore, Celestina Lucero | Executive Creative Director: Barney Goldberg
Creative Director: Ryan Scott | Group Creative Director: Jeff Bossin

Associative Creative Director: David Lord | Director of Photography: Scott Henriksen
Group Brand Director: Jamin Duncan | Managing Director, Brand Management: Marisstella Marinkovic | Account Director: Bryan DiBiagio | Account Manager: Megan Gordon
Copywriter: Marcin Markiewicz | Strategy: Kimberly Bates

Assignment: We wanted to introduce Hyundai's "My Hyundai" app in a big way. And what's bigger than space? The fun thing is, you could actually unlock your car from space with this app, if you happen to be in space. Which is exactly where our astronaut finds herself. And lucky for her husband, she's got her Hyundai app handy to help him out.

Approach: As we read a loving husband's texts of "I miss you" to his wife who is away for work, James Vincent McMorrow's cover of "Higher Love" really helps build the tender feelings they share. However, we soon discover that his loving texts are actually a request for her to unlock his car from outer space using the "My Hyundai" app on her phone. That's where the meaning of the song, "Higher Love" changes from a love ballad to a requirement for patience as an astronaut who is in the middle of her spacewalk is interrupted so that she can unlock his car. Now that's the definition of higher love.

Results: A lonely husband is missing his wife while she is away for work. He texts her a loving message, "I miss you". We cut to the wife, an astronaut, in space on her "work trip." The husband's text interrupts her spacewalk but she takes the time to respond to his loving message. We soon discover that the husband's loving texts are a clever way for him to ask for her help unlocking his car. He has locked his keys in the car and needs her to use the "My Hyundai" app on her phone to unlock his car door. Which is something you could do if you happen to have that app on your phone, even in space. Steve Winwood's song, "Higher Love" is a 1980s American classic. The meaning of higher love both in the context of literally being higher (in space), and the love between a husband and wife fit nicely for this spot. The original song has an 80s vibe to it, so we picked McMorrow's recent cover of the song to give the spot a more contemporary and sentimental feel while keeping the meaning of the original lyrics. By the end of the spot, you could feel the astronaut's higher love for her husband when she helps him fix his mistake even though it's interrupting her far more important spacewalk.

154, 155 DO GIVE | Ad Agency: PPK, USA | Art Director: Trushar Patel
Client: National Pediatric Cancer Foundation | President: Tom Kenney
Executive Creative Director: Dustin Tamilio | Creative Director: Michael Schillig
Director: Chanse Chanthalansy | Producer: Lauren Houlberg
Associative Creative Director: Trushar Patel | Account Director: Jess Vahsholtz
Assistant Account Executive: Brenna Wenger | Account Supervisor: Elizabeth Knight
Editors: Amanda Schreiber, Melissa Reichert, Chanse Chanthalansy
Copywriter: Michael Schillig | Animator: San Nguyen | Recording Engineer: Mike Lessard
Music & Sound: Roger Hughes | Production Company: Contender Production Studios, LLC

Assignment: The National Pediatric Cancer Foundation wanted us to create a video that would be driven by kids who are battling cancer and stress how the NPCF funds collaborative research nationwide to fast track a cure. We wanted to pull at the heart strings and "DO" whatever we could to get people to donate.

Approach: Our goal was to create a very dramatic and touching video that would show different children's brave fights against cancer and how truly beautiful their courage is. To accomplish this, we used real kids (not actors) who were actually undergoing chemotherapy treatments during the filming of the video. Additionally, we wanted to convey how the NPCF is collaborating with hospitals across the nation to fast track less-toxic, more targeted treatments that are saving many kids' lives.

Results: This heartfelt spot was very well-received by the National Pediatric Cancer Foundation's marketing team. It was first unveiled at Fashion Funds The Cure in Tampa Bay and helped the NPCF surpass all their fundraising goals at this event. They will continue to play this video at various fundraising events, which they host all over the country to gain more support and donations for the kids.

156, 157 ONLY YOU FYBECA | Ad Agency: daDá | Art Director: david chandi
Client: Fybeca | Chief Creative Director: Willian Franco // Orlando Vega

158, 159 PLATEAU | Ad Agency: Duncan Channon | Art Directors: Michael Lemme, Steve Couture | Client: Upwork | Senior Producers: Rita Ribera Channon, Keenan Hemje
Associate Producer: Emily Sarale | Strategy Director: Kelleen Peckham
Account Director: Nick Gustafson | Project Manager: Rosheila Robles | Account Management: Mary Beth Carroll, Sydney McComas, Jamie Katz | Copywriter: Rick Herrera

Assignment: Upwork is a global network of freelance talent. Our challenge was to inspire middle managers in need of help to see the site as much more than some indiscriminate mob of freelancers from here, there and everywhere, but rather a unified movement of motivated people — freelancers and managers alike — here to roll up collective sleeves and make stuff happen.

Approach: The spots portrayed an experience familiar to us all in the workaday world: when the moment of "oh shit, how am I going to get this done?" occurs, after an ambitious goal or daunting project lands on our desk. In a colorful, quirky world that's hip to Upwork's freelance platform, managers transform their nagging anxiety into the thrill of making things happen.

Results: Compared to earlier campaigns, the ad dramatically increased site visits and generated record signups among first-time corporate users.

160,161 BUTCHER | Ad Agency: Shine United
Art Director: Eric Cook | Client: Festival Foods | Production Company: Circle Pictures
Director: Carlo "Vinnie" Besasie | Producer: Sue Karpfinger
Associative Creative Directors: Joe Ban, James Breen | Copywriter: James Breen
Director of Photography: Mike Gillis | Food Stylist: Nancy Froncek

Assignment: Increase awareness of Festival Foods via their one of their core, top-of-the line fresh departments: the Meat & Seafood department.

Approach: Festival Foods grocery stores are committed to serving the best and freshest meat and seafood. The talented team of butchers cut and hand-trim products daily. The TV spot worked to highlight these fresh, better products in a bold and mouthwatering way.

Results: The TV spot had effective recognition and recall in research.

GOLD VIDEOS WINNERS:
162 LA NUEVA POTENCIA CHINA ES BAIC | Ad Agency: daDá
Art Director: david chandi | Client: Baic Ecuador | Agency Producer: vertigo films
Chief Creative Directors: Willian Franco & Orlando Vega

Assignment: Lanzamiento de la nueva marca de automóviles chinos en Ecuador, resaltamos las características al máximo.

Approach: Lanzamiento dela campaña "La nueva potencia China es Baic", entra al mercado Ecuatoriano, resaltando sus atributos y con un elemento adicional un personaje 100% tecnológico que lleva la marca al fututo.

Results: Los resultados los vemos tangibilizados en conocimiento de la marca y en ventas, en menos de un año logramos estar dentro de los 4 primeros en participación de mercado con respecto a autos chinos, siemdo ya una de las mejores marcas a nivel nacional.

162 ELEVATOR | Ad Agency: INNOCEAN USA | Art Director: Brook Boley
Client: Hyundai Motor America | Head of Production: Nicolette Spencer
Executive Creative Director: Barney Goldberg | Creative Director: Ryan Scott | Associative Creative Directors: Brook Boley, Carrie Talick | Group Creative Director: Jeff Bossin
Senior Producer: Melissa Moore | Producer: Devondra Dominguez | Strategy Director: Kimberly Bates | Account Executive: Angela Zepeda | Account Director: Bryan DiBiagio
Account Manager: Christy Butler | Account Management: Mike Braue

Assignment: Most people hate car shopping. In a poll, car shopping ranked right alongside other joyless duties like doing taxes. Common complaints were how long the process took, how confusing pricing could be, the inconvenience of test drives, and buyer's remorse.
Hyundai Shopper Assurance, however, was created to change the way people shop for cars. Our job was to change everything people thought they knew, and hated, about car shopping.

Approach: In this film, our hero couple sets out on a car shopping mission that turns out to be an unlikely journey to some of the most dreaded experiences in life, including regular car shopping.
Inspired by Dante's Inferno, our hero couple find themselves on an elevator descending to increasingly hellish floors, operated by a friendly host to the other hapless riders. Our hero couple clarifies that they used Hyundai's new program, which sends the elevator rocketing back up to the car shopping experience of their dreams.

Results: We garnered the title of #1 Auto in USA Today Ad Meter and #4 Overall in USA Today Ad Meter. The film has 55M views and counting. There was an 1000% increase in website traffic and 521K engagements.

163 2019 NISSAN INTELLIGENT MOBILITY | Ad Agency: The Designory
Art Director: Traci Gohata | Client: Nissan | Creative Directors: Carol Fukunaga, Meg Crabtree
Associative Creative Directors: Scott Goldenberg, Traci Gohata
Senior Art Director: Herman Chaneco | Account Director: Scott Fortenberry
Account Manager: Nastrin Crump | Editor: Julia Bute | Animators: Dark Matter

Assignment: Create an informative and exciting video to explain the pillars of Nissan Intelligent Mobility. This is a differentiating brand offering that encompasses driver assistance features, connectivity in your vehicle and to the world around you, and the exciting future of electric vehicles.

Approach: This video seamlessly integrates new, pickup, and stock footage as well as a 3D animated world. Quick cuts and an energetic soundtrack add to the bold and techy feel.

Results: This video was used in the Nissan showrooms and on the website to help explain Nissan Intelligent Mobility. It was used for internal distribution to all company employees.

163 ESCAPE | Ad Agency: INNOCEAN USA | Art Director: Christian Silva | Client: Hyundai Motor Company | Head of Production: Nicolette Spencer | Director: RESET - Joseph Kosinski
Senior Producer: Kira Linton | Associate Producer: Devondra Dominguez
Executive Creative Director: Barney Goldberg | Creative Director: Ryan Scott
Associative Creative Director: Joe Reynoso | Director of Photography: RESET - Claudio Miranda | Project Management Supervisor: Suzanne Cheng | Account Director: Lester Perry
Account Manager: Alison O'Neill | Copywriter: Alvaro Soto

Assignment: Marketing a car to a core demographic group that hates being targeted by marketing presents special challenges. But the chance to feature the Hyundai Veloster in Ant-Man and the Wasp, a feature film with the same millennial target audience, provided the perfect solution. As the hero vehicle in the movie's action-packed chase scene, the Veloster integrated seamlessly into the storyline, giving Hyundai instant credibility with the audience — without feeling forced or contrived. That the Veloster shared Ant-Man's size-shifting ability also granted us

license to create our "Ant Ad" campaign, including TV spots and online videos featuring tiny, ant-sized Hyundais.

Approach: Menacing clouds darken the sky as two Hyundai SUVs speed through an apocalyptic desert scene, trying to escape a billowing sandstorm. Random debris blows past them. Strange objects appear suddenly from the dusty haze — an oversized can, a dried-up leaf.

No problem, the well-equipped Hyundai vehicles dodge and dart past every obstacle with precision and power. But this is no ordinary desert. In fact, it's not a desert at all.

The camera pulls back to reveal a street sweeper cleaning a quiet, residential street. Rather than actual-size cars, the Hyundai vehicles are tiny "ant-sized" replicas trying to outrun the dust and debris kicked up by the street sweeper brushes in the gutter. The spot transitions to a high-action, driving sequence from Ant-Man and the Wasp featuring a Veloster and SUV the partnership between Hyundai and the Marvel Universe defined, the connection clearly made.

Results: We garnered a 77% increase in Brand Sentiment, an 88% increase in social mentions, an 150% increase in dealership traffic, 46 million campaign impressions, a 10% increase in sales, a 106 spike in Veloster mentions, and a 785% increase in Hyundai Drive App installations. The video obtained 46M views online, as well as 900K livestream views with Hyundai sponsorships.

164 2019 NISSAN ALTIMA ALL-WHEEL DRIVE | Ad Agency: The Designory
Art Director: Jared Boyle | Client: Nissan | Director: Tim Damon
Chief Creative Officer: Lynne Grigg | Creative Directors: Carol Fukunaga, Meg Crabtree
Senior Art Director: Herman Chaneco | Account Director: Scott Fortenberry
Account Manager: Meg Richie | Editor: Don Andrews | Copywriter: Moris Machuca

Assignment: Create an informative video to explain the new Nissan Altima Intelligent All-wheel drive system. This is the first Nissan sedan to offer all-wheel drive, so we also wanted to build awareness.

Approach: To create a dramatic scene that could also be a canvas for supporting motion graphics, we shot at night on a flooded testing pad. We used several cameras and incorporated slow motion to capture fans of water spraying out and to emphasize Altima's control in compromised conditions. The video was used on multiple platforms including web site, digital brochures, and YouTube.

Results: The video was used on multiple platforms including web site, digital brochures, and YouTube.

164 DAD, LOOK | Ad Agency: INNOCEAN USA | Art Directors: John Turcios/Tricia Ting
Client: Hyundai Motor America | Director: MJZ - Craig Gillespie
Senior Producer: Melissa Moore | Executive Producer: Nicolette Spencer
Producer: Stephen Estrada | Executive Creative Director: Barney Goldberg
Creative Director: Ryan Scott | Associative Creative Directors: Chris Lynch/Brad Beerbohm
Managing Director: Angela Zepeda | Director of Photography: MJZ - Stuart Graham
Account Executive: Mike Braue | Account Director: Alix Harrisson
Account Manager: Stephanie Yetter | Account Management: Alison O'Neill

Assignment: At a time when families are finding it more difficult than ever to spend quality time together, Hyundai positioned the Santa Fe as the SUV with all the capabilities and features to help families reconnect.

Approach: As the second act for the "Year of the SUV," Innocean crafted an integrated campaign launching their all-new Santa Fe that focuses on a family spending quality time together.

On top of creating awareness that Hyundai offers quality SUVs, creative also highlighted industry first (and life-saving) safety features like "Safe Exit Assist," and the capability of the all-new Santa Fe thanks to the advanced HTRAC AWD.

In "Dad, look" we follow a family sharing experiences together on a road trip. As with most young boys, along the way the son seeks to impress dad with a new discovery or courageous feat. In the end dad, turns the tables on his son teaching him a lesson in the process thanks to the Santa Fe's Safe Exit Assist feature.

Results: We surpassed September and October monthly sales objectives, as well as exceeded sales goals for both months for all SUVs We ranked 3rd overall in 2018 for Relevance (of 275+ ads in non-lux category)

For organic social content: 55.6K Social Mentions (+34% higher than fab five average), YouTube Avg % Viewed (+76% above average), people viewed a higher percent of Santa Fe videos on Facebook (+418% above platform average), Twitter content had a +6.78% higher Engagement Rate, and a +3.27% higher VCR, compared to platform avg. We also obtained an extremely strong engagement: OR of 19.19% and CTOR of 57.67% (over 7 times the industry average and one of the highest CTOR rates of any HMA CRM campaign).

165 INFINITI CARGO ACCESSORIES VIDEO | Ad Agency: The Designory
Art Director: Bryan Kestell | Client: Infiniti USA | Producer: Brenda Liz
Creative Director: Chad Weiss | Associative Creative Director: Jesse Echon
Director of Photography: Jeff Ludes | Project Manager: Christine Oliva
Account Management: Meagan Smith | Copywriter: Terry Orsland

Assignment: Infiniti was looking for authenticity and a sense of the real-world application of accessories. They were also launching a new brand platform meant to demonstrate that luxury can be in sync with real life.

Approach: Designory developed video artfully shot in stills to capture the real-world moments when accessories make a difference, using a "reportage" style with attention to the subtle cues of real life.

Results: The small subdivision of Infiniti has led the visual reinvention of the brand in the US, with the content quickly getting repurposed for the mainstream marketing.

165 ROLLS-ROYCE GHOST — BRIDGE | Ad Agency: Curious Productions
Art Director: John Fairley | Client: Rolls-Royce Motor Cars Limited
Agency Producer: Tom Gibson | Creative Director: John Fairley
Account Director: Lee Sands | Digital Artists: James Gardner, Christopher Veitch
Animators: James Gardner, Christopher Veitch | Retoucher: Gary Marshall

Assignment: The assignment was to create a piece of moving content for use across all international advertising media channels and to create brand awareness for Rolls-Royce Ghost.

Approach: With a name like Ghost, we wanted to create a piece of work for Rolls-Royce that felt other-worldly.

We decided to devise the piece in-house using CGI animation to create an environment that gave the visual impression that the car was travelling in a supernatural world. The ethereal bridge Ghost journey's across adds to this mystical dimension.

Results: The piece has gone on to become the most successfully viewed film on the official Rolls-Royce Instagram channel (rollsroycecars) with over 623,000+ views and 1,000+ favorable comments. Images from the film have been used in print and POS globally.

166 MAKER'S MARK VIRTUAL REALITY GAME | Ad Agency: Doe Anderson
Art Director: Kevin Price | Client: Beam Suntory/Maker's Mark
Director: James Boty - Picasso Pictures | Producer: Richard Price - Picasso Pictures
Agency Producer: Delane Wise | Chief Creative Officer: David Vawter
Implementation Manager: Matt Karaffa | Developer: Jerrod Long
Digital Arts & Multimedia: Jay Boone & Brandon Radford

Assignment: Give customers and prospects a tangible sense of what it's like down at the Maker's Mark distillery, home of America's original handcrafted bourbon.

Approach: We created a literally immersive HD 3D experience that allowed players to virtually dip their own bottle of Maker's in the iconic red wax at the instructions of Maker's Chairman Emeritus Bill Samuels, Jr.

Results: The game created excitement, laughter and long lines everywhere we've brought it as part of our mobile distillery experience.

166 MASS HYSTERIA | Ad Agency: PPK, USA
Art Directors: Xavier Rivera, Trushar Patel | Client: Wichita Brewing Company
Production Company: Contender Production Studios, LLC | President: Tom Kenney
Director: Chanse Chanthalansy | Producer: Lauren Houlberg
Executive Creative Director: Dustin Tamilio | Creative Director: Michael Schillig
Associative Creative Director: Trushar Patel | Assistant Account Executive: David Phillips
Account Director: Jess Vahsholtz | Editors: Amanda Schreiber, Melissa Reichert
Copywriter: Michael Schillig | Animator: San Nguyen | Recording Engineer: Mike Lessard
Music and Sound: Roger Hughes | Voice Talent: Aldon Dodds

Assignment: Wichita Brewing Company has a special seasonal beer called Mass Hysteria. They typically launch it around Halloween and promote it throughout the fall/winter season. We were tasked with creating a social video for them on a very limited budget to hype this beer that is considered "scary good."

Approach: We played off the name of the beer and literally demonstrated how running out of Mass Hysteria beer can create mass hysteria. Since we didn't have much of a budget to work with, we used our own employees in the spot and paid them with beer. Needless to say, everyone had a screaming good time.

Results: Wichita Brewing Company appreciated the ear-catching humor, which definitely caught people's attention and helped drive sales of this seasonal beer. We're also happy to report that Mass Hysteria sold out in only a couple months.

167 HOW TO MAKE THE PERFECT FOUR PILLARS G&T | Ad Agency: Interweave Group
Art Directors: Darren Song, Daniel Cookson | Client: Four Pillars Gin
Agency Producer: Carly Bojadziski | Creative Director: Daniel Cookson
Directors of Photography: David Ellis, Tooth & Claw | Stylist: Marsha Golemac | Music and
Sound: Andrew McGrath, Soundwaves | Brand Strategy: Matt Jones, Four Pillars Gin
Client Support: James Irvine, Creative Director of Gin Drinks, Lucy McGinley, Senior Designer

Assignment: Four Pillars Gin—Australia's leading craft gin maker—set the challenge to create a seasonal campaign, positioning the iconic Four Pillars gin and tonic (featuring the distinctive Four Pillars orange garnish) as the seminal drink of the Summer.

Approach: The resulting campaign was a celebration of classic Australian Summers, modern Australian Gin and the humble orange. The poster series depicted surrealist modern collages featuring iconic Australian landmarks, comprised of vintage imagery and overlaid with a dynamically displaced typographic treatment—all working in perfect harmony, just like the ingredients in the drink of summer—a Four Pillars G&T.

Results: The brand impact was startling. The campaign deeply connecting with the desired audiences, with the results showing significant lifts in all key metrics for Four Pillars Gin—including a 34% increase in Ad recall, a 33% increase in Brand awareness and a 17% lift in Brand preference.

167 HONORE PORT FILM | Ad Agency: Omdesign
Art Director: Diogo Gama Rocha | Client: Quinta do Crasto

Assignment: To mark more than 400 years of history of Quinta do Crasto, an emblematic estate from Douro with wines recognized worldwide, Omdesign created and produced the conceptual film "Honore Port".

Approach: In little more than 5 minutes, it is shown all the history and essence of this unique Douro estate. This film is a tribute to Quinta do Crasto's founder, Constantino de Almeida, who always defended the motto "Honore et Labore" (honour and work) and it also aims to pay homage to all those that, since 1615, invested in cultivating the vineyards and creating unique authentic wines, as Honore Port that we can see in this film.

Results: To Omdesign, the challenge was to create an emotional and highly engaging film, that celebrates more than 400 years of Quinta do Crasto's history and one century on the hands of the same family, that is able to care and perpetuate remarkable wines as Honore Port, a highly luxurious special edition, also created and produced by Omdesign, limited to 400 bottles of a very old Tawny Port with more than 100 years.

168 REAL WISHES DO COME TRUE | Ad Agency: Saatchi & Saatchi Sofia
Art Director: Martina Solakova | Client: A1 Bulgaria | Director: Dragomir Sholev
Producer: Valeria Stefanova (Matchpoint) | Creative Director: Radomir Ivanov
Director of Photography: Krum Rodriguez | Account Director: Eleonora Chervenkova
Account Executive: Damyana Gencheva | Account Manager: Nevena Todorova
Copywriter: Petar Pacholov

Assignment: In 2018, the first mobile provider and biggest telecom in Bulgaria completed its rebranding process becoming A1. Our task was to make people understand what A1 stands for in the context of Christmas.

Approach: Christmas is about spending more time with our loved ones, but when the time comes we often spend more time in the shopping malls, wondering about "the perfect gift." We have forgotten those special moments and experiences we create with and for the ones we love. Christmas is all about the connection, which is not just being in the same place, but being together; not just hearing, but listening to each other. When there's connection, it is then that wishes really do come true. We reminded people that the best gifts for Christmas are not things at all.

Results: The ad series scored the highest ad liking results in the brand's history (since 2015) - both ads received 80% ad liking. The ad series performed better than the average in all indicators: Good brand feeling, Enjoyment, Appeal, Originality, Credibility, Brand fit and Motivation. Although it was planned as an image campaign, it even managed to increase sales with 3% in mobile and 15% in fixed services (compared to the last year's period).

168 THE RIDE | Ad Agency: Shine United | Art Director: Michael Kriefski
Client: The Ride | Executive Producer: Tom Kermgard Creative Director: Michael Kriefski
Senior Producer: Justin Johnson | Copywriter: Theo Harris
Director of Photography: Jack Whaley | Editors: Nick VanEgeren, Chris Dabner

Assignment: Increase awareness of The Ride's annual bike ride to ultimately increase ridership and donations.

Approach: Cancer is an ugly disease that touches many of people whom we know and lives of people whom we don't. No matter people's relationship to cancer, we're all committed to the same fight: to end it. Shine United captured the need for cancer research funding by encouraging people to rally their communities together, in order to accomplish an extraordinary feat.

Results: The Ride is entering the 2019 event pacing ahead of 2018's participant and donation benchmarks. Specifically, the event is trending ahead by nearly 125 riders and has seen an 18.6 percent donation increase.

169 PHILANTHROPIST — TEA TIME | Ad Agency: PPK, USA | Art Director: Trushar Patel
Client: GTE Financial | Production Company: Contender Production Studios, LLC
President: Tom Kenney | Director: Chanse Chanthalansy | Producer: Christine Allen
Executive Creative Director: Dustin Tamilio | Creative Director: Michael Schillig
Associative Creative Director: Trushar Patel | Production Manager: Lauren Houlberg
Account Director: Rey Futch | Account Executive: Jessica Anthony
Editors: Melissa Reichert, Chanse Chanthalansy | Copywriter: Michael Schillig
Animator: San Nguyen | Recording Engineer: Mike Lessard | Music and Sound: Roger Hughes

Assignment: GTE Financial wanted us to create a series of quirky and impactful 15-second TV spots on a limited budget that would reflect their theme line of "going beyond money." They wanted to make people aware of all the monies they donated to local charities last year and how you can be a philanthropist too just by banking with GTE.

Approach: This was one of three 15-second spots in a campaign in which we emphasized how, as a not for profit credit union, GTE Financial donated over $610,000 to local charities. In this particular spot, our main character acts like a high society philanthropist having tea in his study until it's revealed that he's actually having a tea party with his daughter. The funny misdirect reveals that anyone can be a philanthropist with GTE since you contribute to local charities just by using GTE products.

Results: GTE Financial liked this spot, because it was kind of quirky and unique – just like them. The commercial helped to differentiate them from the competition and showed in a fun way how they go beyond money and really contribute to the local community.

169 PHILANTHROPIST — MECHANIC | Ad Agency: PPK, USA | Art Director: Trushar Patel
Client: GTE Financial | Production Company: Contender Production Studios, LLC
President: Tom Kenney | Director: Chanse Chanthalansy | Producer: Christine Allen
Production Manager: Lauren Houlberg | Executive Creative Director: Dustin Tamilio
Creative Director: Michael Schillig | Associative Creative Director: Trushar Patel
Production Manager: Lauren Houlberg Account Director: Rey Futch
Account Executive: Jessica Anthony | Copywriter: Michael Schillig
Editors: Melissa Reichert, Chanse Chanthalansy, Amanda Schreiber | Animator: San Nguyen
Recording Engineer: Mike Lessard | Music and Sound: Roger Hughes

Assignment: GTE Financial wanted us to create a series of quirky and impactful 15-second TV spots on a limited budget that would reflect their theme line of "going beyond money." They wanted to make people aware of all the monies they donated to local charities last year and how you can be a philanthropist too just by banking with GTE.

Approach: This was one of three 15-second spots in a campaign in which we emphasized how, as a not for profit credit union, GTE Financial donated over $610,000 to local charities. In this spot, our main character acts like a high society philanthropist standing in front of a luxurious Rolls Royce. Ultimately, it's revealed that this is really his neighbor's car. The funny misdirect suggests that anyone can be a philanthropist with GTE since you help local charities just by banking with GTE.

Results: GTE Financial liked this spot, because it was kind of quirky and unique – just like them. The commercial helped to differentiate them from the competition and showed in a fun way how they go beyond money and really contribute to the local community.

170 PHILANTHROPIST — GOLF | Ad Agency: PPK, USA | Art Director: Trushar Patel
Client: GTE Financial | Production Company: Contender Production Studios, LLC
President: Tom Kenney | Director: Chanse Chanthalansy | Producer: Christine Allen
Production Manager: Lauren Houlberg | Executive Creative Director: Dustin Tamilio
Creative Director: Michael Schillig | Associative Creative Director: Trushar Patel
Production Manager: Lauren Houlberg | Account Director: Rey Futch
Account Executive: Jessica Anthony | Copywriter: Michael Schillig
Editors: Melissa Reichert, Chanse Chanthalansy, Amanda Schreiber | Animator: San Nguyen
Recording Engineer: Mike Lessard | Music and Sound: Roger Hughes

Assignment: GTE Financial wanted us to create a series of quirky and impactful 15-second TV spots on a limited budget that would reflect their theme line of "going beyond money." They wanted to make people aware of all the monies they donated to local charities last year and how you can be a philanthropist too just by banking with GTE.

Approach: This was one of three 15-second spots in a campaign in which we emphasized how, as a not for profit credit union, GTE Financial donated over $610,000 to local charities. In this spot, our main character acts like a high society philanthropist enjoying a game of golf at a country club. Ultimately, it is revealed that she's actually just practicing on a tiny putting green, as her husband holds the flag for her, while trying to barbecue. The funny misdirect leads to some fiery humor and suggest that anyone can be a philanthropist with GTE since you help local charities just by purchasing things with your GTE credit card.

Results: GTE Financial liked this spot, because it was kind of quirky and unique – just like them. The commercial helped to differentiate them from the competition and showed in a fun way how they go beyond money and really contribute to the local community.

170 FOOD FRIGHT | Ad Agency: Intermark Group | Art Directors: Amy Johnson, Blake Young
Client: Physicians Mutual | Production Company: MJZ | Director: Craig Gillespie
Producer: Martha Davis | Agency Producer: Chris Mann | Chief Strategy Officer: Josh Simpson
Chief Creative Officer: Keith Otter | Director of Photography: Masanobu Takayanagi
Account Director: Paul Brusatori | Copywriters: Dorothy O'Leary, Randy Warner
Editor: Spot Welders | Graphic Designer: Lindsey Mueller
Music and Sound: Shindig Music and Sound | Other: Amanda Trundell

Approach: Creative Idea: Navigating retirement can seem like a nightmare. This campaign portrays retirement coverage anxiety in humorous "fever dreams" which are resolved by reassuring Physicians Mutual is there to listen and find the coverage you need.

171 DR. ACULA | Ad Agency: Intermark Group | Art Directors: Amy Johnson, Blake Young
Client: Physicians Mutual | Production Company: MJZ | Director: Craig Gillespie
Graphic Designer: Lindsey Mueller | Producer: Martha Davis | Executive Producer: Chris Mann
Chief Strategy Officer: Josh Simpson | Chief Creative Officer: Keith Otter
Director of Photography: Masanobu Takayanagi | Account Director: Paul Brusatori
Copywriters: Dorothy O'Leary, Randy Warner | Editor: Spot Welders
Music and Sound: Shindig Music and Sound | Other: Amanda Trundell

Approach: Navigating retirement can seem like a nightmare. This campaign portrays retirement coverage anxiety in humorous "fever dreams" which are resolved by reassuring Physicians Mutual is there to listen and find the coverage you need.

171 NIGHTMARES | Ad Agency: Intermark Group | Art Directors: Amy Johnson, Blake Young
Client: Physicians Mutual | Production Company: MJZ | Director: Craig Gillespie
Graphic Designer: Lindsey Mueller | Producer: Martha Davis | Executive Producer: Chris Mann
Chief Strategy Officer: Josh Simpson | Chief Creative Officer: Keith Otter
Director of Photography: Masanobu Takayanagi | Account Director: Paul Brusatori
Copywriters: Dorothy O'Leary, Randy Warner | Editor: Spot Welders
Music and Sound: Shindig Music and Sound | Other: Amanda Trundell

Approach: Navigating retirement can seem like a nightmare. This campaign portrays retirement coverage anxiety in humorous "fever dreams" which are resolved by reassuring Physicians Mutual is there to listen and find the coverage you need.

172 BE THE DIFFERENTS — EMBRACE YOUR PUNCH | Ad Agency: 50,000feet
Art Director: 50,000feet | Client: Sour Punch — American Licorice

Assignment: American Licorice was looking to extend the success of its Sour Punch platform Embrace Your Punch as well as storytell around the brand's values, tying them to positive campaign messages that inspire audiences to treat themselves to Sour Punch and connect with one another.
Approach: 50,000feet developed the creative strategy for the spots based on an aligned vision and great collaboration with the Sour Punch team as well as Maday Productions, who helped bring the story to life with compelling and powerful videography. "Be the Differents" highlights a range of young adults, showcasing their distinctive personalities, individuality, style and love for Sour Punch, celebrating diversity and making the world interesting and more flavorful.
Results: Building on American Licorice's commitment to partnerships with organizations including Boys & Girls Clubs of Greater Northwest Indiana, the campaign is a call to action to make the world a better, more inclusive and community-focused place.

172 EVERY MOVE IS EXTRAORDINARY | Ad Agency: Proper Villains
Art Director: Jeff Monahan | Client: New England Baptist Hospital | Director: Jeff Monahan
Producer: Jennifer Sargent | Director of Photography: Patrick Ruth
Senior Designer: Beth Almeida | Designer: Marlene Cole | Writer: Myles McDonough

Assignment: The 2019 evolution of our "Every Move Is Extraordinary" campaign for New England Baptist Hospital employs dramatic cinematography, elegant and direct messaging, and a cast of fascinating and memorable characters to draw attention to the Hospital's dedication to healthy movement. The campaign celebrates the human body and its abilities, and demonstrates the importance of healthy movement in everyday life.

173 DOCTORS AND PATIENTS, TWO SIDES OF THE SAME DISCOMFORT
Ad Agency: Kibrit & Calce | Art Director: Maria Favia | Client: Ordine dei Medici Chirurghi e degli Odontoiatri della Provincia di Bari | Creative Director: Concetta Pastore

Assignment: The Order of the Medical doctors of Bari was one of the first Orders in Italy to constantly and systematically exploit advertising communication to make citizens aware of crucial health and healthcare issues, with the explicit intent to lay the foundations for rebuilding the doctor-patient trust relationship.
Given the increasing number of attacks on physicians by patients, the OMCeO has asked the agency to develop a campaign that would serve to reconcile doctors and citizens and to strengthen the relationship between doctor and patient that is the basis of the therapeutic alliance.
Approach: The "Doctors and Patients. Two sides of the same discomfort "has aimed to present health workers on one side and citizens on the other as victims of the malfunctioning of the healthcare system.
Doctors and patients are in fact victims of the same distorted system in which only the balanced budget is pursued, losing the right to health, safety, autonomy and independence of the profession, while they should be allied in a reform of the healthcare system that aims to protect the right to health and the dignity of the profession, as stated in the headline "Doctors and Patients, two sides of the same discomfort. We are asking for more health resources. Together".
The campaign was shown in posters (poster 6x3 in Bari) and in video (conveyed via social media).
Results: The OMCeO of Bari commissioned the research institute Eumetra of Renato Mannheimer to carry out a survey to understand how the communication campaigns of the Order had been received by citizens.
The feedback on the sample of 400 individuals interviewed which showed the "Discomfort" campaign was fully positive. 56% of respondents correctly identified the main content of the message in the common battle. 37% said they felt a greater "understanding" of doctors, while 30% said they felt "solidarity" with healthcare professionals.

173 HEIST | Ad Agency: Brunner | Art Director: Silver Cuellar | Client: YellaWood
Production Company: Framestore | Head of Production: Anne Vega | Production: Cut & Run,
Fixer | Director: Murray Butler | Senior Producer: Nick Fraser
Executive Producers: Dez Macleod-Villeux, Jennifer Siegel, Brad Powell
Producer: Gabrielle Yuro | Chief Creative Officer: Rob Schapiro | Creative Director: Jeff Shill
Associative Creative Director: Silver Cuellar | Director of Photography: Eric Treml
Production Designer: David Batchelor Wilson | Account Director: Zak Cochran
Account Executive: Nate Wachter | Account Management: Alex Kotz | Editor: Jon Grover
Copywriter: Jonathan Banks | Music and Sound: New Math

Assignment: Get contractors and dealers to seek out the YellaWood® brand when planning their next project.
Approach: What better way to position the YellaWood® brand as the best, than by showing nature's most elite builders in pursuit of the Yella Tag. We assembled a rag-tag team of master woodworkers to hunt down and heist the best building material in a 5-mile radius. If it doesn't have that Yella Tag, you don't want it. And neither do crafty beavers.
Results: Instant response from both contractors and dealers. Everyone is excited about the campaign both in-store and online. One dealer reported a business owner unrelated to the lumber industry requesting YellaWood point of sales material to place in their own store.

174 LUMBERYARD | Ad Agency: Brunner | Art Director: Silver Cuellar | Client: YellaWood
Production Company: Framestore | Head of Production: Anne Vega
Production: Cut & Run, Fixer | Director: Murray Butler | Senior Producer: Nick Fraser
Executive Producers: Dez Macleod-Villeux, Jennifer Siegel, Brad Powell
Producer: Gabrielle Yuro | Chief Creative Officer: Rob Schapiro | Creative Director: Jeff Shill
Associative Creative Director: Silver Cuellar | Director of Photography: Eric Treml
Production Designer: David Batchelor Wilson | Account Director: Zak Cochran
Account Executive: Nate Wachter | Account Management: Alex Kotz | Editor: Jon Grover
Copywriter: Jonathan Banks | Music and Sound: New Math

Assignment: Get contractors and dealers to seek out the YellaWood® brand when planning their next project.
Approach: What better way to position the YellaWood® brand as the best, than by showing nature's most elite builders in pursuit of the Yella Tag. We assembled a rag-tag team of master woodworkers to hunt down and heist the best building material in a 5-mile radius. If it doesn't have that Yella Tag, you don't want it. And neither do crafty beavers.
Results: Instant response from both contractors and dealers. Everyone is excited about the campaign both in-store and online. One dealer reported a business owner unrelated to the lumber industry requesting YellaWood point of sales material to place in their own store.

174 CONTROL ROOM | Ad Agency: Brunner | Art Director: Silver Cuellar | Client: YellaWood
Production Company: Framestore | Head of Production: Anne Vega
Production: Cut & Run, Fixer | Director: Murray Butler | Senior Producer: Nick Fraser
Executive Producers: Dez Macleod-Villeux, Jennifer Siegel, Brad Powell
Producer: Gabrielle Yuro | Chief Creative Officer: Rob Schapiro | Creative Director: Jeff Shill
Associative Creative Director: Silver Cuellar | Director of Photography: Eric Treml
Production Designer: David Batchelor Wilson | Account Director: Zak Cochran
Account Executive: Nate Wachter | Account Management: Alex Kotz | Editor: Jon Grover
Copywriter: Jonathan Banks | Music and Sound: New Math

Assignment: Get contractors and dealers to seek out the YellaWood® brand when planning their next project.
Approach: What better way to position the YellaWood® brand as the best, than by showing nature's most elite builders in pursuit of the Yella Tag. We assembled a rag-tag team of master woodworkers to hunt down and heist the best building material in a 5-mile radius. If it doesn't have that Yella Tag, you don't want it. And neither do crafty beavers.
Results: Instant response from both contractors and dealers. Everyone is excited about the campaign both in-store and online. One dealer reported a business owner unrelated to the lumber industry requesting YellaWood point of sales material to place in their own store.

175 TRANE RELENTLESS TESTING TV | Ad Agency: Young & Laramore
Art Director: Dan Shearin | Client: Trane | Director: Joe Wright
Executive Producer: Amy Jo Deguzis | Executive Creative Director: Carolyn Hadlock
Group Creative Director: Bryan Judkins | Photo Director: Peter Konczal
Editor: Bruce Herrman | Writer: Deidre Lichty | Music and Sound: Echolab

Assignment: The world knows "It's hard to stop a Trane," but what they don't know is the lengths Trane goes to test their products. Every Trane product is tested in the harshest conditions imaginable and it was time they got credit for it.
Approach: The environments Trane creates to make products that run through anything is truly indescribable. That's why we didn't even try. Instead of talking about the unrelenting barrage of tests, we wanted to make the audience feel like they were experiencing the extreme range of weather and torture firsthand. The combination of striking visuals, sound design and driving, staccato music puts viewers right into the action— creating a commercial as unstoppable as the product itself.
Results: Initial results show a 9% increase in brand awareness, 11% increase in preference, and 7% increase in purchase consideration. But more importantly, the campaign was embraced by the badass engineers and employees who work on these products every day.

175 MDA SENSE OF FREEDOM | Ad Agency: Traction Factory
Art Director: Mark Brautigam | Client: Muscular Dystrophy Association
Executive Creative Director: Peter Bell | Creative Director: Steve Drifka
Director: William Yunker | Senior Account Executive: Anna Kohnen | Copywriter: Tom Dixon
Assistant Account Executive: Emily Moss | Account Director: Scott Bucher

Assignment: The Muscular Dystrophy Association has a long history with Harley-Davidson business leaders and brand enthusiasts. Each year, MDA and Harley-Davidson partner to build awareness of this life-changing disease and raise funds across North America by engaging followers of their iconic brands. It's a tight-knit community. Fun-loving, passionate and giving, they all have something in common. The concept of personal freedom. Our assignment was to capture that spirit in broadcast for use nationally and in MDA Chapters across North America.
Approach: The spot features MDA Ambassador Reagan Imhoff and her spirit animal, a Harley-Davidson enthusiast. In a private moment in plain view, they share the "biker wave." It serves as an acknowledgement of their common pursuit.
Results: While it has been adopted for national use in all media, it was originally developed to support the 25th Anniversary Black N' Blue Ball in Milwaukee, Wisconsin. That event, attended by 1,400 members of the MDA community, generated 1.1M dollars benefitting kids in search of their own personal freedom.

176 THE FACE OF ALZHEIMER'S ANTHEM | Ad Agency: Proper Villains
Art Director: Jeff Monahan | Clients: Cure Alzheimer's Fund, Barbara Chambers
Director: Jeff Monahan | Producer: Jennifer Sargent | Creative Director: Jeff Monahan
Director of Photography: Patrick Ruth | Senior Designer: Beth Almeida
Designer: Marlene Cole | Writer: Myles McDonough

Assignment: While Alzheimer's is generally thought of as an "old persons' disease," its true impact is actually felt across all age brackets, by people of every race, sex, and gender. "The Faces of Alzheimer's" campaign combines stark, portrait-style cinematography with and a quiet score to present powerful statistics that highlight the unexpected impact that Alzheimer's has on people not typically associated with the disease.

176 BAKERY | Ad Agency: Shine United | Art Director: Eric Cook | Client: Festival Foods
Production Company: Circle Pictures | Director: Carlo "Vinnie" Besasie
Producer: Sue Karpfinger | Creative Director: John Krull
Associative Creative Directors: James Breen, Joe Ban | Director of Photography: Mike Gillis
Copywriter: James Breen | Food Stylist: Nancy Froncek

Assignment: Increase awareness of Festival Foods via their one of their core, top-of-the line fresh departments: the Bakery.
Approach: Festival Foods grocery stores make fresh products every day. The talented team of bakers create hand crafted items in the early morning each day. The TV spot worked to highlight these fresh, better products in a bold and mouthwatering way.
Results: The TV spot had effective recognition and recall in research.

177 DELI | Ad Agency: Shine United | Art Director: Eric Cook | Client: Festival Foods
Production Company: Circle Pictures | Director: Carlo "Vinnie" Besasie
Producer: Sue Karpfinger | Creative Director: John Krull
Associative Creative Directors: James Breen, Joe Ban | Director of Photography: Mike Gillis
Copywriter: James Breen | Food Stylist: Simplyfoodstyling

Assignment: Increase awareness of Festival Foods via their one of their core, top-of-the line fresh departments: the Deli.
Approach: Festival Foods grocery stores make fresh products every day. The talented team of deli associates cook hand-crafted items daily. The TV spot worked to highlight these fresh, better products in a bold and mouthwatering way.
Results: The TV spot had effective recognition and recall in research.

177 POOL DAD — INTERRUPTION | Ad Agency: PPK, USA
Art Director: Javier Quintana | Client: Pinch A Penny Pool Patio Spa | President: Tom Kenney
Group Creative Director: Paul Prato | Associative Creative Directors: Javier Quintana, Burton Runyan | Account Director: Rey Futch | Account Executive: Jessica Anthony
Production Company: Contender Production Studios, LLC

Assignment: Promote Pinch-A-Penny's Spring Sale using a specific product on sale.
Approach: For this year's Pinch A Penny Pool supplies TV campaign, we took the ease of pool care to its logical conclusion: The Ultimate Pool owner. Our pool dad character is enchanted at how easy the products from Pinch A Penny make maintaining the perfect pool. And his confidence and enthusiasm shows.
Results: The sale it was promoting has topped the previous year's sales.

178 POOL DAD — THING OF BEAUTY | Ad Agency: PPK, USA
Art Director: Javier Quintana | Client: Pinch A Penny Pool Patio Spa | President: Tom Kenney
Production Company: Contender Production Studios, LLC
Group Creative Director: Paul Prato | Associative Creative Directors: Javier Quintana, Burton Runyan | Account Director: Rey Futch | Account Executive: Jessica Anthony

Assignment: Promote Pinch-A-Penny's Spring Sale using a specific product on sale.
Approach: For this year's Pinch A Penny Pool supplies TV campaign, we took the ease of pool care to its logical conclusion: The Ultimate Pool owner. Our pool dad character is enchanted at how easy the products from Pinch A Penny make maintaining the perfect pool. And his confidence and enthusiasm shows.
Results: The sale it was promoting has topped the previous year's sales.

178 POOL DAD — CLOSER | Ad Agency: PPK, USA | Art Director: Javier Quintana
Client: Pinch A Penny Pool Patio Spa | Group Creative Director: Paul Prato
President: Tom Kenney | Associative Creative Directors: Javier Quintana, Burton Runyan
Production Company: Contender Production Studios, LLC
Account Director: Rey Futch | Account Executive: Jessica Anthony

Assignment: Promote Pinch-A-Penny's Spring Sale using a specific product on sale.
Approach: For this year's Pinch A Penny Pool supplies TV campaign, we took the ease of pool care to its logical conclusion: The Ultimate Pool owner. Our pool dad character is enchanted at how easy the products from Pinch A Penny make maintaining the perfect pool. And his confidence and enthusiasm shows.
Results: The sale it was promoting has topped the previous year's sales.

SILVER VIDEOS WINNERS:

179 NOT FLYING | Ad Agency: INNOCEAN USA | Art Directors: John Turcios/Tricia Ting
Client: Hyundai Motor America | Director: MJZ - Craig Gillespie
Senior Producer: Melissa Moore | Executive Producer: Nicolette Spencer
Producer: Stephen Estrada | Associative Creative Directors: Chris Lynch/Brad Beerbohm
Director of Photography: MJZ - Stuart Graham | Managing Director: Angela Zepeda
Account Executive: Mike Braue | Account Manager: Stephanie Yetter
Account Management: Alison O'Neill | Copywriter: Peter Albores

179 MILLION MILE ELANTRA | Ad Agency: INNOCEAN USA
Art Director: Jackie Barkhurst | Client: Hyundai Motor America
Director: Katherine Garfield, Huff Films - Chad Huff | Executive Producer: Nicolette Spencer
Producers: Erin Hungerford, Celestina Lucero, Stephen Estrada
Creative Directors: Lori Martin, Jera Mehrdad | Group Creative Director: Jeff Bossin
Director of Photography: Huff Films - Kevin Lachman, Kevin Gosselin
Project Manager: MJ Chow | Group Brand Director: Mike Braue
Associative Creative Director: Jackie Barkhurst, Ryan Simpson
Account Director: Cassie Reed Account Manager: Lacie Worrell
Social Strategy: Katherine Garfield

179 STOPLIGHT STANDOFF | Ad Agency: INNOCEAN USA
Art Director: Christian Silva | Client: Hyundai Motor America
Head of Production: Nicolette Spencer | Director: Biscuit Filmworks - Aaron Stoller
Senior Producer: Kira Linton | Associate Producer: Devondra Dominguez
Executive Creative Director: Barney Goldberg | Creative Director: Ryan Scott
Associative Creative Director: Joe Reynoso | Copywriter: Alvaro Soto
Managing Director, Brand: Marisstella Marinkovic | Group Brand Director: Mike Braue
Director of Photography: Biscuit Filmworks - Hoyte van Hoytema | Strategy: Kimberly Bates
Account Planner: Zach Reusing | Project Management Supervisor: Suzanne Cheng
Account Director: Lester Perry | Account Manager: Tanner Ham

179 REF TO THE RESCUE | Ad Agency: INNOCEAN USA
Art Director: Jose Eslinger | Client: Hyundai Motor America
Head of Production: Nicolette Spencer | Directors: Dave Laden, Bryan Buckley
Producer: Kira Linton | Executive Creative Director: Barney Goldberg
Group Creative Director: Jeff Bossin | Group Brand Director: Mike Braue
Associative Creative Directors: Jose Eslinger & Carissa Levine
Managing Director, Brand Management: Marisstella Marinkovic
Director of Photography: Scott Henriksen
Account Director: Bryan DiBiagio | Account Manager: Megan Gordon
Copywriter: Chris Ribeiro | Strategy Director: Kimberly Bates

180 BOLD NEVER BLENDS | Ad Agency: INNOCEAN USA | Art Director: Gabriel Gama
Client: Hyundai Motor Company | Head of Production: Nicolette Spencer
Director: RESET - Reynald Gresset | Senior Producer: Jamie Shuster
Global CCO: Jeremy Craigen | Executive Creative Director: Barney Goldberg
Group Creative Director: Jeff Bossin | Creative Director: Jeff Spillane
Director of Photography: RESET - Danny Hiele

180 DOE ANDERSON SHAREHOLDER'S VIDEO | Ad Agency: Doe Anderson
Art Director: Kevin Price | Client: Self-Initiated | Production Company: DA Productions
Director: Brandon Radford | Agency Producer: Matt Boyle | Camera: Jay Boone
Chief Creative Officer: David Vawter | Editors: Brandon Radford & Jay Boone

180 LOUISVILLE CITY FOOTBALL CLUB :30 TV | Ad Agency: Doe Anderson
Art Director: Tim Ofcacek | Client: Louisville City Football Club
Production Company: ThoughtFly | Director: Gary Miller | Producer: Stuart McWhirther
Agency Producers: Delane Wise, Chase Stewart, Matt Boyle
Chief Creative Officer: David Vawter | Editor: Matt Niehoff | Copywriter: Natalie Weis
Music and Sound: Joe Stockton

This year's entries showcased a diverse range of creative executions.

Matt Herrmann, *Group Creative Director, BVK*

Index

ADVERTISING AGENCIES

CLIENTS

ART DIRECTORS

PHOTOGRAPHERS

Inspiration is all around us.
It does help though to have it "turbo-charged"
through the pages of Graphis.

John Hegardy, *Bartle Bogle Hegarty*

PLATINUM

ARSONAL
www.arsonal.com
3524 Hayden Ave.
Culver City, CA 90232
United States
Tel +1 310 815 8824
info@arsonal.com

AUDI USA
www.audiusa.com
2200 Ferdinand Porsche Dr.
Herndon, VA 20171
United States
Tel +1 703 364 7000
nick@trsociety.com

Brunner
www.brunnerworks.com
1100 Peachtree St. NE Suite 550
Atlanta, GA 30309
United States
Tel +1 404 279 2200
scuellar@tombras.com

daDá
www.dada.com.ec
De Los Motilones N40-486 and
Camilo Gallegos
Wimper E7 154 and diego de
almagro ed. geneva 801
Quito, Pichincha
Ecuador
Tel +593 979 148 690
david.chandi@hotmail.com

Duncan Channon
www.duncanchannon.com
114 Sansome St., 14th Floor
San Francisco, CA 94104
United States
Tel +1 415 306 9274
awards@duncanchannon.com

Fabian Oefner
www.fabianoefner.com
15 Thorpe Street
Danbury, CT 06810
United States
Tel +1 929 391 3983
studio@fabianoefner.com

FBC Design
10201 W. Pico Blvd. 100/2005A
Los Angeles, CA 90064
United States
Tel +1 310 369 4766
lauren.rubenstein@fox.com

INNOCEAN USA
www.innoceanusa.com
180 Fifth St., Suite 200
Huntington Beach, CA 92648
United States
Tel +1 714 861 5371
awardshows@innoceanusa.com

PPK, USA
www.uniteppk.com
1102 N. Florida Ave.
Tampa, FL 33602
United States
Tel +1 727 518 4053
dphillips@uniteppk.com

Shine United
www.shineunited.com
202 N. Henry St.
Madison WI 53703
United States
Tel +1 608 442 7373
kleslie@shineunited.com

The Designory
www.designory.com
211 East Ocean Blvd., Suite 100
Long Beach, CA 90802
United States
Tel +1 562 624 0200
jennifer.holmes@designory.com

GOLD

360i
www.360i.com
32 Avenue of the Americas, 6th Fl.
New York, NY 10013
United States
Tel +1 (888) 360-9630
Madeleine.goldman@360i.com

50,000feet
www.50000feet.com
1700 W. Irving Park Road, Suite 110
Chicago, IL 60613
United States
Tel +1 773 529 6760
stevens@50000feet.com

adidas Global Brand Design
5055 N Greeley Ave.
Portland, OR 97217
United States
ryan.schroeder@adidas.com

Animal - San Diego
www.IndependentCopywriter.com
225 Portland Ave. #PH440
Minneapolis, MN 55401
United States
Tel +1 952 942 2183
colin@independentcopywriter.com

ARSONAL
www.arsonal.com
3524 Hayden Ave.
Culver City, CA 90232
United States
Tel +1 310 815 8824
info@arsonal.com

Brunner
www.brunnerworks.com
1100 Peachtree St. NE Suite 550
Atlanta, GA 30309
United States
Tel +1 404 279 2200
scuellar@tombras.com

Cold Open
www.coldopen.com
1313 Innes Pl.
Venice, CA 90291
United States
Tel +1 310 399 3307
reception@coldopen.com

**Colin Corcoran,
Independent Copywriter**
www.IndependentCopywriter.com
225 Portland Ave. #PH440
Minneapolis, MN 55401
United States
Tel +1 952 942 2183
colin@independentcopywriter.com

Curious Productions
www.curious-productions.co.uk
27 Ingersoll Road
Shepherd's Bush, London W12 7BE
United Kingdom
Tel +44 785 222 9751
JFairley@curious-productions.co.uk

daDá
www.dada.com.ec
De Los Motilones N40-486 and
Camilo Gallegos
Wimper E7 154 and diego de
almagro ed. geneva 801
Quito, Pichincha
Ecuador
Tel +593 979 148 690
david.chandi@hotmail.com

Dalian RYCX Advertising Co., Ltd.
www.rycxcn.com
A6-12 No.419 Minzheng St.
Shahekou District
Dalian Liaoning 116021
China
Tel +86 155 2479 6568
rycxcn@163.com

DarbyDarby Creative
www.darbydarbycreative.com
18459 Pines Blvd. A130
Pembroke Pines, FL 33029
United States
Tel +1 646 489 1256
kld@darbydarbycreative.com

Darkhorse Design, LLC
www.darkhorsedesign-usa.com
8 Whitefield Lane
Lancaster, PA 17602
United States
Tel +1 908 670 1992
roberttalarczyk@mac.com

Disrupt Idea Co.
disruptidea.com
219 N. Milwaukee St. Suite 640
Milwaukee, WI 53202
United States
Tel +1 414 522 7914
kris.ender@disruptidea.com

Doe Anderson
www.doeanderson.com
620 W. Main St.
Louisville, KY 40202
United States
Tel +1 502 815 3272
twright@doeanderson.com

DOG & PONY
www.dogandponycreative.com
6230-A Wilshire Blvd. #1175
Los Angeles, CA 90048
United States
Tel +1 323 364 7227
jen@dogandponycreative.com

Duncan Channon
www.duncanchannon.com
114 Sansome St., 14th Floor
San Francisco, CA 94104
United States
Tel +1 415 306 9274
awards@duncanchannon.com

FBC Design
10201 W. Pico Blvd. 100/2005A
Los Angeles, CA 90064
United States
Tel +1 310 369 4766
lauren.rubenstein@fox.com

Goodby Silverstein & Partners
www.goodbysilverstein.com
720 California Street
San Francisco, CA 94108
United States
Tel: +1 415 392 0669
meredith_vellines@gspsf.com

INNOCEAN USA
www.innoceanusa.com
180 5th St., Suite 200
Huntington Beach, CA 92648
United States
Tel +1 714 861 5371
awardshows@innoceanusa.com

Intermark Group
www.intermarkgroup.com
101 25th St.
North Birmingham, AL 35203
United States
Tel +1 205 803 0000
keitho@intgroup.com

Interweave Group
www.interweavegroup.com
46 Dundas Pl.
Albert Park, Victoria 3206
Australia
Tel +61 438 343 780
marijana@interweavegroup.com

Jacob Tyler Brand + Digital
www.jacobtyler.com
1013 Clipper Court
Del Mar, CA 92014
United States
richard@thecrownelectric.com

Kibrit & Calce
www.kibritecalce.it
Via Cardassi 66
Bari 70121
Italy
Tel +39 348 640 5829
info@kibritecalce.it

MullenLowe LA
www.morindesignoffice.com
745 E. Orange Grove Blvd., Unit 9
Pasadena, CA 91104
United States
Tel +1 909 967 0072
christian@morindesignoffice.com

nikkeisha, inc.
7-13-20 Ginza
Chuo-ku, Tokyo 1048176
Japan
Tel +81 90 1121 5422
nakamu02@gmail.com

Omdesign
www.omdesign.pt
Rua de Vila Franca
54 - Leça da Palmeira, Matosinhos
4450-802
Portugal
Tel +351 229 982 960
comunicacao@omdesign.pt

Paradise Advertising
www.paradiseadv.com
150 Second Ave.N., Suite 800
St. Petersburg, FL 33701
United States
Tel +1 727 821 5155
tmerrick@paradiseadv.com

PPK, USA
www.uniteppk.com
1102 N. Florida Ave
Tampa, FL 33602
United States
Tel +1 727 518 4053
dphillips@uniteppk.com

Proper Villains
www.propervillains.studio
2 Seaport Lane, 7th Floor
Boston, MA 02210
United States
Tel +1 617 721 7749
jeff@propervillains.agency

Saatchi & Saatchi Sofia
www.saatchi.bg
118 Bulgaria Blvd.
Sofia 1404
Bulgaria
Tel +359 893 049 980
e.chervenkova@publicis.bg

Saatchi & Saatchi Wellness
www.trans-4mation.com
PO Box 780
Sag Harbor, NY 11963
United States
Tel +1 646 660 1419
scott_carlton70@mac.com

Shine United
www.shineunited.com
202 N. Henry St
Madison WI 53703
United States
Tel +1 608 442 7373
kleslie@shineunited.com

The BAM Connection
www.thebam.com
20 Jay St.
Brooklyn, NY 11201
United States
Tel +1 718 801 8299
rob@thebam.com

The Designory
www.designory.com
211 East Ocean Blvd., Suite 100
Long Beach, CA 90802
United States
Tel +1 562 624 0200
jennifer.holmes@designory.com

The Gate | NY
www.thegateworldwide.com/ny
71 Fifth Ave., 8th Floor
New York, NY 10003
United States
Tel +1 212 508 3431
timothy.cozzi@thegateworldwide.com

Traction Factory
www.tractionfactory.com
247 S. Water St.
Milwaukee, WI 53204
United States
Tel +1 414 944 0900
tf_awards@tractionfactory.com

Young & Laramore
www.yandl.com
407 Fulton St.
Indianapolis, NY 46202
United States
chadlock@yandl.com

SILVER

Academy of Motion Picture Arts and Sciences
8949 Wilshire Blvd.
Beverly Hills, CA 90211
United States
dbenedict@oscars.org

AG Creative Group
www.agcreative.ca
#100 2250 Boundary Road
Burnaby BC V5M 3Z3, CA
United States
Tel +1 604 559 1411
stew@agcreative.ca

Art Machine
www.artmachine.com
10201 W Pico Blvd. 100/2005A
Los Angeles, CA 90064
United States
Tel +1 310 369 4766
lauren.rubenstein@fox.com

Aveda Global Creative
4000 Pheasant Ridge Drive NE
Blaine, MN 55449
United States
sgrant@aveda.com

Ayzenberg
www.ayzenberg.com
49 E. Walnut Street
Pasadena, CA 91103
United States
Tel: +1 626 584 4070
BBuckley@ayzenberg.com

Camp3
www.IndependentCopywriter.com
225 Portland Ave. #PH440
Minneapolis, MN 55401
United States
Tel +1 952 942 2183
colin@independentcopywriter.com

Cold Open
www.coldopen.com
1313 Innes Pl.
Venice, CA 90291
United States
Tel +1 310 399 3307

**Colin Corcoran,
Independent Copywriter**
www.IndependentCopywriter.com
225 Portland Ave. #PH440
Minneapolis, MN 55401
United States
Tel +1 952 942 2183
colin@independentcopywriter.com

Colle + McVoy
www.collemcvoy.com
400 First Avenue North
Suite 700
Minneapolis, MN 55401
United States
Tel +1 612 305 6000
colin@independentcopywriter.com

Craig Bromley
www.cbromley.com
1136 Briarcliff Road, NE #2
Atlanta, GA 30306
United States
Tel +1 4C4 229 7279
craig@cbromley.com

Creative Energy
www.creativeenergy.agency
3206 Hanover Road
Johnson City, TN 37604
United States
Tel +1 423 926 9494
wgriffith@cenergy.com

Curious Productions
www.curious-productions.co.uk
27 Ingersoll Road
Shepherd's Bush, London W12 7BE
United Kingdom
Tel +44 785 222 9751
JFairley@curious-productions.
co.uk

Disrupt Idea Co.
www.disruptidea.com
219 N Milwaukee St., Suite 640
Milwaukee, WI 53202
United States
kris.ender@disruptidea.com

Doe Anderson
www.doeanderson.com
620 W. Main St.
Louisville, KY 40202
United States
Tel +1 502 815 3272
twright@doeanderson.com

FBC Design
10201 W. Pico Blvd. 100/2005A
Los Angeles, CA 90064
United States
Tel +1 310 369 4766
lauren.rubenstein@fox.com

Genaro Design, LLC
www.genarodesign.com
13526 George Road, Suite 209
San Antonio, TX 78230
United States
Tel +1 210 455 4900
design@genarodesign.com

INNOCEAN USA
www.innoceanusa.com
180 5th St., Suite 200
Huntington Beach, CA 92648
United States
Tel +1 714 861 5371
awardshows@innoceanusa.com

Karnes Coffey Design
www.karnescoffey.com
4908 Darrowby Road
Glen Allen, VA 23060
United States
christine@karnescoffey.com

L.S. Boldsmith
www.leilasingleton.com
Vancouver British Columbia
Canada
leila@leilasingleton.com

Phenomenon
www.phenomenon.com
5900 Wilshire Blvd, Floor 28
Los Angeles, CA 90036
United States
newbiz@phenomenon.com

PPK, USA
www.uniteppk.com
1102 N. Florida Ave.
Tampa, FL 33602
United States
Tel +1 727 518 4053
dphillips@uniteppk.com

Roger Archbold
www.rogerarchbold.com
607/42A Nelson St.
Ringwood, Victoria 3134
Australia
Tel +61 404 806 354
roger@rogerarchbold.com

Shine United
www.shineunited.com
202 N. Henry St.
Madison, WI 53703
United States
Tel +1 608 442 7373
kleslie@shineunited.com

The Hive Advertising
www.thehiveinc.com
544 King Street W.
Toronto, ON M5V 1M3
Canada
Tel +1 416 923 3800

Traction Factory
www.tractionfactory.com
247 S. Water St.
Milwaukee, WI 53204
United States
Tel +1 414 944 0900
tf_awards@tractionfactory.com

un/common
www.uncommon.us
2700 J Street, 3rd Floor
Sacramento, CA 95816
United States
brantley@uncommon.us

WONGDOODY
www.wongdoody.com
1011 Western Ave., Suite 900
Seattle, WA 98104
United States
Tel +1 206 624 5325
lara.johannsen@wdcw.com

Young & Laramore
www.yandl.com
407 Fulton St.
Indianapolis, NY 46202
United States
chadlock@yandl.com

WINNERS BY COUNTRY

Visit Graphis.com to view the work within each Country, State or Province.

Graphis Advertising Annual 2020
PLATINUM & GOLD AWARD-WINNING WORK

Design Annual 2020	Poster Annual 2020	Nudes 5

Nudes 5

Design Annual 2020

2019
Hardcover: 272 pages
200-plus color illustrations
Trim: 10.06 x 13.41"
ISBN: 978-1-931241-82-3
US $ 90

Awards: 12 Platinum, 107 Gold, and 230 Silver Awards, along with 149 Honorable Mentions.
Platinum Winners: ARSONAL, Carmit Design Studio, Delcan & Company/Visual Arts Press, Ltd, FX Networks/Iconisus, Gunter Rambow, João Machado Design, Lewis Communications, Marcos Minini Design, OGAWAYOUHEI DESIGN, Stephan Bundi, Studio Hinrichs, and Studio Pekka Loiri.
Judges: All entries were judged by a panel of highly accomplished Poster Designers: Takashi Akiyama, Rikke Hansen, Dermot Mac Cormack, Patricia McElroy, Gunter Rambow, and Hajime Tsushima.
Content: Exceptional posters by each of the talented Judges, Platinum, Gold, and Silver Award winning posters, a list of Honorable Mentions, and a Poster Museum Directory.

Poster Annual 2020

2019
Hardcover: 240 pages
200-plus color illustrations
Trim: 8.5 x 11.75"
ISBN: 978-1-931241-81-6
US $ 90

Awards: 12 Platinum, 107 Gold, and 230 Silver Awards, along with 149 Honorable Mentions.
Platinum Winners: ARSONAL, Carmit Design Studio, Delcan & Company/Visual Arts Press, Ltd, FX Networks/Iconisus, Gunter Rambow, João Machado Design, Lewis Communications, Marcos Minini Design, OGAWAYOUHEI DESIGN, Stephan Bundi, Studio Hinrichs, and Studio Pekka Loiri.
Judges: All entries were judged by a panel of highly accomplished Poster Designers: Takashi Akiyama, Rikke Hansen, Dermot Mac Cormack, Patricia McElroy, Gunter Rambow, and Hajime Tsushima.
Content: Exceptional posters by each of the talented Judges, Platinum, Gold, and Silver Award winning posters, a list of Honorable Mentions, and a Poster Museum Directory.

Nudes 5

2019
Hardcover: 256 pages
200-plus color illustrations
Trim: 10.06 x 13.41"
ISBN: 978-1-931241-84-7
US $ 90

The fifth volume in this series, Nudes 5 continues to present some of the most refined and creative nudes photography. Just as this genre helped elevate photography into a realm of fine art, one will find that many of the images on these pages deserve to be presented in museums. Award-winning Photographers include Erik Almas, Rosanne Olson, Klaus Kampert, Howard Schatz, Phil Marco, Jo-el-Peter Witkin, Chris Budgeon, among others.

Photography Annual 2019	New Talent Annual 2019	Branding 7

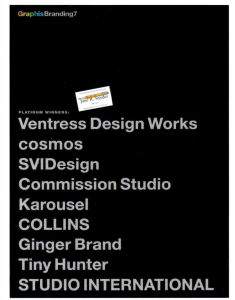

Photography Annual 2019

2019
Hardcover: 256 pages
200-plus color illustrations
Trim: 8.5 x 11.75"
ISBN: 978-1-931241-75-5
US $ 90

Awards: 12 Platinum, 105 Gold, and 184 Silver Awards, along with 146 Honorable Mentions.
Platinum Winners: Athena Azevedo, Caldas Naya, Curious Productions, Jonathan Knowles, Parish Kohanim, Stan Musilek, Joseph Saraceno, Michael Schoenfeld and Staudinger + Franke.
Judges: Graphis Masters Adam Voorhes and Christopher Wilson, as well as Kah Poon and Gregory Reid.
Content: Full-page images of Platinum & Gold Award-winning work from talented Photographers. Silver Award-winning work is also displayed and Honorable Mentions are listed. Up to 500 Platinum, Gold, Silver, and Honorable Mention award-winning entries are archived on graphis.com. This Annual is a valuable resource for Photographers, Design Firms, students, and Photography enthusiasts.

New Talent Annual 2019

2018
Hardcover: 256 pages
200-plus color illustrations
Trim: 8.5 x 11.75"
ISBN: 978-1-931241-66-3
US $ 90

This Annual presents award-winning Instructors and students.
Platinum: Advertising: Frank Anselmo, Josh Ege, Larry Gordon, Seung-Min Han, Patrick Hartmann, Kevin O'Neill, Dong-Joo Park, Hank Richardson, Eileen Hedy Schultz, and Mel White. Design: Brad Bartlett, Devan Carter, Eszter Clark, Carin Goldberg, Seung-Min Han, Marvin Mattelson, Kevin O'Callaghan, Dong-Joo Park, Adrian Pulfer, Ryan Russell, and Kristin Sommese. **Gold:** Advertising: 88; Design: 85; Photography: 5; Film: 36. **Silver:** Advertising: 95; Design: 185; Photography: 9; Film: 40. We award up to 500 Honorable Mentions, encouraging new talent to submit. All winners are equally presented and archived on our website. This book is a tool for teachers to raise their students' standards and gauge how their school stacks up.

Branding 7

2018
Hardcover: 240 pages
200-plus color illustrations
Trim: 8.5 x 11.75"
ISBN: 978-1-931241-73-1
US $ 90

Awards: 10 Platinum, 73 Gold, and 194 Silver Awards, totaling nearly 500 winners, along with 124 Honorable Mentions.
Platinum Winners: Tiny Hunter, COLLINS, cosmos, Ventress Design Works, Karousel, SVIDesign, Ginger Brand, Commission Studio, and STUDIO INTERNATIONAL.
Judges: All entries were judged by a panel of highly accomplished, award-winning Branding Designers: Adam Brodsley of Volume Inc., Cristian "Kit" Paul of Brandient, and Sasha Vidakovic of SVIDesign.
Content: Branding designs from New Talent Annual 2018, award-winning designs by the Judges, and Q&As with this year's Platinum Winners, along with some of their additional work.

Books are available at www.graphis.com/store

In Memory Of My Feelings

original decorations by

Nell Blaine	Jasper Johns
Norman Bluhm	Matsumi Kanemitsu
Joe Brainard	Alex Katz
John Button	Lee Krasner
Giorgio Cavallon	Alfred Leslie
Allan D'Arcangelo	Roy Lichtenstein
Elaine de Kooning	Marisol
Willem de Kooning	Joan Mitchell
Niki de Saint Phalle	Robert Motherwell
Helen Frankenthaler	Reuben Nakian
Jane Freilicher	Barnett Newman
Michael Goldberg	Claes Oldenburg
Philip Guston	Robert Rauschenberg
Grace Hartigan	Larry Rivers
Al Held	Jane Wilson

In Memory
Of My Feelings

—

A Selection of Poems by
Frank O'Hara

Edited by Bill Berkson

The Museum of Modern Art

New York

Preface

Frank O'Hara, the poet, was part of the community of artists who are giving form to the issues, tensions, and release of our turbulent time and who, by doing so, are shaping the living fabric of the present.

Frank O'Hara, the art critic and curator, was also part of that group who are called to use judgment and considerable action to make the artists' work accessible to all who may need it.

Frank was one of the very few who are able to combine these two callings seemingly without conflict; on the contrary, his close associations with artists, as an artist himself, gave his work as critic and curator authority and the warmth of personal experience.

Frank was so sure of his own reactions towards works of art that he did not need to be aggressive. He had absolute integrity without self-righteousness.

For the part of my colleagues at the Museum and myself, it is hard to exaggerate what he gave us. This gift can be measured not only by the solid record of exhibitions in which he participated or the publications that he wrote. It is just possible that his being with us and part of us as a group of people striving to do a decent job was just as important, if not more, than his recorded achievements. It is not easy to describe the value of a person's presence—his works, his temper, his being there. But I know that many of us, because of Frank's presence, learned to see better, to communicate their experiences in clearer forms.

With all this in mind, it was decided that the best way the Museum might honor Frank O'Hara, after his sudden death, would be the publication of a book of his poems decorated by the plastic artists with whom he was associated. This is that book, a homage to the sheer poetry—in all guises and roles—of the man.

RENÉ D'HARNONCOURT

Reuben Nakian	1	Ann Arbor Variations *(July 1951)*
Alex Katz	2	Jane Awake *(ca. 1951)*
Alfred Leslie	3	Poem ("The eager note...") *(February 1950)*
Robert Motherwell	4	Poem *to James Schuyler (ca. 1951)*
Marisol	5	Chez Jane *(September 1952)*
Joe Brainard	6	Blocks *(October 1952)*
Al Held	7	from Second Avenue *(March-April 1953)*
Roy Lichtenstein	8	Romanze, or The Music Students *(October 1953)*
Jane Wilson	9	Ode *(June 18, 1954)*
Joan Mitchell	10	Meditations in an Emergency *(June 25, 1954)*
Elaine de Kooning	11	On the Way to the San Remo *(July 1954)*
John Button	12	Music *(October 1954)*
Niki de Saint Phalle	13	To the Film Industry in Crisis *(November 15, 1955)*
Barnett Newman	14	Sleeping on the Wing *(December 29, 1955)*
Jasper Johns	15	In Memory of My Feelings *(June-July 1956)*
Robert Rauschenberg	16	A Step Away from Them *(August 16, 1956)*
Willem de Kooning	17	Ode to Willem de Kooning *(1957)*

1 · 1

Reuben Nakian / Ann Arbor Variations

Ann Arbor Variations

1

Wet heat drifts through the afternoon
like a campus dog, a fraternity ghost
waiting to stay home from football games.
The arches are empty clear to the sky.

Except for leaves: those lashes of our
thinking and dreaming and drinking sight.
The spherical radiance, the Old English
look, the sum of our being, "hath perced

to the rote" all our springs and falls
and now rolls over our limpness, a daily
dragon. We lose our health in a love
of color, drown in a fountain of myriads,

as simply as children. It is too hot,
our birth was given up to screaming. Our
life on these sweet lawns seems silent.
The leaves chatter their comparisons

to the wind and the sky fills up
before we are out of bed. O infinite
our siestas! adobe effigies in a land
that is sick of us and our tanned flesh.

The wind blows towards us particularly
the sobbing of our dear friends on both
coasts. We are sick of living and afraid
that death will not be by water, o sea.

Along the walks and shaded ways
pregnant women look snidely at children.
Two weeks ago they were told, in these

selfsame pools of trefoil, "the market
for emeralds is collapsing", "chlorophyll
shines in your eyes", "the sea's misery

is progenitor of the dark moss which hides
on the north side of trees and cries".
What do they think of slim kids now?

and how, when the summer's gong of day
and night slithers towards their sweat
and towards the nests of their arms

and thighs, do they feel about children
whose hides are pearly with days of swimming?
Do they mistake these fresh drops for tears?

The wind works over these women constantly!
trying, perhaps, to curdle their milk
or make their spring unseasonably fearful,

season they face with dread and bright eyes.
The leaves, wrinkled or shiny like apples,
wave women courage and sigh, a void temperature.

The alternatives of summer do not remove
us from this place. The fainting into skies
from a diving board, the express train to
Detroit's damp bars, the excess of affection
on the couch near an open window or a Bauhaus
fire-escape, the lazy regions of stars, all
are strangers. Like Mayakovsky read on steps
of cool marble, or Yeats danced in a theatre
of polite music. The classroom day of dozing
and grammar, the partial eclipse of the head
in the row in front of the head of poplars,
sweet Syrinx! last out the summer in a stay
of iron. Workmen loiter before urinals, stare
out windows at girders tightly strapped to clouds.
And in the morning we whimper as we cook
an egg, so far from fluttering sands and azure!

The violent No! of the sun
burns the forehead of hills.
Sand fleas arrive from Salt Lake
and most of the theatres close.

The leaves roll into cigars, or
it seems our eyes stick together
in sleep. O forest, o brook of
spice, o cool gaze of strangers!

the city tumbles towards autumn
in a convulsion of tourists
and teachers. We dance in the dark,
forget the anger of what we blame

on the day. Children toss and murmur
as a rumba blankets their trees and
beckons their stars closer, older, now.
We move o'er the world, being so much here.

It's as if Poseidon left off counting
his waters for a moment! In the fields
the silence is music like the moon.
The bullfrogs sleep in their hairy caves,

across the avenue a trefoil lamp
of the streets tosses luckily.
The leaves, finally, love us! and
moonrise! we die upon the sun.

Alex Katz / Jane Awake

Jane Awake

The opals hiding in your lids
 as you sleep, as you ride ponies
mysteriously, spring to bloom
 like the blue flowers of autumn

each nine o'clock. And curls
 tumble languorously towards
the yawning rubber band, tan,
 your hand pressing all that

riotous black sleep into
 the quiet form of daylight
and its sunny disregard for
 the luminous volutions, oh!

and the budding waltzes
 we swoop through in nights.
Before dawn you roar with
 your eyes shut, unsmiling,

your volcanic flesh hides
 everything from the watchman,
and the tendrils of dreams
 strangle policemen running by

too slowly to escape you,
 the racing vertiginous waves
of your murmuring need. But
 he is day's guardian saint

that policeman, and leaning
 from your open window you ask
him what dress to wear and how
 to comb your hair modestly,

for that is now your mode.
 Only by chance tripping on stairs
do you repeat the dance, and
 then, in the perfect variety of

subdued, impeccably disguised,
 white black pink blue saffron
and golden ambiance, do we find
 the nightly savage, in a trance.

Alfred Leslie / Poem

THE EAGER NOTE ON MY DOOR SAID " CALL ME,

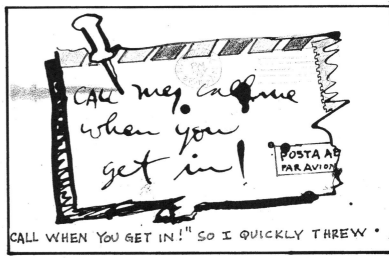

CALL WHEN YOU GET IN!" SO I QUICKLY THREW ·

A FEW TANGERINES INTO MY OVERNIGHT BAG,

STRAIGHTENED MY EYELIDS AND SHOULDERS, AND

HEADED STRAIGHT FOR THE DOOR. IT WAS AUTUMN

BY THE TIME I GOT AROUND THE CORNER, OH ALL

UNWILLING TO BE EITHER PERTINENT OR BEMUSED, BUT

THE LEAVES WERE BRIGHTER THAN GRASS ON THE SIDEWALK!

Poem

The eager note on my door said "Call me, call when you get in!" so I quickly threw a few tangerines into my overnight bag, straightened my eyelids and shoulders, and

headed straight for the door. It was autumn by the time I got around the corner, oh all unwilling to be either pertinent or bemused, but the leaves were brighter than grass on the sidewalk!

Funny, I thought, that the lights are on this late and the hall door open; still up at this hour, a champion jai-alai player like himself? Oh fie! for shame! What a host, so zealous! And he was

there in the hall, flat on a sheet of blood that ran down the stairs. I did appreciate it. There are few hosts who so thoroughly prepare to greet a guest only casually invited, and that several months ago.

Robert Motherwell / Poem

Poem

to James Schuyler

There I could never be a boy,
though I rode like a god when the horse reared.
At a cry from mother I fell to my knees!
there I fell, clumsy and sick and good,
though I bloomed on the back of a frightened black mare
who had leaped windily at the start of a leaf
and she never threw me.

I had a quick heart
and my thighs clutched her back.
I loved her fright, which was against me
into the air! and the diamond white of her forelock
which seemed to smart with thoughts as my heart smarted with life!
and she'd toss her head with the pain
and paw the air and champ the bit, as if I were Endymion
and she, moon-like, hated to love me.

All things are tragic
when a mother watches!
and she wishes upon herself
the random fears of a scarlet soul, as it breathes in and out
and nothing chokes, or breaks from triumph to triumph!

I knew her but I could not be a boy,
for in the billowing air I was fleet and green
riding blackly through the ethereal night
towards men's words which I gracefully understood,

and it was given to me
as the soul is given the hands
to hold the ribbons of life!
as miles streak by beneath the moon's sharp hooves
and I have mastered the speed and strength which is the armor of the world.

Marisol / Chez Jane

Chez Jane

The white chocolate jar full of petals
swills odds and ends around in a dizzying eye
of four o'clocks now and to come. The tiger,
marvellously striped and irritable, leaps
on the table and without disturbing a hair
of the flowers' breathless attention, pisses
into the pot, right down its delicate spout.
A whisper of steam goes up from that porcelain
eurythra. "Saint-Saëns!" it seems to be whispering,
curling unerringly around the furry nuts
of the terrible puss, who is mentally flexing.
Ah be with me always, spirit of noisy
contemplation in the studio, the Garden
of Zoos, the eternally fixed afternoons!
There, while music scratches its scrofulous
stomach, the brute beast emerges and stands,
clear and careful, knowing always the exact peril
at this moment caressing his fangs with
a tongue given wholly to luxurious usages;
which only a moment before dropped aspirin
in this sunset of roses, and now throws a chair
in the air to aggravate the truly menacing.

Joe Brainard / Blocks

Blocks

1

Yippee! she is shooting in the harbor! he is jumping
up to the maelstrom! she is leaning over the giant's
cart of tears which like a lava cone let fall to fly
from the cross-eyed tantrum-tousled ninth grader's
splayed fist is freezing on the cement! he is throwing
up his arms in heavenly desperation, spacious Y of his
tumultuous love-nerves flailing like a poinsettia in
its own nailish storm against the glass door of the
cumulus which is withholding her from these divine
pastures she has filled with the flesh of men as stones!
O fatal eagerness!

2

O boy, their childhood was like so many oatmeal cookies.
I need you, you need me, yum, yum. Anon it became suddenly

3

like someone always losing something and never knowing what.
Always so. They were so fond of eating bread and butter and
sugar, they were slobs, the mice used to lick the floorboards
after they went to bed, rolling their light tails against
the rattling marbles of granulation. Vivo! the dextrose
those children consumed, lavished, smoked, in their knobby
candy bars. Such pimples! such hardons! such moody loves.
And thus they grew like giggling fir trees.

7 · 1

Al Held / from Second Avenue

from Second Avenue

7

"You come to me smelling of the shit of Pyrrhian maidens!
and I as a fast come-on for fascinating fleas-in-ice
become ravenously casual avec quel haut style de chambre!
and deny myself every pasture of cerise cumulus cries.
You yourself had taken out volumes of rare skies' pillars
and then bowed forth screaming 'Lindy Has Made It!' until
everyone showed their teeth to the neighbors of Uncle,
how embarrassing! the whiteness of the imitation of the glass
in which one elegant pig had straddled a pheasant and wept.
Well enough. To garner the snowing snow and then leave,
what an inspiration! as if suddenly, while dancing, someone,
a rather piratish elderly girl, had stuck her fan up her ass
and then become a Chinese legend before the bullrushes ope'd.
Yet I became aware of history as rods stippling the dip
of a fancied and intuitive scientific roadmap, clarté et
volupté et vif! swooping over the valley and under the lavender
where children prayed and had stillborn blue brothers of
entirely other races, the Tour Babel, as they say, said.
I want listeners to be distracted, as fur rises when most needed
and walks away to be another affair on another prairie,
yowee, it's heaven in Heaven! with the leaves falling
like angels who've been discharged for sodomy
and it all almost over, that is too true to last, that is,
'rawther old testament, dontcha know'. When they bite,
you've never seen anything more beautiful, the sheer fantail
of it and them delicately clinging to the crimson box
like so many squid, for sweetness. Do you have the haveness
of a collapse, of a rummaging albatross that sings? No!
don't even consider asking me to the swimming team's tea-
and-alabaster breakfast. I just don't want to be asked."

The mountains had trembled, quivering as if about to withdraw,
and where the ships had lined up on the frontier waiting for
the first gunshot, a young girl lunched on aspergum. A cow
belched. The sun went. Later in the day Steven farted.
He dropped his torpedo into the bathtub. Flowers. Relativity.

Al Held / from Second Avenue

He stayed under water 65 seconds the first time and 84 the second.
Sheer Olympia, the last of the cat-lovers, oh Jimmy!
the prettiest cat in New York. A waiter stole the dollar bill
while the people sang in the Cicada Circle built in 1982
at a cost of three rose petals. She told him she'd miss him
when she went to live in the marshgrass, did Berdie,
and he thought, "You'll miss me like that emerald I have at home
I forgot to give you when I lost my pink Birthday Book
when it was smuggled out of Europe in a box of chocolate-cherries."
Thirty-five cancerous growths were removed from as many breasts
in one great iron-grill-work purple apartment house yesterday,
and this tribute to the toughness of the Air Corps is like rain.

Had not all beautiful things become real on Wednesday?
and had not your own bumbleshoot caressed a clergyman and autos?
To be sure, the furniture was wrinkled, but a cat doesn't wink,
and her motto exists on the Liberian Ambassador's stationery,
"Amor vincit et Cicero vidit" in sachets of morning-glories.

8

Candidly. The past, the sensations of the past. Now!
in cuneiform, of umbrella satrap square-carts with hotdogs
and onions of red syrup blended, of sand bejewelling the prepuce
in tank suits, of Majestic Camera Stores and Schuster's,
of Kenneth in an abandoned storeway on Sunday cutting ever more
insinuating lobotomies of a yet-to-be-more-yielding world
of ears, of a soprano rallying at night in a cadenza, Bill, of
"Fornications, la! garumph! tereu! lala la! vertigo! Weevy! Hah!",
of a limp hand larger than the knee which seems to say "Addio"
and is capable of resigning from the disaster it summoned ashore.
Acres of glass don't make the sign clearer of the landscape
less blue than prehistorically, yet less distant, eager, dead!
and generations of thorns are reconstructed as a mammoth
unstitched from the mighty thigh of the glacier, the Roaring Id.
You remained for me a green Buick of sighs, o Gladstone!
and your wife Trina, how like a yellow pillow on a sill
in the many-windowed dusk where the air is compartmented!

her red lips of Hollywood, soft as a Titian and as tender,
her grey face which refrains from thrusting aside the mane
of your languorous black smells, the hand crushed by her chin,
and that slumberland of dark cutaneous lines which reels
under the burden of her many-darkly-hued corpulence of linen

and satin bushes, is like a lone rose with the sky behind it.
A yellow rose. Valentine's Day. "Imagine that substance
extended for two hours of theatre and you see the inevitable,
the disappearance of vigor in a heart not sufficiently basted
or burnt, the mere apparition of feeling in an empty bedroom.
Zounds!! you want money? Take my watch which is always fast."

Accuracy has never envisaged itself as occurring; rather a
negligence, royal in retreating upwards of the characteristics
of multitudes. "You call me Mamie, but I'm monickered Sanskrit
in the San Remo, and have a divorce inside my lamé left breast,"
so into the headlands where the peaceful aborigines eat the meat
that's always white, no muscles, no liver, no brains, no, no,
tongue, that's it. Weary. Well, forgetting you not is forgetting,
even if I think of you tall the day, and forgetting you is
forgiving you not, for I am weeping from a tall wet dream, oh.
Cantankerous month! have you ever moved more slowly into surf?
Oh Bismarck! fortitude! exceptional delights of intelligence!
yappings at cloister doors! dimpled marshmallows! oh March!

11

My hands are Massimo Plaster, called "White Pin in the Arm of the Sea"
and I'm blazoned and scorch like a fleet of windbells down the Pulaski Skyway,
tabletops of Vienna carrying their bundles of cellophane to the laundry,
ear to the tongue, glistening semester of ardency, young-old daringnesses
at the foot of the most substantial art product of our times,
the world, the jongleurs, fields of dizzyness and dysentery
before reaching Mexico, the palace of stammering sinking success
before billows of fangs, red faces, orange eyebrows, green, yes! ears,
O paradise! my airplanes known as "Banana Line Incorporealidad",
saviors of connections and spit, dial HYacinth 9-9945, "Isn't that
a conundrum?" asked him Sydney Burger, humming "Mein' Yiddisher Mama",
I emulate the black which is a cry but is not voluptuary like a warning,
which has lines, cuts, drips, aspirates, trembles with horror,
O black looks at the base of the spine! kisses on the medulla oblongata
of an inky clarity! always the earlobes in the swiftest bird's-death
of night, the snarl of expiation which is the skirt of Hercules,
and the remorse in the desert shouts "Flea! Bonanza! Cheek! Teat!
Elbow of roaches! You wear my white rooster like a guerdon in vales
of Pompeiian desires, before utter languorousness puts down its chisel",
and the desert is here. "You've reached the enormous summit of passion
which is immobility forging an entrail from the pure obstruction of the air."

Romanze,
or The Music Students

1

The rain, its tiny pressure
on your scalp, like ants
passing the door of a tobacconist.
"Hello!" they cry, their noses
glistening. They are humming
a scherzo by Tscherepnine.
They are carrying violin cases.
With their feelers knitting
over their heads the blue air,
they appear at the door of
the Conservatory and cry "Ah!"
at the honey of its outpourings.
They stand in the street and hear
the curds drifting on the top
of the milk of Conservatory doors.

2

They had thought themselves
in Hawaii when suddenly the pines,
trembling with nightfulness,
shook them out of their sibyllance.
The surf was full of outriggers
racing like slits in the eye of
the sun, yet the surf was full
of great black logs plunging, and
then the surf was full of needles.
The surf was bland and white,
as pine trees are white when,
in Paradise, no wind is blowing.

8 · 2

Roy Lichtenstein / Romanze, or The Music Students

3

In Ann Arbor on Sunday afternoon
at four-thirty they went to an organ
recital: Messiaen, Hindemith, Czerny.
And in their ears a great voice said
"To have great music we must commission
it. To commission great music
we must have great commissioners."
There was a blast! and summer was over.

4

Rienzi! A rabbit is sitting in the hedge!
it is a brown stone! it is the month
of October! it is an orange bassoon!
They've been standing on this mountain
for forty-eight hours without flinching.
Well, they are soldiers, I guess,
and it is all marching magnificently by.

Jane Wilson / Ode

Ode

An idea of justice may be precious,
one vital gregarious amusement . . .

What are you amused by? a crisis
like a cow being put on the payroll
with the concomitant investigations and divinings?
Have you swept the dung from the tracks?

 Am I a door?
If millions criticize you for drinking too much,
the cow is going to look like Venus and you'll make a pass
yes, you and your friend from High School,
the basketball player whose black eyes exceed yours
as he picks up the ball with one hand.
 But doesn't he doubt, too?

 To be equal? it's the worst!
 Are we just muddy instants?
No, you must treat me like a fox; or, being a child,
kill the oriole though it reminds you of me.
Thus you become the author of all being. Women
 unite against you.

It's as if I were carrying a horse on my shoulders
and I couldn't see his face. His iron legs
hang down to the earth on either side of me
like the arch of triumph in Washington Square.
I would like to beat someone with him
but I can't get him off my shoulders, he's like evening.
Evening! your breeze is an obstacle,

 it changes me, I am being arrested,
 and if I mock you into a face
and, disgusted, throw down the horse—ah! there's his face!
and I am, sobbing, walking on my heart.

9 · 2

Jane Wilson / Ode

I want to take your hands off my hips
 and put them on a statue's hips;
then I can thoughtfully regard the justice of your feelings
for me, and, changing, regard my own love for you
as beautiful. I'd never cheat you and say "It's inevitable!"

 It's just barely natural.
 But we do course together
like two battleships maneuvering away from the fleet.
I am moved by the multitudes of your intelligence
and sometimes, returning, I become the sea—
in love with your speed, your heaviness and breath.

10 · 1

Joan Mitchell / Meditations in an Emergency

Meditations in an Emergency

Am I to become profligate as if I were a blonde? Or religious as if I were French?

Each time my heart is broken it makes me feel more adventurous (and how the same names keep recurring on that interminable list!), but one of these days there'll be nothing left with which to venture forth.

Why should I share you? Why don't you get rid of someone else for a change?

I am the least difficult of men. All I want is boundless love.

Even trees understand me! Good heavens, I lie under them, too, don't I? I'm just like a pile of leaves.

However, I have never clogged myself with the praises of pastoral life, nor with nostalgia for an innocent past of perverted acts in pastures. No. One need never leave the confines of New York to get all the greenery one wishes — I can't even enjoy a blade of grass unless I know there's a subway handy, or a record store or some other sign that people do not totally *regret* life. It is more important to affirm the least sincere; the clouds get enough attention as it is and even they continue to pass. Do they know what they're missing? Uh huh.

My eyes are vague blue, like the sky, and change all the time; they are indiscriminate but fleeting, entirely specific and disloyal, so that no one trusts me. I am always looking away. Or again at something after it has given me up. It makes me restless and that makes me unhappy, but I cannot keep them still. If only I had grey, green, black, brown, yellow eyes; I would stay at home and do something. It's not that I'm curious. On the contrary, I am bored but it's my duty to be attentive, I am needed by things as the sky must be above the earth. And lately, so great has *their* anxiety become, I can spare myself little sleep.

Now there is only one man I love to kiss when he is unshaven, Heterosexuality! you are inexorably approaching. (How discourage her?)

St. Serapion, I wrap myself in the robes of your whiteness which is like midnight in Dostoevsky. How am I to become a legend, my dear? I've tried love, but that hides you in the bosom of another and I am always springing forth from it like the lotus—the ecstasy of always bursting forth! (but one must not be distracted by it!) or like a hyacinth, "to keep the filth of life away," yes, there, even in the heart, where the filth is pumped in and slander and pollutes and determines. I will my will, though I may become famous for a mysterious vacancy in that department, that greenhouse.

Destroy yourself, if you don't know!

It is easy to be beautiful; it is difficult to appear so. I admire you, beloved, for the trap you've set. It's like a final chapter no one reads because the plot is over.

"Fanny Brown is run away—scampered off with a Cornet of Horse; I do love that little Minx, & hope She may be happy, tho' She has vexed me by this Exploit a little too. —Poor silly Cecchina! of F: B: as we used to call her.—I wish She had a good Whipping and 10,000 pounds." —Mrs. Thrale.

I've got to get out of here. I choose a piece of shawl and my dirtiest suntans. I'll be back, I'll re-emerge, defeated, from the valley; you don't want me to go where you go, so I go where you don't want me to. It's only afternoon, there's a lot ahead. There won't be any mail downstairs. Turning, I spit in the lock and the knob turns.

Elaine de Kooning / On the Way to the San Remo

On the Way to the San Remo

The black ghinkos snarl their way up
the moon growls at each blinking window
the apartment houses climb deafeningly into the purple

 A bat hisses northwards
 the perilous steps lead to a grate
 suddenly the heat is bearable

The cross-eyed dog scratches a worn patch of pavement
his right front leg is maimed in the shape of a V
there's no trace of his nails on the street a woman cajoles

 She is very old and dirty
 she whistles her filthy hope
 that it will rain tonight

The 6th Avenue bus trunk-lumbers sideways
it is full of fat people who cough as at a movie
they eat each other's dandruff in the flickering glare

 The moon passes into clouds
 so hurt by the street lights
 of your glance oh my heart

The act of love is also passing like a subway bison
through the paper-littered arches of the express tracks
the sailor sobers he feeds pennies to the peanut machines

 Though others are in the night
 far away lips upon a dusty armpit
 the nostrils are full of tears

High fidelity reposed in a box a hand on the windowpane
the sweet calm the violin strings tie a young man's hair
the bright black eyes pin far away their smudged curiosity

 Yes you are foolish smoking
 the bars are for rabbits
 who wish to outlive the men

John Button / Music

Music

If I rest for a moment near The Equestrian
pausing for a liver sausage sandwich in the Mayflower Shoppe,
that angel seems to be leading the horse into Bergdorf's
and I am naked as a table cloth, my nerves humming.
Close to the fear of war and the stars which have disappeared.
I have in my hands only 35c, it's so meaningless to eat!
and gusts of water spray over the basins of leaves
like the hammers of a glass pianoforte. If I seem to you
to have lavender lips under the leaves of the world,
 I must tighten my belt.
It's like a locomotive on the march, the season
 of distress and clarity
and my door is open to the evenings of midwinter's
lightly falling snow over the newspapers.
Clasp me in your handkerchief like a tear, trumpet
of early afternoon! in the foggy autumn.
As they're putting up the Christmas trees on Park Avenue
I shall see my daydreams walking by with dogs in blankets,
put to some use before all those coloured lights come on!
 But no more fountains and no more rain,
 and the stores stay open terribly late.

Niki de Saint Phalle / To the Film Industry in Crisis

To the Film Industry in Crisis

Not you, lean quarterlies and swarthy periodicals
with your studious incursions toward the pomposity of ants,
nor you, experimental theatre in which Emotive Fruition
is wedding Poetic Insight perpetually, nor you,
promenading Grand Opera, obvious as an ear (though you
are close to my heart), but you, Motion Picture Industry,
it's you I love!

In times of crisis, we must all decide again and again whom we love.
And give credit where it's due: not to my starched nurse, who taught me
how to be bad and not bad rather than good (and has lately availed
herself of this information), not to the Catholic Church
which is at best an over-solemn introduction to cosmic entertainment,
not to the American Legion, which hates everybody, but to you,
glorious Silver Screen, tragic Technicolor, amorous Cinemascope,
stretching Vistavision and startling Stereophonic Sound, with all
your heavenly dimensions and reverberations and iconoclasms! To

Richard Barthelmess as the "tol'able" boy barefoot and in pants,
Jeanette MacDonald of the flaming hair and lips and long, long neck,
Sue Carroll as she sits for eternity on the damaged fender of a car
and smiles, Ginger Rogers with her pageboy bob like a sausage
on her shuffling shoulders, peach-melba-voiced Fred Astaire of the feet,
Erich von Stroheim, the seducer of mountain-climbers' gasping spouses,
the Tarzans, each and every one of you (I cannot bring myself to prefer
Johnny Weissmuller to Lex Barker, I cannot!) Mae West in a furry sled,
her bordello radiance and bland remarks, Rudolph Valentino of the moon,
its crushing passions, and moon-like, too, the gentle Norma Shearer,
Miriam Hopkins dropping her champagne glass off Joel McCrea's yacht
and crying into the dappled sea, Clark Gable rescuing Gene Tierney
from Russia and Allan Jones rescuing Kitty Carlisle from Harpo Marx,
Cornel Wilde coughing blood on the piano keys while Merle Oberon berates,
Marilyn Monroe in her little spike heels reeling through Niagara Falls,

Niki de Saint Phalle / To the Film Industry in Crisis

Niki de Saint Phalle

Joseph Cotten puzzling and Orson Welles puzzled and Dolores del Río
eating orchids for lunch and breaking mirrors, Gloria Swanson reclining,
and Jean Harlow reclining and wiggling, and Alice Faye reclining
and wiggling and singing, Myrna Loy being calm and wise, William Powell
in his stunning urbanity, Elizabeth Taylor blossoming, yes, to you

and to all you others, the great, the neargreat, the featured, the extras
who pass quickly and return in dreams saying your one or two lines,
my love!
Long may you illumine space with your marvellous appearances, delays
and enunciations, and may the money of the world glitteringly cover you
as you rest after a long day under the kleig lights with your faces
in packs for our edification, the way the clouds come often at night
but the heavens operate on the star system. It is a divine precedent
you perpetuate! Roll on, reels of celluloid, as the great earth rolls on!

14

Barnett Newman / Sleeping on the Wing

Sleeping on the Wing

Perhaps it is to avoid some great sadness,
as in a Restoration tragedy the hero cries "Sleep!
O for a long sound sleep and so forget it!"
that one flies, soaring above the shoreless city,
veering upward from the pavement as a pigeon
does when a car honks or a door slams, the door
of dreams, life perpetuated in parti-colored loves
and beautiful lies all in different languages.

Fear drops away too, like the cement, and you
are over the Atlantic. Where is Spain? where is
who? The Civil War was fought to free the slaves,
was it? A sudden down-draught reminds you of gravity
and your position in respect to human love. But
here is where the gods are, speculating, bemused.
Once you are helpless, you are free, can you believe
that? Never to waken to the sad struggle of a face?
to travel always over some impersonal vastness,
to be out of, forever, neither in nor for!

The eyes roll asleep as if turned by the wind
and the lids flutter open slightly like a wing.
The world is an iceberg, so much is invisible!
and was and is, and yet the form, it may be sleeping
too. Those features etched in the ice of someone
loved who died, you are a sculptor dreaming of space
and speed, your hand alone could have done this.

Curiosity, the passionate hand of desire. Dead,
or sleeping? Is there speed enough? And, swooping,
you relinquish all that you have made your own,
the kingdom of your self sailing, for you must awake
and breathe your warmth in this beloved image
whether it's dead or merely disappearing,
as space is disappearing and your singularity.

15 · 1

Jasper Johns / In Memory of My Feelings

In Memory of My Feelings

1

My quietness has a man in it, he is transparent
and he carries me quietly, like a gondola, through the streets.
He has several likenesses, like stars and years, like numerals.

My quietness has a number of naked selves,
so many pistols I have borrowed to protect myselves
from creatures who too readily recognize my weapons
and have murder in their heart!
 though in winter
they are warm as roses, in the desert
taste of chilled anisette.
 At times, withdrawn,
I rise into the cool skies
and gaze on at the imponderable world with the simple identification
of my colleagues, the mountains. Manfred climbs to my nape,
speaks, but I do not hear him,
 I'm too blue.
An elephant takes up his trumpet,
money flutters from the windows of cries, silk stretching its mirror
across shoulder blades. A gun is "fired."
 One of me rushes
to window #13 and one of me raises his whip and one of me
flutters up from the center of the track amidst the pink flamingoes,
and underneath their hooves as they round the last turn my lips
are scarred and brown, brushed by tails, masked in dirt's lust,
definition, open mouths gasping for the cries of the bettors for the lungs
of earth.
 So many of my transparencies could not resist the race!
Terror in earth, dried mushrooms, pink feathers, tickets,
a flaking moon drifting across the muddied teeth,
the imperceptible moan of covered breathing,
 love of the serpent!
I am underneath its leaves as the hunter crackles and pants
and bursts, as the barrage-balloon drifts behind a cloud
and animal death whips out its flashlight,
 whistling

15 · 2

Jasper Johns / In Memory of My Feelings

and slipping the glove off the trigger hand. The serpent's eyes
redden at sight of those thorny fingernails, he is so smooth!
 My transparent selves
flail about like vipers in a pail, writhing and hissing
without panic, with a certain justice of response
and presently the aquiline serpent comes to resemble the Medusa.

 2

The dead hunting
and the alive, ahunted.
 My father, my uncle,
my grand-uncle and the several aunts. My
grand-aunt dying for me, like a talisman, in the war,
before I had even gone to Borneo
her blood vessels rushed to the surface
and burst like rockets over the wrinkled
invasion of the Australians, her eyes aslant
like the invaded, but blue like mine.
An atmosphere of supreme lucidity,
 humanism,
the mere existence of emphasis,
 a rusted barge
painted orange against the sea
full of Marines reciting the Arabian ideas
which are a proof in themselves of seasickness
which is a proof in itself of being hunted.
A hit? *ergo* swim.
 My 10 my 19,
my 9, and the several years. My
12 years since they all died, philosophically speaking.
And now the coolness of a mind
like a shuttered suite in the Grand Hotel
where mail arrives for my incognito,
 whose façade
has been slipping into the Grand Canal for centuries;
rockets splay over a *sposalizio*,
 fleeing into night
from their Chinese memories, and it is a celebration,
the trying desperately to count them as they die.
But who will stay to be these numbers
when all the lights are dead?

The most arid stretch is often richest,
the hand lifting towards a fig tree from hunger
 digging
and there is water, clear, supple, or there
deep in the sand where death sleeps, a murmurous bubbling
proclaims the blackness that will ease and burn.
You preferred the Arabs? but they didn't stay to count
their inventions, racing into sands, converting themselves into
so many,
 embracing, at Ramadan, the tenderest effigies of
themselves with penises shorn by the hundreds, like a camel
ravishing a goat.
 And the mountainous-minded Greeks could speak
of time as a river and step across it into Persia, leaving the pain
at home to be converted into statuary. I adore the Roman copies.
And the stench of the camel's spit I swallow,
and the stench of the whole goat. For we have advanced, France,
together into a new land, like the Greeks, where one feels nostalgic
for mere ideas, where truth lies on its death-bed like an uncle
and one of me has a sentimental longing for number,
as has another for the ball gowns of the Directoire and yet
another for "Destiny, Paris, destiny!"
 or "Only a king may kill a king."

How many selves are there in a war hero asleep in names? under
a blanket of platoon and fleet, orderly. For every seaman
with one eye closed in fear and twitching arm at a sigh for Lord Nelson,
he is all dead; and now a meek subaltern writhes in his bedclothes
with the fury of a thousand, violating an insane mistress
who has only herself to offer his multitudes.
 Rising,
he wraps himself in the burnoose of memories against the heat of life
and over the sands he goes to take an algebraic position *in re*
a sun of fear shining not too bravely. He will ask himselves to
vote on fear before he feels a tremor,
 as runners arrive from the mountains
bearing snow, proof that the mind's obsolescence is still capable
of intimacy. His mistress will follow him across the desert

15 · 3

Jasper Johns / In Memory of My Feelings

Jasper Johns / In Memory of My Feelings

like a goat, towards a mirage which is something familiar about
one of his innumerable wrists,
 and lying in an oasis one day,
playing catch with coconuts, they suddenly smell oil.

<div align="center">4</div>

Beneath these lives
the ardent lover of history hides,
 tongue out
leaving a globe of spit on a taut spear of grass
and leaves off rattling his tail a moment
to admire this flag.
 I'm looking for my Shanghai Lil.
Five years ago, enamored of fire-escapes, I went to Chicago,
an eventful trip: the fountains! The Art Institute, the Y
for both sexes, absent Christianity.
 At 7, before Jane
was up, the copper lake stirred against the sides
of a Norwegian freighter; on the deck a few dirty men,
tired of night, watched themselves in the water
as years before the German prisoners on the *Prinz Eugen*
dappled the Pacific with their sores, painted purple
by a Naval doctor.
 Beards growing, and the constant anxiety
over looks. I'll shave before she wakes up. Sam Goldwyn
spent $2,000,000 on Anna Sten, but Grushenka left America.
One of me is standing in the waves, an ocean bather,
or I am naked with a plate of devils at my hip.
 Grace
to be born and live as variously as possible. The conception
of the masque barely suggests the sordid identifications.
I am a Hittite in love with a horse. I don't know what blood's
in me I feel like an African prince I am a girl walking downstairs
in a red pleated dress with heels I am a champion taking a fall
I am a jockey with a sprained ass-hole I am the light mist
 in which a face appears
and it is another face of blonde I am a baboon eating a banana
I am a dictator looking at his wife I am a doctor eating a child

and the child's mother smiling I am a Chinaman climbing a mountain
I am a child smelling his father's underwear I am an Indian
sleeping on a scalp

 and my pony is stamping in the birches,
and I've just caught sight of the *Niña*, the *Pinta* and the *Santa Maria*.
 What land is this, so free?

 I watch
the sea at the back of my eyes, near the spot where I think
in solitude as pine trees groan and support the enormous winds,
they are humming *L'Oiseau de feu*!

 They look like gods, these whitemen,
and they are bringing me the horse I fell in love with on the frieze.

 5

And now it is the serpent's turn.
I am not quite you, but almost, the opposite of visionary.
You are coiled around the central figure,

 the heart
that bubbles with red ghosts, since to move is to love
and the scrutiny of all things is syllogistic,
the startled eyes of the dikdik, the bush full of white flags
fleeing a hunter,

 which is our democracy

 but the prey
is always fragile and like something, as a seashell can be
a great Courbet, if it wishes. To bend the ear of the outer world.

 When you turn your head
can you feel your heels, undulating? that's what it is
to be a serpent. I haven't told you of the most beautiful things
in my lives, and watching the ripple of their loss disappear
along the shore, underneath ferns,

 face downward in the ferns
my body, the naked host to my many selves, shot
by a guerrilla warrior or dumped from a car into ferns
which are themselves *journalières*.

 The hero, trying to unhitch his parachute,
stumbles over me. It is our last embrace.

 And yet

I have forgotten my loves, and chiefly that one, the cancerous
statue which my body could no longer contain,

 against my will
 against my love

become art,
 I could not change it into history
and so remember it,
 and I have lost what is always and everywhere
present, the scene of my selves, the occasion of these ruses,
which I myself and singly must now kill
 and save the serpent in their midst.

16 · 1

Robert Rauschenberg / A Step Away from Them

BUTT TO IMAGE

A Step Away from Them

It's my lunch hour, so I go
for a walk among the hum-colored
cabs. First, down the sidewalk
where laborers feed their dirty
glistening torsos sandwiches
and Coca-Cola, with yellow helmets
on. They protect them from falling
bricks, I guess. Then onto the
avenue where skirts are flipping
above heels and blow up over
grates. The sun is hot, but the
cabs stir up the air. I look
at bargains in wristwatches. There
are cats playing in sawdust.
 On
to Times Square, where the sign
blows smoke over my head, and higher
the waterfall pours lightly. A
Negro stands in a doorway with a
toothpick, languorously agitating.
A blonde chorus girl clicks: he
smiles and rubs his chin. Everything
suddenly honks: it is 12:40 of
a Thursday.
 Neon in daylight is a
great pleasure, as Edwin Denby would
write, as are light bulbs in daylight.
I stop for a cheeseburger at JULIET'S
CORNER. Giulietta Masina, wife of
Federico Fellini, è bell'attrice.
And chocolate malted. A lady in
foxes on such a day puts her poodle
in a cab.

16 · 2

Robert Rauschenberg / A Step Away from Them

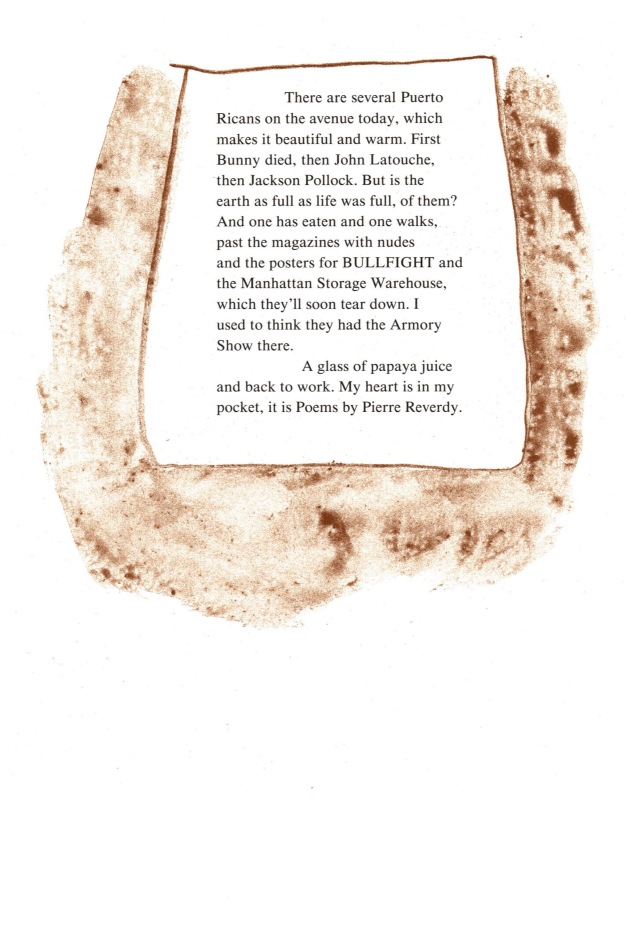

There are several Puerto
Ricans on the avenue today, which
makes it beautiful and warm. First
Bunny died, then John Latouche,
then Jackson Pollock. But is the
earth as full as life was full, of them?
And one has eaten and one walks,
past the magazines with nudes
and the posters for BULLFIGHT and
the Manhattan Storage Warehouse,
which they'll soon tear down. I
used to think they had the Armory
Show there.

A glass of papaya juice
and back to work. My heart is in my
pocket, it is Poems by Pierre Reverdy.

17 · 1

Willem de Kooning / Ode to Willem de Kooning

Ode to Willem de Kooning

<center>1</center>

Beyond the sunrise
where the black begins

<div style="margin-left:40%">an enormous city
is sending up its shutters</div>

and just before the last lapse of nerve which I am already sorry for,
that friends describe as "just this once" in a temporary hell, I hope

I try to seize upon greatness
which is available to me

<div style="margin-left:40%">through generosity and
lavishness of spirit, yours</div>

not to be inimitably weak
and picturesque, my self

<div style="margin-left:40%">but to be standing clearly
alone in the orange wind</div>

while our days tumble and rant through Gotham and the Easter narrows
and I have not the courage to convict myself of cowardice or care

for now a long history slinks over the sill, of patent absurdities
and the fathomless miseries of a small person upset by personality

and I look to the flags
in your eyes as they go up

<div style="margin-left:40%">on the enormous walls
as the brave must always ascend</div>

into the air, always the musts
like banderillas dangling

and jingling jewel-like amidst the red drops on the shoulders of men
who lead us not forward or backward, but on as we must go on

<div style="margin-left:40%">out into the mesmerized world
of inanimate voices like traffic</div>

noises, hewing a clearing
in the crowded abyss of the West

17 · 2

Willem de Kooning / Ode to Willem de Kooning

Stars of all passing sights,
language, thought and reality,
"I am assuming that one knows
what it is to be ashamed"
and that the light we seek
is broad and pure, not winking
and that the evil inside us
now and then strolls into a field
and sits down like a forgotten rock
while we walk on to a horizon
line that's beautifully keen,
precarious and doesn't sag
beneath our variable weight

In this dawn as in the first
it's the Homeric rose, its scent
that leads us up the rocky path
into the pass where death
can disappear or where the face
of future senses may appear
in a white night that opens
after the embattled hours of day

And the wind tears up the rose
fountains of prehistoric light
falling upon the blinded heroes
who did not see enough or were not
mad enough or felt too little
when the blood began to pour down
the rocky slopes into pink seas

17 · 3

Willem de Kooning / Ode to Willem de Kooning

Dawn must always recur
 to blot out stars and the terrible systems
of belief
 Dawn, which dries out the web so the wind can blow it
 spider and all, away
Dawn,

 erasing blindness from an eye inflamed,
 reaching for its
morning cigarette in Promethean inflection
 after the blames
and desperate conclusions of the dark
 where messages were intercepted
by an ignorant horde of thoughts
 and all simplicities perished in desire
A bus crashes into a milk truck
 and the girl goes skating up the avenue
with streaming hair
 roaring through fluttering newspapers
and their Athenian contradictions
 for democracy is joined
with stunning collapsible savages, all natural and relaxed and free

as the day zooms into space and only darkness lights our lives,
with few flags flaming, imperishable courage and the gentle will
which is the individual dawn of genius rising from its bed

"maybe they're wounds, but maybe they are rubies"
 each painful as a sun

Philip Guston / Ode to Michael Goldberg('s Birth and Other Births)

Ode to Michael Goldberg ('s Birth and Other Births)

I don't remember anything of then, down there around the magnolias
 where I was no more comfortable than I've been since
 though aware of a certain neutrality called satisfaction
 sometimes
and there's never been an opportunity to think of it as an idyll
as if everyone'd been singing around me, or around a tulip tree

a faint stirring of that singing seems to come to me in heavy traffic
but I can't be sure that's it, it may be some more recent singing
from hours of dusk in bushes playing tag, being called in, walking up
onto the porch crying bitterly because it wasn't a veranda
"smell that honeysuckle?" or a door you can see through terribly clearly,
 even the mosquitoes saw through it
suffocating netting
or more often being put into a brown velvet suit and kicked around
perhaps that was my last real cry for myself
in a forest you think of birds, in traffic you think of tires,
 where are you?
in Baltimore you think of hats and shoes, like Daddy did

 I hardly ever think of June 27, 1926
 when I came moaning into my mother's world
 and tried to make it mine immediately
 by screaming, sucking, urinating
 and carrying on generally
 it was quite a day

18 · 2

Philip Guston / Ode to Michael Goldberg('s Birth and Other Births)

I wasn't proud of my penis yet, how did I know how to act? it was 1936
"no excuses, now"

 Yellow morning
 silent, wet
 blackness under the trees over stone walls
hay, smelling faintly of semen
 a few sheltered flowers nodding and smiling
at the clattering cutter-bar
 of the mower ridden by Jimmy Whitney
"I'd like to put my rolling-pin to her" his brother Bailey
 leaning on his pitch-fork, watching
 "you shove it in and nine months later
it comes out a kid"
 Ha ha where those flowers would dry out
and never again be seen
 except as cow-flaps, hushed noon drinking cold
water in the dusty field "their curly throats" big milk cans

 full of cold spring water, sandy hair, black hair

 I went to my first movie
 and the hero got his legs
 cut off by a steam engine
 in a freightyard, in my second

 Karen Morley got shot
 in the back by an arrow
 I think she was an heiress
 it came through her bathroom door

 there was nobody there
 there never was anybody
 there at any time
 in sweet-smelling summer
I'd like to stay
 in this field forever
 and think of nothing
but these sounds,
 these smells and the tickling grasses
 "up your ass, Sport"

Up on the mountainous hill
behind the confusing house
where I lived, I went each
day after school and some nights
with my various dogs, the
terrier that bit people, Arno
the shepherd (who used to
be wild but had stopped), the
wire-haired that took fits
and finally the boring gentle
cocker, spotted brown and white,
named Freckles there,

the wind sounded exactly like
Stravinsky
 I first recognized art
as wildness, and it seemed right,
 I mean rite, to me

climbing the water-tower I'd
look out for hours in wind
and the world seemed rounder
and fiercer and I was happier
because I wasn't scared of falling off

nor off the horses, the horses!
to hell with the horses, bay and black

 It's odd to have secrets at an early age, trysts
whose thoughtfulness and sweetness are those of a very aggressive person
 carried beneath your shirt like an amulet against your sire
 what one must do is done in a red twilight
 on colossally old and dirty furniture with knobs,
 and on Sunday afternoons you meet in a high place
 watching the Sunday drivers and the symphonic sadness
 stopped, a man in a convertible puts his hand up a girl's skirt
 and again the twitching odor of hay, like a minor irritation
that gives you a hardon, and again the roundness of horse noises

18 · 3

Philip Guston / Ode to Michael Goldberg('s Birth and Other Births)

"Je suis las de vivre au pays natal"
 but unhappiness, like Mercury, transfixed me
 there, un repaire de vipères
 and had I known the strength and durability
of those invisible bonds I would have leaped from rafters onto prongs
then
 and been carried shining and intact
 to the Indian Cemetery near the lake
 but there is a glistening
 blackness in the center
 if you seek it

here . . . it's capable of bursting
 into flame or merely
 gleaming profoundly in
 the platinum setting
 of your ornamental
 human ties and hates
hanging between breasts
 or, cross-like, on a chest of hairs
the center of myself is never silent
 the wind soars, keening overhead
and the vestments of unnatural safety
 part to reveal a foreign land
toward whom I have been selected to bear
 the gift of fire
 the temporary place of light, the land of air

down where a flame illumines gravity and means warmth and insight,
 where air is flesh, where speed is darkness

and
 things can suddenly be reached, held, dropped and known

where a not totally imaginary ascent can begin all over again in tears

 A couple of specifically anguished days
 make me now distrust sorrow, simple sorrow
 especially, like sorrow over death

 it makes you wonder who you are to be sorrowful
 over death, death belonging to another
 and suddenly inhabited by you without permission

you moved in impulsively and took it up
declaring your Squatters' Rights in howls
or screaming with rage, like a parvenu in a Chinese laundry

disbelieving your own feelings is the worst
and you suspect that you are jealous of this death

YIPPEE! I'm glad I'm alive

 "I'm glad you're alive
too, baby, because I want to fuck you"
 you are pink
 and despicable in the warm breeze drifting in the window
and the rent
 is due, in honor of which you have borrowed $34.96 from Joe
and it's all over but the smoldering hatred of pleasure
 a gorgeous purple like somebody's favorite tie
 "Shit, that means you're getting kind of ascetic, doesn't it?"

 So I left, the stars were shining
 like the lights around a swimming pool

 you've seen a lot of anemones, too
 haven't you, Old Paint? through the
 Painted Desert to the orange covered
 slopes where a big hill was moving in
 on LA and other stars were strolling
 in shorts down palm-stacked horse-walks
 and I stared with my strained SP stare
 wearing a gun
 the doubts
 of a life devoted to leaving rumors of love for new
from does she love me to do I love him,
 sempiternal farewell to hearths
and the gods who don't live there

 in New Guinea a Sunday morning figure
 reclining outside his hut in Lamourish languor
 and an atabrine-dyed hat like a sick sun
 over his ebony land on your way to breakfast

 he has had his balls sowed into his mouth
 by the natives who bleach their hair in urine
 and their will; a basketball game and a concert
 later if you live to write, it's not all advancing
 towards you, he had a killing desire for their women

18 · 4

Philip Guston / Ode to Michael Goldberg('s Birth and Other Births)

but more killing still the absence of desire, which in religion
 used to be called hope,
I don't just mean the lack of a hardon, which may be sincerity
 or the last-minute victory of the proud spirit over flesh,
 no: a tangerine-like sullenness in the face of sunrise
 or a dark sinking in the wind on the forecastle
 when someone you love hits your head and says "I'd sail with
 you any where, war or no war"

who was about
 to die a tough blond death
 like a slender blighted palm
in the hurricane's curious hail
 and the maelstrom of bull-dozers
 and metal sinkings,
 churning the earth
even under the fathomless deaths
 below, beneath
 where the one special
 went to be hidden, never to disappear
 not spatial in that way

 Take me, I felt, into the future fear of saffron pleasures
crazy strangeness and steam
 of seeing a (pearl) white whale, steam of
being high in the sky
 opening fire on Corsairs,
 kept moving in berths
where I trade someone *The Counterfeiters* (I thought it was
about personal freedom then!) for a pint of whiskey,
 banana brandy in Manila, spidery
steps trailing down onto the rocks of the harbor
 and up in the black fir, the
pyramidal whiteness, Genji on the Ginza,
 a lavender-kimono-sized
loneliness,
 and drifting into my ears off Sendai in the snow Carl
T. Fischer's *Recollections of an Indian Boy*
 this tiny over-decorated
rock garden bringing obviously heart-shaped
 the Great Plains, as is

18 · 5

Philip Guston / Ode to Michael Goldberg('s Birth and Other Births)

my way to be obvious as eight o'clock in the dining car
 of the
20th Century Limited (express)
 and its noisy blast passing buttes to be
Atchison-Topeka-Santa Fé, Baltimore and Ohio (Cumberland),
 leaving
beds in Long Beach for beds in Boston, via C-(D,B,) 47 (6)
pretty girls in textile mills,
 drowsing on bales in a warehouse of cotton
listening to soft Southern truck talk

 perhaps it is "your miraculous
low roar" on Ulithi as the sailors pee into funnels, ambassadors of green-
 beer-interests bigger than Standard Oil in the South
Pacific, where the beaches flower with cat-eyes and ear fungus
 warm as we never wanted to be warm, in an ammunition
dump, my foot again crushed (this time by a case of 40 millimeters)
 "the
 only thing you ever gave New Guinea was your toe-nail and now
 the Australians are taking over" ... the pony of war?

 to "return" safe who will never feel safe
 and loves to ride steaming in the autumn of
 centuries of useless aspiration towards artifice
 are you feeling useless, too, Old Paint?
 I am really an Indian at heart, knowing it is all
 all over but my own ceaseless going, never
 to be just a hill of dreams and flint for someone later
 but a hull laved by the brilliant Celebes response,
 empty of treasure to the explorers who sailed me not

King Philip's trail,
 lachrymose highway of infantile regrets and cayuse
meannesses,
 Mendelssohn driving me mad in Carnegie Hall like greed
grasping
 Palisades Park smiling, you pull a pretty ring out of the pineapple
and blow yourself up
 contented to be a beautiful fan of blood
 above the earth-empathic earth

 Now suddenly the fierce wind of disease and Venus, as
when a child
 you wonder if you're not a little crazy, laughing
because a horse
 is standing on your foot
 and you're kicking his hock
with your sneaker, which is to him
 a love-tap, baring big teeth
laughing . . .
 thrilling activities which confuse
 too many, too loud
too often, crowds of intimacies and no distance
 the various cries
and rounds
 and we are smiling in our confused way, darkly
in the back alcove
 of the Five Spot, devouring chicken-in-the-basket
and arguing,
 the four of us, about loyalty

 wonderful stimulation of bitterness
 to be young and to grow bigger
 more and more cells, like germs
 or a political conspiracy

 and each reason for love always
 a certain hostility, mistaken
 for wisdom
 exceptional excitement
 which is finally simple blindness
 (but not to be sneezed at!) like
 a successful American satellite . . .

 Yes, it does, it would still
 keep me out of a monastery if
 I were invited to attend one

 from round the window, you can't
 see the street!
 you let the cold wind course through
 and let the heart pump and gurgle
 in febrile astonishment,
 a cruel world

Philip Guston / Ode to Michael Goldberg('s Birth and Other Births)

to which you've led it by your mind,
 bicycling no-hands
 leaving it gasping
there, wondering where you are and how to get back,
 although you'll never let
 it go

 while somewhere everything's dispersed
at five o'clock
 for Martinis a group of professional freshnesses meet
and the air's like a shrub—Rose o'Sharon? the others,
 it's not
a flickering light for us, but the glare of the dark
 too much endlessness
stored up, and in store:
 "the exquisite prayer
 to be new each day
 brings to the artist
 only a certain kneeness"

I am assuming that everything is all right and difficult, where hordes of stars
 carry the burdens of the gentler animals like ourselves with wit
 and austerity beneath a hazardous settlement which we understand
 because we made
 and secretly admire

 because it moves
yes! for always, for it is our way, to pass the tea-house and the ceremony by
 and rather fall sobbing to the floor with joy and freezing than to spill
 the kid upon the table and then thank the blood
 for flowing
 as it must throughout the miserable, clear and willful
 life we love beneath the blue,
 a fleece of pure intention sailing like
 a pinto in a barque of slaves
 who soon will turn upon their captors
 lower anchor, found a city riding there
 of poverty and sweetness paralleled
 among the races without time,
 and one alone will speak of being
 born in pain
 and he will be the wings of an extraordinary liberty

19

Claes Oldenburg / Image of the Buddha Preaching

3"

3"

3"

4½"

3¾"

4¾"

7"

TEAPOT

Image of the Buddha Preaching

I am very happy to be here at the Villa Hügel
and Prime Minister Nehru has asked me to greet the people of Essen
and to tell you how powerfully affected we in India
have been by Germany's philosophy, traditions and mythology
though our lucidity and our concentration on archetypes
puts us in a class by ourself
 "for in this world of storm and stress"
—5,000 years of Indian art! just think of it, oh Essen!
is this a calmer region of thought, "a reflection of the mind
through the ages"?
 Max Müller, "primus inter pares" among Indologists
remember our byword, Mokshamula, I rejoice in the fact of 900 exhibits

I deeply appreciate filling the gaps, oh Herr Doktor Heinrich Goetz!
and the research purring onward in Pakistan and Ceylon and Afghanistan
soapstone, terracotta-Indus, terracotta-Maurya, terracotta Sunga,
 terracotta-Andhra, terracotta fragments famous Bharhut Stupa
Kushana, Ghandara, Gupta, Hindu and Jain, Secco, Ajanta, Villa Hügel!
Anglo-German trade will prosper by Swansea-Mannheim friendship
waning now the West Wall by virtue of two rolls per capita
and the flagship BERLIN is joining its "white fleet" on the Rhine
though better school and model cars are wanting, still still oh Essen
 Nataraja dances on the dwarf
 and unlike their fathers
 Germany's highschool pupils love the mathematics

 which is hopeful of a new delay in terror
 I don't think

20

Grace Hartigan / The Day Lady Died

The Day Lady Died

It is 12:20 in New York a Friday
three days after Bastille day, yes
it is 1959 and I go get a shoeshine
because I will get off the 4:19 in Easthampton
at 7:15 and then go straight to dinner
and I don't know the people who will feed me

I walk up the muggy street beginning to sun
and have a hamburger and a malted and buy
an ugly NEW WORLD WRITING to see what the poets
in Ghana are doing these days
 I go on to the bank
and Miss Stillwagon (first name Linda I once heard)
doesn't even look up my balance for once in her life
and in the GOLDEN GRIFFIN I get a little Verlaine
for Patsy with drawings by Bonnard although I do
think of Hesiod, trans. Richmond Lattimore or
Brendan Behan's new play or *Le Balcon* or *Les Nègres*
of Genet, but I don't, I stick with Verlaine
after practically going to sleep with quandariness

and for Mike I just stroll into the PARK LANE
Liquor Store and ask for a bottle of Strega and
then I go back where I came from to 6th Avenue
and the tobacconist in the Ziegfeld Theatre and
casually ask for a carton of Gauloises and a carton
of Picayunes, and a NEW YORK POST with her face on it

and I am sweating a lot by now and thinking of
leaning on the john door in the 5 SPOT
while she whispered a song along the keyboard
to Mal Waldron and everyone and I stopped breathing

21 · 1
Michael Goldberg / Rhapsody

Rhapsody

515 Madison Avenue
door to heaven? portal
stopped realities and eternal licentiousness
or at least the jungle of impossible eagerness
your marble is bronze and your lianas elevator cables
swinging from the myth of ascending
I would join
or declining the challenge of racial attractions
they zing on (into the lynch, dear friends)
while everywhere love is breathing draftily
like a doorway linking 53rd with 54th
the east-bound with the west-bound traffic by 8,000,000s
o midtown tunnels and the tunnels, too, of Holland

where is the summit where all aims are clear
the pin-point light upon a fear of lust
as agony's needlework grows up around the unicorn
and fences him for milk- and yoghurt-work
when I see Gianni I know he's thinking of John Ericson
playing the Rachmaninoff 2nd or Elizabeth Taylor
taking sleeping-pills and Jane thinks of Manderley
and Irkutsk while I cough lightly in the smog of desire
and my eyes water achingly imitating the true blue

a sight of Manahatta in the towering needle
multi-faceted insight of the fly in the stringless labyrinth
Canada plans a higher place than the Empire State Building
I am getting into a cab at 9th Street and 1st Avenue
and the Negro driver tells me about a $120 apartment
"where you can't walk across the floor after 10 at night
not even to pee, cause it keeps them awake downstairs"
no, I don't like that "well, I didn't take it"
perfect in the hot humid morning on my way to work
a little supper-club conversation for the mill of the gods

21 · 2

Michael Goldberg / Rhapsody

you were there always and you know all about these things
as indifferent as an encyclopedia with your calm brown eyes
it isn't enough to smile when you run the gauntlet
you've got to spit like Niagara Falls on everybody or
Victoria Falls or at least the beautiful urban fountains of Madrid
as the Niger joins the Gulf of Guinea near the Menemsha Bar
that is what you learn in the early morning passing Madison Avenue
where you've never spent any time and stores eat up light

I have always wanted to be near it
though the day is long (and I don't mean Madison Avenue)
lying in a hammock on St. Mark's Place sorting my poems
in the rancid nourishment of this mountainous island
they are coming and we holy ones must go
is Tibet historically a part of China? as I historically
belong to the enormous bliss of American death

Matsumi Kanemitsu / Song

Song

Is it dirty
does it look dirty
that's what you think of in the city

does it just seem dirty
that's what you think of in the city
you don't refuse to breathe do you

someone comes along with a very bad character
he seems attractive. is he really. yes. very
he's attractive as his character is bad. is it. yes

that's what you think of in the city
run your finger along your no-moss mind
that's not a thought that's soot

and you take a lot of dirt off someone
is the character less bad. no. it improves constantly
you don't refuse to breathe do you

23
Helen Frankenthaler / Poem

Poem

Hate is only one of many responses
true, hurt and hate go hand in hand
but why be afraid of hate, it is only there

think of filth, is it really awesome
neither is hate
don't be shy of unkindness, either
it's cleansing and allows you to be direct
like an arrow that feels something

out and out meanness, too, lets love breathe
you don't have to fight off getting in too deep
you can always get out if you're not too scared

an ounce of prevention's
enough to poison the heart
don't think of others
until you have thought of yourself, are true

all of these things, if you feel them
will be graced by a certain reluctance
and turn into gold

if felt by me, will be smilingly deflected
by your mysterious concern

Norman Bluhm / Naphtha

bluhm

Naphtha

Ah Jean Dubuffet
when you think of him
doing his military service in the Eiffel Tower
as a meteorologist
in 1922
you know how wonderful the 20th Century
can be
and the gaited Iroquois on the girders
fierce and unflinching-footed
nude as they should be
slightly empty
like a Sonia Delaunay
there is a parable of speed
somewhere behind the Indians' eyes
they invented the century with their horses
and their fragile backs
which are dark

we owe a debt to the Iroquois
and to Duke Ellington
for playing in the buildings when they are built
we don't do much ourselves
but fuck and think
of the haunting Métro
and the one who didn't show up there
while we were waiting to become part of our century
just as you can't make a hat out of steel
and still wear it
who wears hats anyway
it is our tribe's custom
to beguile

how are you feeling in ancient September
I am feeling like a truck on a wet highway
how can you
you were made in the image of god
I was not
I was made in the image of a sissy truck-driver
and Jean Dubuffet painting his cows
"with a likeness burst in the memory"
apart from love (don't say it)
I am ashamed of my century
for being so entertaining
but I have to smile

25

Allan D'Arcangelo / Poem

Poem

Khrushchev is coming on the right day!
 the cool graced light
is pushed off the enormous glass piers by hard wind
and everything is tossing, hurrying on up
 this country
has everything but *politesse*, a Puerto Rican cab driver says
and five different girls I see
 look like Piedie Gimbel
with her blonde hair tossing too,
 as she looked when I pushed
her little daughter on the swing on the lawn it was also windy
last night we went to a movie and came out,
 Ionesco is greater
than Beckett, Vincent said, that's what I think, blueberry blintzes
and Khrushchev was probably being carped at
 in Washington, no *politesse*
Vincent tells me about his mother's trip to Sweden
 Hans tells us
about his father's life in Sweden, it sounds like Grace Hartigan's
painting *Sweden*
 so I go home to bed and names drift through my head
Purgatorio Merchado, Gerhard Schwartz and Gaspar Gonzales,
 all
 unknown figures of the early morning as I go to work

where does the evil of the year go
 when September takes New York
and turns it into ozone stalagmites
 deposits of light
 so I get back up
make coffee, and read François Villon, his life, so dark
 New York seems blinding and my tie is blowing up the street
I wish it would blow off
 though it is cold and somewhat warms my neck
as the train bears Khrushchev on to Pennsylvania Station
 and the light seems to be eternal
 and joy seems to be inexorable
 I am foolish enough always to find it in wind

26

Giorgio Cavallon / Variations on Pasternak's "Mein liebchen,
was willst du noch mehr?"

Variations on Pasternak's "Mein liebchen, was willst du noch mehr?"

Walls, except that they stretch through China
like a Way, are melancholy fingers in the snow
of years
 time moves, but is not moving in its strange grimace
the captive fights the distances within a flower of wire
and seldom wins a look from the dull tin receptacle he decorates

 not that anything is really there
the country is the city without houses, the city
merely a kissed country, a hamster of choices
whether you own forty cats or just three snakes you're rich
as you appear, miraculous appearance, I had forgotten
that things could be beautiful in the 20th Century under the moon

the drabness of life peels away like an old recording by Lotte Lenya
it is not lucky to be German and you know it, though doom has held off
 perhaps it is waiting like a smile in the sky
 but no, it's the moon drifting and trudging
 and the clouds are imitating Diana Adams

 now the rain comes
and your face, like a child's soul, is parting its lids
 pouring down the brown plaster faces over doors and windows
over the casual elegancies of the last century and the poor
 over the lintels and the sniffs and the occasional hay fever
 to where nothing
 appears to be watering the city trees
 though they live, live on, as we do

what do you think has happened
that you have pushed the wall and
 stopped thinking of Bunny
 you have let death go, you have stopped
 you are not serene, you desire something, you are not ending
it is not that the world expects the people, but it does
the brassiness of weeds becomes sculptural and bridal
everything wants to be you and wisdom is unacceptable
 in the leaden world of fringes and distrust and duty

I have discovered that beneath the albatross there is a goose
 smiling
 a centenarian goes down the street and sees
 George Balanchine, that makes the day for him
just as the sight of you, no wall, no moon, no world, makes
 everything day to me

27

Nell Blaine / Poem

Poem

to Donald M. Allen

Now the violets are all gone, the rhinoceroses, the cymbals
a grisly pale has settled over the stockyard where the fur flies
and the sound
 is that of a bulldozer in heat stuck in the mud
where a lilac still scrawnily blooms and cries out "Walt!"
so they repair the street in the middle of the night
and Allen and Peter can once again walk forth to visit friends
in the illuminated moonlight over the mists and the towers
having mistakenly thought that Bebe Daniels was in *I Cover the Waterfront*
instead of Claudette Colbert it has begun to rain softly and I walk
slowly thinking of becoming a stalk of asparagus for Hallowe'en
 which idea Vincent poopoos as not being really '40s
so the weight
 of the rain drifting amiably is like a sentimental breeze
and seems to have been invented by a collapsed Kim Novak balloon

yet Janice is helping Kenneth appeal to The Ford Foundation in
her manner oft described as The Sweet Succinct and Ned is glad
 not to be up too late
 for the sake of his music and his ear
 where discipline finds itself singing and even screaming away

I shall not dine another night like this with Robin and Don and Joe
as lightly as the day is gone but that was earlier
 a knock on the door
my heart your heart
 my head and the strange reality of our flesh in the rain
so many parts of a strange existence independent but not searching in the night
 nor in the morning when the rain has stopped

28

Jane Freilicher / Poem V (F) W

Poem V (F) W

I don't know if you doubt it
but I think you do
I am independent of the Cabaret Voltaire
the Café Grinzing the Black Cat
the anubis
two parallel lines always meet
except mentally
which brings on their quarrels
and if I sit down I admit
it is not at a table
underneath elms
to read

you were walking down a street softened by rain
and your footsteps were quiet
and I came around the corner
inside the room
to close the window
and thought what a beautiful person
and it was you
no I was coming out the door
and you looked sad
which you later said was tired
and I was glad
you had wanted to see me
and we went forward
back to my room
to be alone in your mysterious look
among the relics of post-war hysterical pleasures
I see my vices
lying like abandoned works of art
which I created so eagerly
to be worldly and modern
and with it
what I can't remember
I see them with your eyes

Lee Krasner / Poem

Poem

Light clarity avocado salad in the morning
after all the terrible things I do how amazing it is
to find forgiveness and love, not even forgiveness
since what is done is done and forgiveness isn't love
and love is love nothing can ever go wrong
though things can get irritating boring and dispensable
(in the imagination) but not really for love
though a block away you feel distant the mere presence
changes everything like a chemical dropped on a paper
and all thoughts disappear on a strange quiet excitement
I am sure of nothing but this, intensified by breathing

30 · 1

Larry Rivers / For the Chinese New Year & for Bill Berkson

For the Chinese New Year & for Bill Berkson

One or another
Is lost, since we fall apart
Endlessly, in one motion depart
From each other.
 —D. H. Lawrence

Behind New York there's a face
and it's not Sibelius's with a cigar
it was red it was strange and hateful
and then I became a child again
like a nadir or a zenith or a nudnik

what do you think this is my youth
and the aged future that is sweeping me away
carless and gasless under the Sutton
and Beekman Places towards a hellish rage
it is there that face I fear under ramps

didn't you know we was all going to be Zen Buddhists after
what we did you sure don't know much about war-guilt
or nothin and the peach trees continued to rejoice around
the prick which was for once authorized by our Congress
though inactive what if it had turned out to be a volcano

that's a mulatto of another nationality of marble
it's time for dessert I don't care what street this is
you're not telling me to take a tour are you
I don't want to look at any fingernails or any toes
I just want to go on being subtle and dead like life

I'm not naturally so detached but I think
they might send me up any minute so I try to be free
you know we've all sinned a lot against science
so we really ought to be available as an apple on a bough
pleasant thought fresh air free love cross-pollenization

it is perhaps the period that ends
the problem as a proposition of days of days
just an attack on the feelings that stay
poised in the hurricane's center that
eye through which only camels can pass

but I do not mean that tenderness doesn't
linger like a Paris afternoon or a wart
something dumb and despicable that I love
because it is silent oh what difference
does it make me into some kind of space statistic

a lot is buried under that smile
a lot of sophistication gone down the drain
to become the mesh of a mythical fish
at which we never stare back never stare back
where there is so much downright forgery

under that I find it restful like a bush
some people are outraged by cleanliness
I hate the lack of smells myself and yet I stay
it is better than being actually present
and the stare can swim away into the past

can adorn it with easy convictions rat
cow tiger rabbit dragon snake horse sheep
monkey rooster dog and pig "Flower Drum Song"
so that nothing is vain not the gelded sand
not the old spangled lotus not my fly

which I have thought about but never really
looked at well that's a certain orderliness
of personality "if you're brought up Protestant
enough a Catholic" oh shit on the beaches so
what if I did look up your trunks and see it

II

then the parallel becomes an eagle parade
of Busby Berkeleyites marching marching half-toe
I suppose it's the happiest moment in infinity
because we're dissipated and tired and fond no
I don't think psychoanalysis shrinks the spleen

30 · 2

Larry Rivers / For the Chinese New Year & for Bill Berkson

30 · 3
Larry Rivers / For the Chinese New Year & for Bill Berkson

here we are and what the hell are we going to do
with it we are going to blow it up like daddy did
only us I really think we should go up for a change
I'm tired of always going down what price glory
it's one of those timeless priceless words like come

well now how does your conscience feel about that
would you rather explore tomorrow with a sponge
there's no need to look for a target you're it
like in childhood when the going was aimed at a
sandwich it all depends on which three of us are there

but here come the prophets with their loosening nails
it is only as blue as the lighting under the piles
I have something portentous to say to you but which
of the papier-mâché languages do you understand you
don't dare to take it off paper much less put it on

yes it is strange that everyone fucks and every-
one mentions it and it's boring too that faded floor
how many teeth have chewed a little piece of the lover's
flesh how many teeth are there in the world it's like
Harpo Marx smiling at a million pianos call that Africa

call it New Guinea call it Poughkeepsie I guess
it's love I guess the season of renunciation is at "hand"
the final fatal hour of turpitude and logic demise
is when you miss getting rid of something delouse
is when you don't louse something up which way is the inn

III

I'm looking for a million-dollar heart in a carton
of frozen strawberries like the Swedes where is sunny England
and those fields where they still-birth the wars why
did they suddenly stop playing why is Venice a Summer
Festival and not New York were you born in America

the inscrutable passage of a lawn-mower punctuates
the newly installed Muzack in the Shubert Theatre am I nuts
or is this the happiest moment of my life who's arguing it's
I mean 'tis lawd sakes it took daddy a long time to have
that accident so Ant Grace could get completely into black

oh oh god how I'd love to dream let alone sleep it's night
the soft air wraps me like a swarm it's raining and I have
a cold I am a real human being with real ascendancies
and a certain amount of rapture what do you do with a kid
like me if you don't eat me I'll have to eat myself

it's a strange curse my "generation" has we're all
like the flowers in the Agassiz Museum perpetually ardent
don't touch me because when I tremble it makes a noise
like a Chinese wind-bell it's that I'm seismographic is all
and when a Jesuit has stared you down for ever after you clink

I wonder if I've really scrutinized this experience like
you're supposed to have if you can type there's not much
soup left on my sleeve energy creativity guts ponderableness
lent is coming in imponderableness "I'd like to die smiling" ugh
and a very small tiptoe is crossing the threshold away

whither Lumumba whither oh whither Gauguin
I have often tried to say goodbye to strange fantoms I
read about in the newspapers and have always succeeded
though the ones at "home" are dependent on Dependable
Laboratory and Sales Company on Pulaski Street strange

I think it's goodbye to a lot of things like Christmas
and the Mediterranean and halos and meteorites and villages
full of damned children well it's goodbye then as in Strauss
or some other desperately theatrical venture it's goodbye
to lunch to love to evil things and to the ultimate good as "well"

the strange career of a personality begins at five and ends
forty minutes later in a fog the rest is just a lot of stranded
ships honking their horns full of joy-seeking cadets in bloomers
and beards it's okay with me but must they cheer while they honk
it seems that breath could easily fill a balloon and drift away

scaring the locusts in the straggling grey of living dumb
exertions then the useful noise would come of doom of data
turned to elegant decoration like a strangling prince once ordered
no there is no precedent of history no history nobody came before
nobody will ever come before and nobody ever was that man

you will not die not knowing this is true this year

Afterword

He always appeared delightfully conscious of the existence of artists other than himself—other poets, painters, composers, and those critics and scholars recognizably on the side of the angels. Kenneth Koch remembers him as "very polite and also very competitive"; John Ashbery compliments him on having been "an *animateur.*" When Frank made up his dramatic monologue *Franz Kline Talking*, he had the painter say: "Hell, half the world wants to be like Thoreau at Walden worrying about the noise of traffic on the way to Boston; the other half use up their lives being part of that noise. I like the second half. Right?"

"To be right is the most terrific personal state that nobody is interested in."

James Schuyler claims Frank "decided to be an artist when he saw Assyrian sculpture in Boston," and, taking *Second Avenue* as an instance of connection between poetry and painting, imagines "it's probably true to deduce that he'd read the Cantos and Whitman (he had); also Breton, and looked at de Koonings and Duchamp's great Dada installation at the Janis Gallery . . ." All enthusiasms aside, he opted for poetry as "the highest art, everything else, however gratifying . . .moving and grand, is less demanding, more indulgent, more casual, more gratuitous, more instantly apprehensible, which I assume is not exactly what we are after."

Starting out as a music student in Massachusetts, he said, he used to hate the very idea of writing; somehow he had gotten the idea it was "sissy." Not much later, a teen-age sailor in the Pacific War, he worried about his carrier's guns downing any pilot "who might just happen to be a great Japanese composer."

Become a writer, he was certainly no victim of specialization, neither was he any kind of literary snob. In a sense, "everything else" provided grist for the mill, yet it got plenty in return: Frank gave to the things he admired (just as to his friends and their unsuspecting remarks) first of all, their place in his own poetry— he had a knack for immortalizing just about any proper noun, from "George Balanchine" or "Bird in Flight" to "Bones Mifflin"—and second, a seemingly endless output of critical advertisement, outright fan letters, and general moral support, not to mention an eventually full-time enhancement of the exhibitions program of The Museum of Modern Art. The last poem he wrote was the *Little Elegy for Antonio Machado*, a catalogue-piece for the Tibor de Nagy show of Spanish painting to aid refugees from the Franco regime.

It was fantastic to notice how much he knew—his day-by-day awareness of the slightest tremors in the atmosphere—and how much he thought about so much of it! He could even sort out the relevant from the massive banal—a Herculean task in today's ingeniously absurd "information" world. In the talk of last night's concert or this afternoon's gallery opening or tomorrow's little magazine, his distinctions seemed to strike from nowhere, stunning the room. A very special, somewhat overloaded, genius, you might say. "Don't be bored, don't be lazy,

don't be trivial, and don't be proud. The slightest loss of attention leads to death." He was very free with his knowledge.

A few years ago in Paris, cooling off an argument about social behavior, Frank said quite plainly how important it was to him that a man be an artist and not something else—how, in some respects, it seemed to him impossible to be anything else and still be said to exist. Koch describes his "way of acting and feeling as though being an artist were the most natural thing in the world." "Compared to him everyone else seemed a little self-conscious, abashed or megalomaniacal." His seriousness was such that he could be luxuriantly flippant about his own ambitions, which were, naturally, very keen. No need for gravity, cant or Bohemian postures to flaunt a professional look. Once in a blue moon there's a poet "to the manner born."

We are used to those odd discussions in the course of which painters mention "presence" or the lack of it—an all too ineffable quality by which art objects are said to win or lose. In poetry, we say it is a "voice" that does or doesn't come across to the ear. A contemporary translation of *The Seafarer* begins "This verse is my voice, it is no fable"; and the rigors of "finding your own voice" are well-known to workshop students, though lately the premium on individual quirks seems to be dwindling. At any rate, the voice of a good poet is liable to be just that intimation of truthfulness that enters his work most without his knowing; it exists in ratio to his conviction and beyond technique in the ordinary sense. In Frank O'Hara's case it is almost everything. He is "all talk"—which is not to say all verbiage or bluff, but the effect of his poetry is mainly that of spontaneous utterance from a very definite source. It is this, I think, that makes his work so strangely comprehensive, so alive and inimitable. It's a fierce game he plays, "staying on the boards," "going on your nerve"—no masks, no margins, no malarky. He is willing to "mean" just about anything—except something pusillanimous or pompous or dull. The pressure of the syntax relates to the pressures of life. You feel the language suddenly intimate with the emotions of a particular person. If the subject is "survival" (endurance or duration), one might just as well say it is "time"—the way time can buoy up or defeat—or how to kill time in "a jealous society of accident." An O'Hara poem will always denote some change in the poet's world. There is always more to say because there is always more to feel, and *vice versa*.

Only a fool or a troglodyte could miss his faults; they're obvious, they can even be charming. You will find, for instance, an impatience that causes confusions of tone, or some occasionally unmet demands for sentiment breeding bitter sophistries of "disillusion," sudsy rhetoric, or, worse, a case of the giggles, a kind of hysteria. You well might wonder if Whitman at his dizziest was more self-indulgent, all naked idiocies laid right on the line. But aren't even the most far-fetched, however you feel about them, perfectly common to the world outside poetic conventions? After all, who isn't silly about sex or vaguely idealistic about politics or despairing of one's own abject affinities? And this outside world lacks

O'Hara's irony—his self-knowledge and verbal care, which make even his bad or mediocre poems worth reading, if only for a sudden miraculous line, or some other bit that is anyway exceptional.

Neither does one miss the overriding particular virtues: sheer poetic finesse (so tactfully concealed), a speed almost synonymous with inspiration, the happy identification and excitement of real things—the utter range of noun and implied action; a jolting sophistication; the split-second enjambments (one line rattling onto the next: sharp transitions, telescoped flourishes of imagery); the quick, specific truths. The best of his poems are full of ordinary human passion, and you can't beat that.

I hope the thirty poems in this book will indicate the beauty of Frank O'Hara's work as a whole. Granted the advice of those whose opinions I value most, the choice still stands as a personal one. Being a close friend of a poet you admire affords and forbids you certain luxuries in reading him. I can't say I've had the best interests of history at heart at every turn; I've tried to sort out O'Hara at his most memorable. As special a choice as this is not intended to compete with a Collected or even a Selected Poems, and it is on such volumes that we will have to depend for complete satisfaction regarding the poetry proper.

The choice spans a good portion of a poetic career, eleven out of some fifteen years (if one discounts undergraduate work). The emphasis falls naturally, I think, not so much on certain kinds of poems as on certain years of wildly diverse accomplishment. 1959, for instance, from which I've included eleven poems: somebody's mercury must have soared to leap from the super-audacious *Rhapsody* to that exquisite, nasty lyric beginning "Hate is only one of many responses," then on to the bounce and sweep and mysterious resolution of the "Khrushchev" poem. O'Hara hit his stride about 1953, and the next seven years constitute, to my thinking, his richest period. He ran into a bad stretch in the last few years and the year he died, for reasons one can only guess at, hardly wrote a thing.

Something should be said about the choice of artists to decorate the poems: I have been guided by my knowledge of Frank O'Hara's involvements and associations over the years and by the hints of some who knew better. Since we decided to limit the list to American artists, I should like to mention some of the many Europeans who might otherwise have participated; they are: the Canadian Jean-Paul Riopelle, the Dutchman Jan Cremer, the Frenchmen Jean Dubuffet and Jean Tinguely, the Italians Arnoldo Pomodoro and Mario Schifano, and the Spaniards Anton Tápies Puig, Antonio Saura, and Pablo Serrano. Other Americans too, but the list would go on forever.

At the funeral, standing Lincoln-like and low-voiced under the big elm at Springs, Edwin Denby said that Frank O'Hara's reputation, never what was due, would most likely increase. It was Frank's idea that, for the happy few, such matters usually take care of themselves. The work stands as it is.

BILL BERKSON *August 4, 1967*

Acknowledgments

This book has been in many respects a group project. In both editing the poetry and determining which artists should decorate which poems, I have drawn freely on the good advice, some of it unwitting, of many poets, artists, and friends.

First of all, I wish to thank Mrs. Walter Granville-Smith, the late Frank O'Hara's sister and the Executrix of his Estate, for granting permission for the publication of all the poems in this book. Both she and her husband have been extremely generous, helpful, and patient in the face of countless details.

Kenneth Koch and John Ashbery served as consultants on the selection of the poetry. We had few arguments; I owe a special debt to each of these poets for pointing out the superior qualities of certain of Frank O'Hara's works which had previously escaped my attention. I have been assured that my final selection, if not exactly the one either would have made on his own, at least succeeds in presenting the range and high points of O'Hara's extraordinarily varied *oeuvre*. Given the nature of the book as planned, this was the most I felt one might aspire to.

Robert Motherwell served as artistic advisor and, as such, gave generously of his time and his knowledge in matters of graphic technique and design. We owe a debt in this connection as well to all the artists who produced and contributed drawings especially for this occasion. The presence of each has determined to a great extent the conception and ultimate appearance of the book.

My thanks for other, particularly helpful, advice and encouragement go to: Morris Golde, Joseph LeSueur, Kynaston McShine, Mrs. John Barry Ryan III, and Virgil Thomson.

Finally, I must gratefully acknowledge the kindness of various publishers and magazines in granting permission to reprint copyright poems: Grove Press, City Lights Books, Tiber Press, Tibor de Nagy Gallery Editions, Totem/Corinth Books, Poetry: A Magazine of Verse.

B.B.

Colophon for the original edition of 1967:

The book was designed by Susan Draper Tundisi

The poems are set in Times Roman
and the typesetting was done by The Composing Room, Inc.

The book was printed by Crafton Graphic Company, Inc.
and bound by Russell-Rutter, Inc.

The paper is Mohawk Superfine Smooth

Of a unique edition of 2500 copies this is copy number

.

*The present edition was typeset, printed, and bound
by Stamperia Valdonega, Verona,
on Munken Pure 130 gsm acid-free paper*